# Retreat from Likeness in the Theory of Painting

# Retreat from Likeness in the Theory of Painting

FRANCES BRADSHAW BLANSHARD

SECOND EDITION, REVISED & ENLARGED

 BOOKS FOR LIBRARIES PRESS

FREEPORT, NEW YORK

INTERNATIONAL STANDARD BOOK NUMBER:
0-8369-6733-X

LIBRARY OF CONGRESS CATALOG CARD NUMBER:
72-37913

PRINTED IN THE UNITED STATES OF AMERICA
BY
NEW 'WORLD BOOK MANUFACTURING CO., INC.
HALLANDALE, FLORIDA 33009

*To* M. R. B. *and* E. D. H.

# Preface

THIS edition represents a complete revision, with illustrations added and much other new material, especially in the chapters, "From Likeness to Expression," "The Heritage of Abstract Painting," and "The Theory of Abstract Painting." Unlike some discussions of a puzzling phase of twentieth-century art, this book is neither an attack nor a defense, but simply an attempt at a clearer understanding. It is addressed to general readers as much as to special students of art theory, and can be read without a glance at a footnote. The notes are there for those with a taste for documentation and for elaboration of a few fine points. The illustrations should serve both as an introduction to the text and as a final summing up of stages in the retreat from likeness.

F. B. B.

*New Haven, Connecticut*
*May, 1949*

# Acknowledgments

THERE are four writers to whom I owe far more than any lines quoted from their works: Samuel Alexander, E. F. Carritt, R. G. Collingwood, and Roger Fry.

For special help with this edition I am grateful to Mr. Henry Silver 2nd, formerly of King's Crown Press, to Dr. William Bridgwater and Mr. Henry H. Wiggins of Columbia University Press, and to Professor George Heard Hamilton of the Department of the History of Art at Yale University. Dorothy Hamilton Brush kindly read the manuscript and made valuable suggestions. My constant thanks go to my husband for his loyal encouragement.

Much courteous aid was given me generously by assistants in the Reading Room of the British Museum, where I had the good fortune to work in 1938–39. For recent help I am greatly indebted to the librarian of the Library of the School of the Fine Arts at Yale, Miss Lydia H. Wentworth.

Permission to quote from the following works was obtained for the first edition of this book: from Samuel Alexander, *Beauty and Other Forms of Value*, The Macmillan Company; from Alfred H. Barr, Jr., *Cubism and Abstract Art*, The Museum of Modern Art; from Paul Cézanne, *Letters*, translated by Marguerite Kay and edited by John Rewald, Bruno Cassirer; from Roger Fry, *The Artist and Psychoanalysis*, The Hogarth Press, and *Vision and Design*, Brentano's; from Stephen Mackenna's translation of the *Enneads* of Plotinus, The Medici Society; from W. Worringer, *Form in Gothic*, G. P. Putnam's Sons; from Willard Huntington Wright,

x                                                    Acknowledgments

*Modern Painting*, Dodd, Mead and Company. In this second edi-
tion I am under further obligation for quotations: from Alfred H.
Barr, Jr., *Picasso; Forty Years of His Art*, The Museum of Modern
Art; from Guillaume Apollinaire, *The Cubist Painters*, and Was-
sily Kandinsky, *Concerning the Spiritual in Art*, Wittenborn,
Schultz, Inc.; from Piet Mondrian, *Plastic Art and Pure Plastic
Art*, Mr. Harry Holtzman and Wittenborn, Schultz, Inc.; from
Hilla Rebay, *In Memory of Wassily Kandinsky*, The Solomon R.
Guggenheim Foundation; from R. H. Wilenski, *Modern French
Painters*, Reynal & Hitchcock.

I owe thanks for the following to the generous loan of plates:
from the Museum of Modern Art, of the Picasso *Dog and Cock*;
from the Museum of Non-Objective Painting, of two Kandinskys,
*Improvisation* and *Above and Left*; and from Mr. A. E. Gallatin,
of the Mondrian *Painting, 1937*. I have the Philadelphia Museum
of Art to thank for permission to reproduce the following: the
Van Heemskerck *Portrait of an Old Lady* in the John G. Johnson
Collection, the Gainsborough *Miss Linley*, Poussin's *The Triumph
of Neptune and Amphitrite*, and Cézanne's *The Bathers.*

                                                            F. B. B.

# Contents

# Illustrations

Following page 158

# Retreat from Likeness
# in the Theory of Painting

# Introduction

ABSTRACT PAINTING has now reached a respectable middle age, having come into existence in 1910. That was the year when the Russian painter, Wassily Kandinsky, exhibited his first *Improvisation* in Munich. He chose a title from music, implying what he said many times later, that his design of colors and shapes without recognizable objects was like music in making its effect by immediate impact on the senses. Painting of this sort has been variously called "pure," "non-objective," or, most commonly, "abstract." [1]

Before the first World War, artists were painting abstractly in many countries of Europe and in the United States. Some of them started "schools," each with its distinctive name, style, theory, and defender.[2] From 1913 until 1921, Moscow was one exciting center of experiment in abstraction. The new painting showed two strains.[3] One was intellectual, using geometrical forms, stemming from Cézanne and the Cubists, and appearing in Suprematism and Constructivism. The other, emotional, used soft organic shapes, and owed much to the German Expressionists and to Russian primitive art. Here the famous innovator was Kandinsky. The founder of Suprematism, Kasimir Malevich, defined it as "the supremacy of pure feeling or perception in the pictorial arts." This definition hardly prepares us for the austerity of his first Suprematist painting,

[1] Kandinsky, 1866–1944, Abstract Expressionist painter and author of several books on art. His theory will be discussed in detail in the last chapter. Reproductions of his paintings follow p. 158. For a full discussion of definitions, see below, pp. 117–22.

[2] Barr, *Cubism and Abstract Art*; an excellent full account of schools and individuals, only a sampling of which is mentioned here.

[3] See Lozowick, *Modern Russian Art*.

a black square on a white ground. Malevich explains how he came to paint this picture in a "desperate struggle to free art from the ballast of the objective world" through escape into pure form. Malevich reached his apex with his famous *White on White*, one hardly visible white square tilted against another. To this painting Alexander Rodchenko opposed his *Black on Black*, dark, faintly outlined elliptical forms against a dark circle. With this he introduced a new school, Non-Objectivism.[4] These schools found favor at first with the government that followed the revolution.[5] Abstraction then represented a welcome revolt against bourgeois tradition in art, and expressed the spirit of a social order that was to be regenerated through science and machinery—both, in a sense, abstractions from nature. But in spite of its ideological propriety, the new art failed to appeal to the people. They would not support it, and consequently it lost official approval. Artists who had been honored were treated coldly. Kandinsky, for one, had been invited to make plans for an Institute of Art [6] which should promote research into the effects of color and line and also into serviceable relations between painting, sculpture, and architecture—the painting naturally to be abstract. The Institute was never set up as he had planned it, and in 1921 he left for Berlin, going the next year to the Bauhaus in Weimar. In 1920, Rodchenko, dissatisfied with his earlier Non-Objectivism, joined with Naum Gabo and Anton Pevsner to found a new school, Constructivism.[7] This could hardly be called a school of painting, since its adherents did not set brush to canvas, but rather built arrangements of planes and wires in architectural designs. Gabo eventually helped to carry Constructivism to Germany, thence to London, and finally to the United States.[8]

[4] Barr, *op. cit.*, pp. 122, 124.          [5] Lozowick, *op. cit.*, pp. 29 ff.
[6] *In Memory of Wassily Kandinsky*, arranged and edited by Hilla Rebay, p. 92.
[7] Lozowick, *op. cit.*, pp. 29–45.
[8] See *Circle*, a collection of essays, edited by J. L. Martin, Ben Nicholson, N. Gabo, published in London [1937]. One essay by Gabo sets forth the principles of Constructivism. Gabo has now set up a studio in Woodbury, Connecticut.

Another early experiment in abstraction, Vorticism, startled London in 1914. Vorticism proposed to explode tradition in all the arts and whirl them into new life. The prime movers were Wyndham Lewis and a group including Richard Aldington and Ezra Pound. The vehicle of revolution, the periodical *Blast*, blared forth their gospel in screaming bold type. All art, they said, should speak for this present age of clashing machinery, of cities hard with masonry and asphalt, yet palpitating with a fierce vitality. To belong to this age, painting must be abstract. Only by renouncing art that represented old and outmoded ways of living could artists discover forms that should express their own day. Lewis acknowledged an interest in Cubism, Futurism, and Kandinsky, while trying to set them all right. There is enough critical sharpness and wisdom in his writings to make one regret that the war reduced *Blast* to silence after only two issues.[9] In 1921 Lewis took the field once more against art rooted in the past in a new periodical, *Tyro*.[10] Now one of his contributors was T. S. Eliot. But *Tyro* also did not survive its second number. *Tyro* is to *Blast* as a somewhat chastened adult to a bumptious and brilliant schoolboy, but both were consistently devoted to the claims of abstraction.

Paris of the war years saw a short-lived school of abstraction, Synchromism, created by two young Americans, Morgan Russell and S. MacDonald Wright. The name in its Greek derivation proclaimed that these artists would work *with color* alone. They rejoiced in an eloquent apologist, Wright's father, Willard Huntington Wright. His explanation of their position, *Modern Painting* (1915), contains a succinct and forceful statement of the mission of pure painting which could be accepted by adherents of many other schools: "The subject matter of painting,—that is, the recognizable

[9] *Blast*, No. 1, June 20, 1914; War Number, July, 1915. Those who signed the "Manifesto of Vorticism," published in the first number of *Blast*, p. 43, were: R. Aldington, Arbuthnot, L. Atkinson, Gaudier Breska, J. Dismore, C. Hamilton, E. Pound, W. Roberts, H. Sanders, E. Wadsworth, Wyndham Lewis.

[10] *Tyro*, published by the Egoist Press, no date (1921? 1922?).

object, the human obstacle—had to be forced out. . . . A picture
in order to represent its intensest emotive power must be an abstract
presentation expressed entirely in the medium of painting, and that
medium is colour. . . . So long as painting deals with objective
nature it is impure art, for recognizability precludes the highest
aesthetic emotion." [11] Paris was not one of the most important cen-
ters of early pure abstraction, no doubt partly because the Cubists still
held the field with their use of forms that retained some degree of
representation.

During the First World War, two Dutch painters, Piet Mondrian
and Theo van Doesburg,[12] founded a periodical, De Stijl, with a pro-
gram of reform in the arts of building and decoration along "func-
tional" lines. Its influence on architecture and on designs of furni-
ture, posters, even typography, can hardly be measured. De Stijl
stood for what is generally called "modern" style. Its effect on paint-
ing in the hands of Mondrian was to produce a "T-Square" style
which he called Neo-Plasticism. In his most characteristic period,
Mondrian used only straight lines and right angles, and pure primary
colors. These materials he held to be dictated by his high aim, to
create pure reality. "To create pure reality plastically, it is necessary
to reduce natural form to *constant elements* of form and natural
color to *primary* color." [13]

Russian and Dutch abstraction converged in the Bauhaus,
founded in Weimar in 1919 by Walter Gropius,[14] and transferred
in 1925 to Dessau. Gropius invited Kandinsky and later Van
Doesburg to join his group. Both were equipped by previous ex-

[11] *Modern Painting*, pp. 328, 332, 333, 342. Willard Huntington Wright is better
known as the writer of mystery stories, S. S. Van Dine.

[12] Piet Mondrian, 1872–1944; his theories will be considered in detail in the last
chapter. Theo van Doesburg, 1883–1931.

[13] Mondrian, *Plastic Art and Pure Plastic Art*, p. 10.

[14] Walter Gropius, 1883–  , architect and writer; founded the Bauhaus in 1919
in Weimar; moved to Dessau in 1925; 1928–37 in private practice; 1938–   Chair-
man of the Department of Architecture in Harvard University.

perience to further the aim of the Bauhaus: [15] cooperation among architects, painters, and sculptors in applying the principles of a machine age to construct completely appropriate quarters for living and work. Kandinsky was one of three teachers of painting at the Bauhaus in its early days; the other two, Paul Klee and Lyonel Feininger.[16] All had been Expressionists before the war, but Feininger was soon influenced by the geometrical functionalism of *De Stijl* and introduced an angular abstraction that has seemed characteristic of the Bauhaus through most of its history.

In the United States, one of the first abstractions that has become famous was Georgia O'Keeffe's *Blue Lines*.[17] She painted it in 1915, two years after the Armory Show had shocked America into awareness of what had happened to art in Europe. O'Keeffe had learned a free use of color and form from her teacher, Arthur Dow, who had seen Gauguin's work at Pont-Aven, and had been struck also with the quality of newly popular Oriental design. O'Keeffe, with Joseph Stella, Alfred Maurer, and Arthur B. Dove, made up the small group of painters rash enough to practice abstraction then. By the majority of American artists and critics, this way of painting during most of its first twenty years was easily dismissed as a "passing phase."

A handful of unusually daring connoisseurs did persist in spite of ridicule in taking the whole modern movement seriously, to the ultimate benefit of abstraction: Alfred Stieglitz, brilliant photographer, with his flair for discovering European and American artists, introduced them in his famous galleries, "291" Fifth Avenue, "Intimate Gallery," and "An American Place." Frank Crownin-

[15] See *Bauhaus 1918–1928*, edited by Herbert Bayer, Walter Gropius, Ise Gropius.

[16] Klee, 1879–1940; Feininger, 1871–  .

[17] Georgia O'Keeffe, 1887–  ; her *Blue Lines* is reproduced as frontispiece of Northrop's *The Meeting of East and West*. The date assigned to it there is 1916, but it is dated 1915 by Daniel Catton Rich in his catalogue of an exhibition of O'Keeffe's work at the Chicago Art Institute in 1943, p. 10.

shield, art editor of the *Century Magazine* at the time of the Armory Show, described himself as its "unofficial press agent" and later, as editor of *Vanity Fair*, gave publicity to modern painting. Katherine S. Dreier, herself a painter, helped to found the "Société Anonyme: Museum of Modern Art 1920," the pioneer organization "to promote art *progressive* in all its branches," and to recognize its broad international range. Dr. Albert C. Barnes, celebrated collector of French and African art, as early as 1918 helped educate unaccustomed eyes to original constructions of form.[18] The new movement took a turn for the better in 1926 when the Société Anonyme presented the famous International Exhibition of Modern Art in the Brooklyn Museum. This exhibition, representing the work of more than a hundred artists and twenty-three countries, was acclaimed by a relatively conservative journal, *Art News*, as far more exciting and satisfying than the Pittsburgh International. The very new *New Yorker* praised it for showing that art could be in touch with life, and raised a cry for a gallery in Manhattan where the new art could be shown, a cry answered in 1929 by the foundation of the Museum of Modern Art.[19] This Museum's exhibitions and publications have proved perhaps the greatest single force in developing understanding and appreciation of the art of the day.

Abstraction, singled out from other phases of "modernism," came to the fore in 1937 when the Solomon R. Guggenheim Foundation drew plans for the Museum of Non-Objective Painting, to be opened in 1939 under the direction of Hilla Rebay. Its exhibitions and publications have taken special notice of two painters, Wassily Kandinsky and Rudolf Bauer. In 1936 a group taking the name "American Abstract Artists" held the first of their annual exhibitions. Ten years later when they published a collection of articles

[18] I owe a great personal debt to Dr. Barnes, who let me see his remarkable collection in 1918 when he had it still in his own house, and again several times after he had established The Barnes Foundation in Merion, Pennsylvania.

[19] *Art News*, XXV (November 20, 1926), 1, 3. *New Yorker*, II (December 11, 1926), 98–99; II (December 18, 1926), 78.

with the same title, the editor, George L. K. Morris, noted a striking shift in attitude toward abstraction during the decade. Art formerly renounced as "foreign" had now become widely accepted.[20] Paradoxically, this shift has been hastened by an influx of artists undeniably "foreign," artists who came to this country as the result of upheavals in Europe: László Moholy-Nagy, of Bauhaus fame, who became Director of the Chicago Bauhaus, later the Institute of Design, in 1937; Naum Gabo with his studio in Connecticut; Josef Albers, distinguished member of the faculty of Black Mountain College in North Carolina; Piet Mondrian, who arrived in New York at the age of sixty-eight in 1940, had his first one-man show two years later, and fell in love with the city, painting its *Broadway Boogie Woogie*.

The decade 1936–46 saw uncounted exhibitions of abstract art in many parts of the country. At the Carnegie Institute in 1946, the first prize went to an abstraction, Karl Knath's *Gear*. The literature of the subject has been greatly enriched by a new series of publications, started in 1944: "The Documents of Modern Art," edited by the painter, Robert Motherwell, and issued by Wittenborn.

To American artists born since the Armory Show, abstraction is a perfectly familiar way of painting. Having always known it, they may feel that it has always been, and may use it without self-consciousness. The actual extent of its acceptance by younger artists was estimated by two curators of the Art Institute of Chicago who traveled the length and breadth of the United States to prepare an exhibition of abstract and surrealist painting which was opened in the fall of 1947. George Morris' impressions were supported by their findings that in the last ten years the number of artists experimenting with non-objective forms had doubled or trebled, not only in large cities but in smaller places too: Walnut Creek, California; Muscola, Wisconsin; Lincoln, Nebraska. The Director of the Institute, Daniel Catton Rich, reached the conclusion that for young

[20] In his Introduction.

American artists "abstraction, together with a moody form of expressionism, has become one of the two most popular approaches to painting." [21] Another discovery: three-fourths of the painters now working in this style were native-born.

Although abstract painting has achieved the right to exist, its status is by no means unequivocal. A month before Mr. Rich's show opened in Chicago, a book was published which ridiculed abstraction, among other modern movements, as a sinister kind of hoax. The book, *Mona Lisa's Moustache*, by T. H. Robsjohn-Gibbings, (1947), may be no more than clever journalism, but it represents an antagonism that is still strong, judged by the demand for a second edition in two months.

Why this deep cleavage? It is partly the result of mistaken claims made by some apologists for abstraction themselves. They announce that the new movement has ushered in a revolution which they like to call Copernican: "Artists of the Twentieth Century have discovered that the object is just as far from being the center of art as the earth is from being the focal point of the universe." [22] This statement and others like it imply that the chief novelty in abstraction is in its theory: in principles implied and expressed as to what constitutes the essence of a painting and its unique value. Anyone who begins to test this assumption will find some evidence to support it. He observes that the revolution, if any, is not in abstract design, as such. Non-representative motifs have been common throughout the history of decoration, used to ornament buildings, furniture, household utensils, and textiles of many kinds. Consider only one of the most ancient and familiar, the swastika. Again, the edict made familiar by defenders of abstraction which bans recognizable objects is not their invention. "Graven images" were forbidden by Mosaic Law and by the Koran on religious grounds that implied a

[21] This paragraph is based on the article by David Catton Rich, "Freedom of the Brush," in the *Atlantic Monthly*, CLXXXI (February, 1948), 47–51.

[22] *Catalogue of the Solomon R. Guggenheim Collection of Non-Objective Painting*, 1936: Introduction by Hilla Rebay.

subtle compliment to the artist. His images might seem so full of life as to be worshiped in themselves. But there is novelty now in a current use of abstractions. No longer regarded as "mere" decoration, they may be framed and hung upon the wall, treated as independent works of art. And the ground for ousting images today is not religious but aesthetic. Such images may be dangerous sources of associations with their originals in practical life, associations which must interfere with painting's true purpose, to make its effect through the impact of color and form in themselves. It is true that both points have to do with the theory of painting, that is, with definitions of the aims and value of art. But the novelty here is less than the would-be revolutionary would have us believe. He has not made a new discovery, though he has indeed brought fresh clarity and emphasis to a point which generations of artists and critics have come to see less and less obscurely.

The theory of abstract painting is an extreme stage in a movement of thought which began many centuries ago, a movement called here *the retreat from likeness*. The point of departure for this retreat is the copy theory of painting, distinguished by the notion that a painting should be above all "lifelike," that the artist "holds a mirror up to nature," that his work should be treasured as a record of natural beauty or as a means of inspiring sentiments and conduct approved in daily life. This is the theory implicit in the praise of exploits of Greek painters, such as Apelles, who produced a horse so lifelike that other horses neighed at it. Apelles was extolled for doing superbly what painters of the time were expected to do: to copy the appearance of a model as accurately as possible. For the copy theory, painting is an art in which likeness is essential.

Likeness is a term adopted to denote the relation of resemblance between a painting and its original, a relation that involves some degree of repetition of the original's color and shape. Likeness obviously stands for one of the many meanings of the classical term, "imitation," and of the modern "representation." We avoid these

terms, however, because within the aesthetic tradition, each has various other meanings. Imitation [23] was the handy word of Greek aesthetics, applied to virtually every step in the creation and enjoyment of all the fine arts. Representation, while less inclusive, may denote not only likeness but also a painter's use of material that is not sensuous; he may "represent" a mood or a chronicle— *Melancholy* or the *Rape of the Sabine Women*. Furthermore, representation belongs as much to the verbal arts as to the graphic, while the problem of likeness seems to be peculiarly one of painting and sculpture. The relation of resemblance between a painting and its original is clearly not the same as that between a character or scene in a poem or play and its prototype, whether in history or in the writer's imagination. It seems more natural to say of a painting than of a character in a story that it is "a good likeness."

The retreat from likeness began when a contemporary of Apelles, Plato, accepting the copy theory, drew conclusions as to the worthlessness of painting which could not be tolerated by anyone who set a high value on art. Plato said in effect: "A painting is the accurate copy of the appearance of a particular model, and nothing more. Such copies are no better than childish make-believe. Hence painters may justly be exiled from the society of rational adults." That this conclusion follows from the premises can hardly be denied. If the devotee of art is to challenge it, he must correct Plato's conception of painting in a way that will give the art new recognition. So the retreat begins, from likeness in its most literal interpretation. But the demand for likeness is not abandoned; the resemblance considered essential to painting is re-examined and likeness conceived as something different from a mirrored reflection. Each stage in the retreat makes its own reinterpretation of likeness until the last. Then emerges the conviction that likeness is burdened with aesthetically

[23] For discussions of the meanings of "imitation," see McKeon, "Literary Criticism and the Concept of Imitation in Antiquity," *Modern Philology*, XXXIV (August, 1936), 1–35. For discussion of meanings of "representation," see Alexander, *Beauty and Other Forms of Value*.

irrelevant associations which must prevent the recognition of the intrinsic worth of painting. There follows the self-denying ordinance that the painter should dispense with recognizable objects altogether.

The purpose of this study is to trace stages of this retreat, to follow the movement of thought from the disciples of Apelles to the apologists for abstract art. The withdrawal has been no steady and gradual one but a curiously uneven and disorderly movement in which a laborious advance to a new and more critical position has at times been completely forgotten, only to be made again with a triumphant sense of originality many centuries later. A strictly chronological study of such "backing and filling" would be tedious. The most profitable kind of treatment is philosophical, one which subordinates the demands of chronology to those of logic. And logically the movement has proceeded through a series of fairly well-marked stages. When these stages represent points of view that have been held at more than one period, it seems appropriate to illustrate them by coupling together writers ancient and modern. Leonardo will be mentioned with Plato, Reynolds with Aristotle, Schopenhauer with Plotinus. In such parallels there is much that is enlightening.

Our conclusion will admit that the abstract artist has demonstrated with startling emphasis that a painting without likeness can be aesthetically effective; hence, that likeness is not essential to painting. He has pressed home a point that would hardly have been denied except by the copyist, that the *sine qua non* of painting is form. The painter is above all a creator of form. To force this lesson upon the eye of artist and public has been instructive. Furthermore, the abstract artist has developed a way of painting which remains as one instrument of aesthetic expression. For some temperaments, for some attitudes toward the world, abstraction may remain the favorite instrument. But it will prove also to have its serious limitations.

# One

## THE COPY THEORY

THE COPY THEORY of painting in its simplest form is implied in the familiar demand that a painting should be a good likeness. Men apply the theory, often unconsciously, when they praise a landscape for trees that are clearly oaks, not maples; for hills that can be easily identified as the Berkshires, the Adirondacks, or the Green Mountains. They want a portrait to be a "speaking likeness," and enjoy the sight of painted velvet that looks soft to the touch. If they are choosing paintings to live with, they look for subjects that are "beautiful" —charming ladies and angelic children, "Lovers' Lanes" and breaking waves. Implied in these preferences and judgments is the notion that a painting should be an accurate copy of something that one knows, likes, admires, outside the canvas. The painting is valued in large part for its pleasant associations; it serves as a substitute for its original. This is the copy theory. No one needs more than the evidence of his own ears to be convinced that it is still very common.

The theory belongs to the Greek scientific spirit which liked painting that could provide complete data about objects. This is Roger Fry's explanation.[1] It helps to account for a difference between the art of the Greeks and that of the less scientific Chinese, which never stressed accurate likeness. The Chinese were interested rather in "rhythmic vitality," a quality which gave objects the appearance of

[1] "The Arts of Painting and Sculpture," in *An Outline of Modern Knowledge*, p. 934.

coming alive and being ready to move. The Chinese legend of good painting told of a dragon so full of life that he flew into the sky, out of the sight of the astonished virtuoso.[2] This stands in contrast with the Greek stories of Zeuxis, who painted grapes that deceived the birds, and of Parrhasios, whose curtain tricked Zeuxis himself into trying to draw it aside.[3]

The Greek scientific spirit may have been responsible ultimately for the adoption of the copy theory. The immediate cause of its hold in the fifth century B.C. was the discovery of a technique with astonishing new possibilities of realism. The skill to make a flat surface look like a solid object, to paint grapes so that they stood out in the round, had developed with startling rapidity. In the first half of the century, the great painter Polygnotos knew virtually nothing of the magic which brought fame to Zeuxis in the last quarter.

Polygnotos himself had made important technical advances. They can be estimated even now, not, of course, from his original wall paintings, but from descriptions in literature and better still from monuments and vases known to have copied his style: the pediments of the Parthenon and the Olympia, the Argonaut Krater in the Louvre and another in the Metropolitan. Polygnotos' figures had lost the stiffness of archaic statues and were ranged on different levels in space composition that gave the effect of distance. But for Polygnotos, technique was subordinate to moral quality, to dignity and grandeur of conception, and to skill in portraying spirit and greatness of character.[4]

[2] Laurence Binyon, *The Flight of the Dragon* (London, 1911), p. 20.

[3] For anecdotes of Greek painters, see *The Elder Pliny's Chapters on the History of Art*, translated by K. Jex-Blake, pp. 109–11 (xxxv. 65–66). Zeuxis flourished during the last quarter of the fifth century, B.C.; Parrhasios, about 400 B.C.; Apelles, 352–308 B.C.

[4] Polygnotos, fl. 475–455 B.C., painter of heroic murals. For an account of his work and of the advances in painting made during fifty years, see Mary Swindler's *Ancient Painting*, Chapter VII. The painter who is credited with the discovery of perspective is the scene painter, Agatharchos, who flourished from 460–430 B.C. Apollodoros was said to be the inventor of illusionist technique through his use of gradations of color and of light and shade. According to Pliny, "He was the first to give his figures the ap-

Zeuxis and Parrhasios, for their part, extended painting literally into a new dimension with their use of shading and their understanding of perspective. It is not surprising that they were carried away with their own technique. Ethical greatness did not interest them at all. Zeuxis liked to paint subjects that were unusual and exotic, sometimes trivial: the infant Herakles strangling serpents, a family of centaurs. He caused something of a scandal by painting a woman nude, contrary to the accepted custom. He named the painting *Helen of Troy*, but it was commonly called *Helen the Courtesan*, both because of its shamelessness and because he took it from place to place, showing it for money. Parrhasios approached legend from a humanistic point of view derived perhaps from Euripides. Both painters were egotists of incredible vanity. Zeuxis was so proud of the wealth earned by his art that he had his name embroidered in gold on the robe he wore to the Olympic Games. Parrhasios "carried his success with an arrogance that none has equalled," and claimed a divine source of his genius, vowing that "he was of the seed of Apollo." [5] This in a milieu sensitive to the dangers of *hubris*, that overvaulting pride especially unpopular with the Olympian deities! It seems likely that Zeuxis and Parrhasios were greater as craftsmen than as human beings. The copy theory in these beginnings was associated with painters and painting known primarily for cleverness.

In later periods, when new skills were giving painting new life, the copy theory appeared at times in the work of artists who were great men. Leonardo da Vinci made amazing progress in the use of light and shade; he also led the way in improving the accuracy of his drawing by scientific study of perspective and anatomy. What wonder that his paintings brought forth anecdotes rivaling Pliny's tales of

---

pearance of reality, and he first bestowed true glory on the brush. . . . It was he who opened the gates of art through which Zeuxis . . . passed . . . giving to the painter's brush . . . the full glory to which it already aspired." *Op. cit.*, I, 60, 61, p. 107.

[5] See Swindler, *op. cit.*, pp. 228 ff.; Pliny, *op. cit.*, xxxv. 72, 62, 71.

the Greeks! Vasari describes the marvel of Leonardo's painting of
Medusa, so fearfully real that it frightened the artist's father into
starting to run away. Similar stories appear in Leonardo's own
*Notebooks*.

I once saw a painting deceive a dog by its likeness to his master and the
animal was overjoyed to see it. I have also seen dogs bark and eager to bite
other dogs in a picture, and a monkey frolic like anything before the paint-
ing of a monkey, and swallows flying about and alighting upon the painted
railings depicted on the windows of buildings.[6]

Whether or not these facts are credible, the tone of the anecdote
leaves no doubt that Leonardo heralded such accurate likeness with
admiration. Albrecht Dürer also accepted the Renaissance dogma
that a work of art should copy a natural object faithfully. He writes:
"The more accurately one approaches nature by way of imitation,
the better and more artistic" one's work becomes.[7] To carry further
the science of accurate copying, Dürer made exhaustive studies of
perspective and of human proportions.

A new freshness in the use of color by Hubert and Jan van Eyck
added interest in painting that should rival nature. The Van Eycks,
though hardly deserving their traditional title of "discoverers" of oil
painting, were among the first to succeed conspicuously in mixing
pigments with oil, achieving an effect of likeness without precedent.
Admiration for this feat gives charm to the epitaph of Jan van Eyck,
which ranks him higher than the miraculous Apelles:

Here lies Johannes, who was celebrated for his surpassing skill, and whose
felicity in painting excited wonder. He painted breathing forms and the
earth's surface covered with flowery vegetation, completing each work to
the life. Hence Phidias and Apelles must give place to him, and Polycletus
be considered his inferior in art.[8]

In the nineteenth century, discoveries in physics of the effects

---

[6] Vasari, *Leonardo da Vinci*, p. 8.          [7] Panofsky, *Albrecht Dürer*, p. 243.
[8] Conway, *The Van Eycks and Their Followers*, p. 53; Eastlake, *Materials for a
History of Oil Painting*, I, 189. The Church of St. Donatus, at Bruges, where this
epitaph was said to have been found, no longer exists.

of light on color stimulated painters to develop a new technique in accordance with a copy theory. These painters were the Impressionists who labored to record what the eye sees, colors as they appear in light. They painted the same objects as the light changed their colors, faithfully "copying nature," and producing paintings so different from what was commonly conceived to be a mirrored reflection as to prove at first virtually unrecognizable. Their theory was indeed a copy theory, but their paintings would be called copies only by someone to whom their theory was well known.[9]

The case of the Impressionists makes clear that "to copy" may mean "to acquire a new way of seeing" as a result of new knowledge. This was true in some degree of other painters mentioned here. The paintings of none of them with the exception of some by Dürer would naturally be described as "exact copies."

What paintings would seem to meet more obviously the demands of the copy theory? The group could include some acknowledged masterpieces along with much that is second-rate, even vulgar. On the one hand, Dürer's studies of praying hands, of violets, an owl and a hare; interiors by Vermeer and Pieter de Hooch; on the other, a portrait by Denner, an apostle by Veit Stoss, a host of paintings by unknown artists—a fiddle or an apple or a dead fish that projects out from the canvas; a landscape mistaken by a flattering visitor for an actual view from a window. Denner painted microscopically, spending four years on a portrait. He immortalized every wrinkle and blackhead, even reflections on a shiny skin from nearby objects: the result is virtually perfect illusion. Stoss delighted to represent every vein on the hand of an apostle, to count every hair in his curly beard. But the master, Dürer, was hardly less precise in his rendering of praying hands, or of an owl's claws and the petals of a violet. Vermeer's *Young Woman at a Casement* shows the designs of the rug on the table and the leads of the window pane so clearly that they could be used as a pattern by a weaver or a glasier. *The Pantry*

[9] Rewald, *The History of Impressionism.*

*Door* by Pieter de Hooch gives full information about furniture and fabrics. If careful accuracy is the end of painting, then all these artists are equally great. But clearly they are not. Denner and Stoss are so little important that their names are hardly known, though there is no surpassing their skill as copyists.[10] The difference between the lesser and the greater artists lies outside the sphere of illusionist technique.

The character of the difference is reflected in the contrast between appropriate reactions of the spectator. Before the Denner or the Stoss it seems natural to exclaim, "How difficult to do! How did the artist ever get such a perfect likeness!" Before the Dürers, "What a charming little owl!" "What pathos in those hands!" If the spectator tries to imagine the attitudes of these artists, he may hear Denner saying, "See how clever I am! Look at me!" Dürer says rather, "Here is something you shouldn't miss! Look at every bit of this!" He expresses a feeling toward his original that makes representation of every detail essential. Copying for Dürer seems an outlet for love of the delicate charm of small living things, of lines that show subtle spiritualizing of the flesh; for De Hooch, an expression of quiet delight in the colors and surfaces of a comfortable room; for Vermeer, a joy in light that glorifies homely objects. For Denner, misguided man, copying is no more than the expression of a craftsman's satisfaction in his own skill.

Since skill in copying offers no guarantee of aesthetic success, the copy theory proves to be a mistaken guide. A faithful likeness may be one means of expression, but no more than a means.

There is a second form of the copy theory which shifts the emphasis. Now the likeness of consequence is that between the effects of a painting and of its original upon the spectator's emotions and conduct. It is assumed that likeness in color and shape produces likeness in effect on feeling. This is a phase of the copy theory which

[10] H. Taine, *Lectures on Art* (New York, 1875), I, 53; Fry edition of Dürer's *Records of Journeys to Venice and the Low Countries*, p. xiii.

received attention from a contemporary of Zeuxis, Plato himself.

Plato held that the spectator's reaction to a painting was a kind of imitation. The spectator identified himself with what he saw and became like it. To see a picture of moral deformity was to keep bad company. Pictures of bad men, like bad men themselves, should be kept strictly under control by anyone interested in the virtue of good citizens in a good state. Plato applies here to painting the strictures which he was bringing with even greater force against poetry. He inevitably coupled the two arts at a time when painting primarily illustrated the poems used as a Bible by the Greeks, the *Iliad* and the *Odyssey*. Since these poems served as guides in conduct, their pictured companion pieces naturally should further a similar purpose. Plato found many scenes in Homer that were unedifying, if not positively vicious. Whether these scenes were set forth in words or in pigments, he took their effects to be alike deplorable.[11]

This stage of the copy theory, like the first, appears and reappears in the history of art and has had curiously varied supporters. Consider the many writers and painters from Plato until the end of the eighteenth century who saw painting as chiefly concerned with episodes in Biblical and secular history; painting should point a moral and adorn a tale. Throughout these centuries, artists and critics agree that painting and poetry are sister arts: painting is "silent poetry," poetry is "speaking painting." They are "sisters" in their common effect on feeling and conduct.[12] From the Iconoclastic

[11] *Republic* iii. 401; cf. R. L. Nettleship, *Lectures on Plato's Republic* (London and New York, 1898), p. 82.

[12] The original coupling of the Arts was attributed to Simonides by Plutarch, *De glor. Ath.* 3, p. 345 F.

Plato discusses the two together in *Republic* iii and x; in the latter book, he leads up to his banishment of the poets from the ideal state by proving first that painting outrages the understanding, and then concluding that what holds true of painting must apply to poetry also (595; 607–8).

Aristotle in the *Poetics* (ii. 1448a. 5–6; vi. 1450a, b) explains the method of the poet by comparison with the work of well-known painters.

Horace's phrase, "Ut pictura poesis" (*Ars poetica* I.361), was accepted as gospel through centuries of criticism. The context shows that Horace was making a casual

Controversy[13] in the seventh and eighth centuries until Sir Joshua Reynolds wrote at the end of the eighteenth century, paintings of great characters were expected to make men nobler, duplicating the supposed influence of saints and heroes in the flesh. The sister arts became alienated at the end of the eighteenth century in a famous rift sharpened by Lessing's *Laokoon*, which pointed to the disastrous results of failing to distinguish the sphere belonging to poetry from those of painting and sculpture.[14] But even after the painter had ceased to poetize, he might still be expected to depict noble subjects for the beholder's improvement. Witness Ruskin's characteristic critical pronouncement: "The Highest Thing That Art Can Do Is To Set Before You The True Image Of The Presence Of A Noble Human Being. It Has Never Done More Than This, And It Ought Not To Do Less." [15]

comment, not enunciating the basis of an artistic credo. Both paintings and poems, he says, need to be seen in the right perspective.

> "Ut pictura poesis: erit, quae, si propius stes,
> Te capiat magis, et quaedam, si longius abstes,
> Haec amat obscurum, volet haec sub luce videri,
> Judicis argutum quae non formidat acumen."

The history of the phrase, "ut pictura poesis," from 1436, when it appeared in the treatise, *Della pittura*, by Leon Battista Alberti, until 1766, has been traced in an admirable monograph by Mr. William Guild Howard, "Ut Pictura Poesis," *PMLA*, XXIV (new series, XVII) (1909), 40–103. More recently, Rensselaer Lee has discussed the same topic in the *Art Bulletin*, XXII (Dec., 1940), 197–269.

An early and famous coupling of the two arts in English criticism appears in Dryden's "Parallel betwixt Painting and Poetry," published in 1695 as the preface to his translation of *The Art of Painting*, by Charles Alphonse Du Fresnoy. (See below, p. 40.)

[13] Pope Gregory wrote: "What those who can read learn by means of writing, that do the uneducated learn by looking at a picture. . . . That, therefore, ought not to have been destroyed which had been placed in the churches, not for worship, but solely for instructing the minds of the ignorant." *Encyc. Brit.*, eleventh ed., XIV, 273 (*s.v.* Iconoclasts).

[14] Lessing discussed painting and sculpture as one art, the more naturally that when he wrote his treatise, he knew the famous statue, *Laocoön*, only in a steel engraving. (*Laokoon*, ed. A. Hamann, Oxford, 1878, p. xxv.) He pointed out the harm done by the failure to realize that one sphere belongs to poetry, and another to painting and sculpture: "*They differ in the material and in the modes of their imitation.*"

[15] Ruskin's lecture, "The Relation of Art to Religion," in *Lectures on Art* (Oxford, 1870), p. 43.

There is an incongruous bond between this lofty point of view and that of far less exalted bands: the "popular" painters of sentimental scenes, the furtive producers of pornography, the commercial "artists" whose gowns, teapots and easy chairs presumably make the desire to buy the real articles irresistible. All these painters share a confidence that between painting and original there is a powerful likeness of effect. Their works are valued for what they make men want to do. But most of these paintings admittedly do not deserve the name of art. They are to be found, not in museums, but in gift shops and on post cards, or in the advertising pages of magazines. Nevertheless, so far as they are intended to influence action, they must be grouped with the altarpiece designed to make men noble. All illustrate the copy theory, but when brought together, they serve also to discredit it. If a theory intended to explain art can be applied as well to what is not art, so much the worse for the theory!

Someone may rise to defend advertisements on aesthetic grounds, pointing to European railway posters and Surrealist paintings attached to perfumes. Surely some of these are works of art? It is true that advertisements may have an interest apart from the practical one. Railway posters may delight the eye of a person with no desire to travel, even in daydream,—a confirmed homebody who enjoys simply the striking colors and design. Yves Tanguy's desert flowers in the New Yorker may be treasured by men who have lost their sense of smell. True enough. A "commercial" artist may be better than he knows. And on a very different level, an artist with a religious motive may produce what moves men, although not to accept his creed. An African artist makes an image to enforce beliefs of which we remain wholly ignorant, even while we respond to the power of his form. This all goes to show that the same painting may have two different effects, one which conforms to the copy theory and another which does not. The painting may at some times for some people revive experiences in the practical world and serve as a cue for action;

at other times or for other people it may induce a way of seeing color and form that seems to belong to art alone. Not all painting, however, lends itself to both effects. There are advertisements with no aesthetic charm, and designs that give the observer no thought of action. In these latter cases, the line between what is and is not art is clear and easy to draw.

If paintings which are clearly not art could be distinguished by a name of their own, serious confusion might be avoided. A name has actually been suggested by an English writer on aesthetics, R. G. Collingwood, the name of "magic." [16] He places painters engaged in uplift, corruption or salesmanship in the class with medicine men who make idols to protect themselves and to harm their enemies. Such painters affect a community in ways that may be beneficial or harmful, and should consequently be subject to public control. Here the censor has his rightful province. But he should confine his purges to paintings that are not art. Where "art proper" is concerned, there is no incitement to action, hence no need of moral scrutiny. The difficulty comes with paintings which serve a dual end, the work of men who are not only preachers and promoters, but artists in spite of themselves. As long as a painting can be art and magic at the same time, there will be confusion and trouble for both the censor and the defender of aesthetic freedom.

The art intended to work magic may exemplify feats of illusionist technique, but this is not necessarily the case. Equal power may belong to paintings that make no pretence at accuracy. A symbol would seem to be as effective as a likeness. The rudest drawing of the cross may move the believer to Christian virtue with stronger force than the most naturalistic painting of the Crucifixion. Observing this fact, a critic may accept the second stage of the copy theory and give up the first. If effects can be gained without likeness, why trouble to be accurate?

The copy theory might be dismissed as too naïve to require

[16] Collingwood, *The Principles of Art*, Book I, Chap. IV.

criticism were it not for its persistent vitality. One point to be urged against it is obvious enough. It is clear that painting has not generally sought to deceive.

One of the witnesses here is Adam Smith, who had views on art as well as on economics:

The works of the great masters in Statuary and Painting never produce their effect by deception. They never are, and it is never intended that they should be, mistaken for the real objects which they represent.

Next Dr. Johnson (he is speaking of theatrical deception, but his words have a general bearing):

The truth is that the spectators are always in their senses, and know, from the first act to the last, that the stage is only a stage, and that the players are only players.

Next Goethe, who insists that *illusion* should not become *delusion*:

The highest problem of all art is to produce by illusion the semblance of a higher reality. But it is false endeavor to push the realization of the illusion so far that at last only a commonplace reality remains.[17]

Here Goethe touches on an obvious difficulty in the copy theory. The peculiar character of the likeness in art depends upon its being perceived in conjunction with an equally important difference, namely, a difference in the medium, the material of which a work of art is made. Awareness of this combination of likeness and difference prompted one of the earliest aesthetic judgments in the literature of Western Europe, an expression of admiration for the carving in gold on the shield of Achilles:

The earth looked dark behind the plough, and like to ground that had been ploughed, *although it was made of gold: that was a marvellous piece of work.*

DeQuincey says, a little pedantically perhaps, of all the fine arts:

[17] Adam Smith, "Of the Nature of That Imitation Which Takes Place in What Are Called the Imitative Arts," *The Whole Works of Adam Smith* (London, Richardson, 1822), V, 119; Johnson, Preface to *The Plays of Shakespeare*, 4th ed. (London, 1793), I, 201; Goethe, *Dichtung und Wahrheit*, Part III, Book XI.

The object is to reproduce in the mind some great effect, through the agency of *idem in alio*. The *idem*, the same impression, is to be restored, but *in alio*, in a different material—by means of some different instrument.

Coleridge agrees:

In all imitation two elements must coexist, and not only coexist, but must be perceived as coexisting. These two constituent elements are likeness and unlikeness, or sameness and difference, and in all genuine works of art there must be a union of these disparates . . . If there be a likeness to nature without any check of difference, the result is disgusting, and the more complete the delusion, the more loathesome the effect.[18]

Hence the disagreeable impression of waxwork figures.

Further evidence, if needed, that paintings are neither meant nor felt as deceptions can be drawn from the custom of accentuating their "unreality" by mounting them in frames. Thus the painting is placed at a proper "aesthetic distance," just as in the theatre the stage keeps a play clear from confusion with everyday life. In sculpture also naturalistic coloring is avoided to prevent too close a resemblance. Indeed, against the theory that painting is intended to deceive, it is enough to object that artists could, if they would, deceive their public in countless ways which it never occurs to them to adopt.

A less obvious objection to the copy theory points out that it is based on faulty analysis of the process of perception and of the artist's way of working. Holders of the copy theory assume that the artist's eye perceives an object as passively as the camera's lens registers patches of light and shade, that the artist's hand records precisely the vision of his passive eye. In the light of modern research in psychology, these processes appear to be not passive and mechanical but active and constructive.

In every act of perceiving there are important processes of selec-

[18] Quoted from *Iliad* XVII. 548, in Bosanquet, *History of Aesthetic*, p. 12; De-Quincey, "The Antigone of Sophocles," *Works* (Edinburgh, Black, 1863), XIII, 209; Coleridge, "On Poesy or Art," *Lectures upon Shakspeare*, Lecture XIII.

tion and organization. Some stimuli do not register themselves in sensation at all; others, owing to low intensity or lack of interest, register themselves only in a marginal way. And even those that manage to get effectively represented are often modified profoundly by unsuspected tendencies working within the perceiver's mind. The Gestalt psychologists have made these "internal forces of organization" a subject of detailed experimental study. Sometimes the inner tensions will prescribe to the given data the simplest possible shape, sometimes distort or supplement them for the sake of completing a pattern. A spot which is not quite a square will be perceived as a square.

Simple, well-balanced figures are perceived when irregular figures are actually exposed: the fact that we see rectangles everywhere is due to the fact that the true rectangle is a better organized figure than the slightly inaccurate one would be, and that only a slight dislocation is necessary to change the latter into the former.[19]

Superimposed upon these innate forces are others which have developed in the course of the artist's experience, his feelings, taste and temperament, his knowledge of the structure and significance of the object before him. Although these forces are normally below the level of consciousness when the artist is at work, their importance has long been apparent to critics and teachers of art. For example, the study of anatomy and of perspective has long been recognized as profoundly affecting an artist's perception of a body or a landscape. It was the possession of this scientific knowledge by the Florentine painters and the Flemish painters' lack of it that accounted partly for their different worlds of "nature." [20]

An early correction of the copy theory was offered by one of the masters of deception, Parrhasios himself. He was reported to have had a conversation with Socrates to the effect that a painter does not

[19] Koffka, *Principles of Gestalt Psychology*, pp. 140, 141 and *passim*.
[20] Fry, "The Arts of Painting and Sculpture," in *An Outline of Modern Knowledge*, p. 949.

imitate a single model but selects the best features of many to combine in a composite likeness. The point was repeated several centuries later by Cicero, who declared that the artist must exercise this power of choice in order to make up for the defects of nature. Nature rarely can make a face or form that is perfect in every respect, but provides items of perfection which the painter can put together. Leonardo and Dürer in their turns noted the same need for constructing a partial likeness of each of several models.

To advise a painter to select and combine features is to leave him asking how to identify the "most beautiful" and how to invent a formula for assembling them. The first question was answered now on the basis of common sense, now in terms of mathematical formulae. Common sense prompted Leonardo's advice to the young artist, "Be on the watch to take the best parts of many beautiful faces of which the beauty is established by general repute." Dürer's touchstone was "everybody's opinion"; painters should note "what all the world esteemeth beautiful and ourselves strive to produce the like." But when "all the world" does not agree, what then? And can it be maintained that the beauty of a face or figure depends upon the perfection of each part, considered separately? It is easy to imagine a collection of beautiful features and limbs that, put together inharmoniously, would be far from beautiful. One suggestion is that common sense must be corrected, supplemented, and made infallible by mathematics. Leonardo and Dürer, as well as the Greeks before them, urged that the beautiful can be identified and constructed by mathematical proportions.[21]

Tradition had it that the first application of mathematics to the arts was made by the wonder-worker, Pythagoras. According to legend, he discovered certain mathematical relations in music, the proportions between the lengths of the vibrating strings of an in-

---

[21] "Memorabilia," in *The Life and Death of Socrates*, ed. G. Grote, London, 1897, p. 72; Jex-Blake's edition of Pliny, xxxv. 64; Leonardo da Vinci, *Note-Books*, trans. McCurdy, pp. 190, 191; Conway, *Literary Remains of Albrecht Dürer*, p. 177.

strument and the tones in the octave. The concept of proportion, ἀναλογία, thereafter had a profound effect on Greek thinking about art and about many other problems as well. Having seen that the intervals in music could be expressed with complete precision mathematically, the Greeks asked, "Why not everything else? It is not too much to say that Greek philosophy was henceforth to be dominated by the notion of the perfectly tuned string." [22] Hence the hope that everywhere in art and in life there might be a simple numerical formula giving the essence of each relationship, a formula that would ensure success, if it could only be found.

Pythagoras himself was reputed to have told his disciples that the Analogy was at the root of "everything that is most beautiful." This statement by his biographer, Iamblichus, was echoed years later by an eighteenth-century enthusiast, Lambert Hermanson ten Kate. Ten Kate describes the Analogy as "the true key for finding all harmonious proportions in Painting, Sculpture, Architecture, Musick etc.," and says that Pythagoras discovered it during his travels in "Phoenicia, Egypt and Chaldea," bringing it home to his countrymen to their great benefit. "After him the Grecians, by the help of this Analogy, began (and not before) to excel other nations in Sciences and Arts. . . . Pamphilus ( . . . who taught that no Man could excel in Painting without Mathematicks) the Scholar of Pausias and Master of Apelles, was the first who artfully appli'd the said Analogy to the Art of Painting." Since the lapse of time between the dates when Pythagoras and Pamphilus "flourished" was almost two hundred years, the miraculous Analogy would appear to have been a little slow in taking hold.[23]

[22] Burnet, *Early Greek Philosophy*, p. 112.

[23] Iamblichus, *Life of Pythagoras*, trans. Taylor, pp. 64–65; Ten Kate, *The Beau Ideal* (1724), trans. Le Blon, p. 11. A reference by Aristotle to one of the early Pythagoreans may show this myth in the making: "This is how Eurytus decided what was the number of what [e.g., of man or of horse], viz. by imitating the figures of living things with pebbles, as some people bring numbers into the forms of triangles or squares." *Metaphysics* N. xiv. 1092b. 10.

But Pamphilus was undoubtedly one of the earliest artists to apply mathematics to art. He is classed with the sculptor, Polykleitos, who worked out a famous "Canon" of the ideal proportions of the human body. Polykleitos set forth his Canon in a treatise and had the courage to apply it also in a statue. Here is his cryptic formula: "Thus the foot measured 3 palms, the lower leg 6, the thigh 6, the space from navel to ear 6; the foot was as long as one-sixth of the total height, the face one-tenth, the hand one-seventh." Pamphilus was described by Pliny as "the first painter who was thoroughly trained in every branch of learning, more particularly in arithmetic and geometry; without which, so he held, art could not be perfect." Both plane and solid geometry were important; plane gave a knowledge of perspective, while solid expressed relations of volumes,[24] including the volumes of the perfectly proportioned human figure.

Hope of learning to construct the perfect human figure mathematically took on new life during the Renaissance. It was one of Leonardo's many scientific interests; he was reputed to have supplied the drawings to illustrate the treatise of his friend, Fra Luca de Pacioli, "On Divine Proportion" (De divina proportione). Albrecht Dürer also studied the subject; he produced four volumes of diagrams of human figures corresponding to tables of proportions. Michelangelo was said to have taught his "scholler," Marcus de Sciena, "that he should alwaies make a figure Pyramidall, Serpentlike, and multiplied by one two and three." The last utterance becomes no less puzzling when Lomazzo explains it: "For the Diameter of the biggest place, betweene the knee and the foote is double to the least, and the largest parts of the thigh triple." Sculptors and painters, please demonstrate! Ten Kate, he who praised the wonders of the Analogy, considered that the most perfect master of the secret was Raphael. The tone of his eulogy of Raphael suggests that when an artist attained great success, his ad-

[24] Pliny, op. cit., xxxiv. 55; xxxv. 76; Lawrence, Classical Sculpture, p. 211; Richter, The Sculpture and Sculptors of the Greeks, pp. 246–47.

mirers naturally exclaimed, "Surely he must have found the lost Analogy!" It had all the glamour of the philosopher's stone that would turn base metals into gold.[25]

The theory that a painting is a composite, put together mathematically, is a correction of the copy theory which still holds to the importance of likeness and never questions that art has value. Another, far more devastating treatment of the copy theory was made by a younger contemporary of Parrhasios who accepted it in its full implications and then concluded on metaphysical grounds that painting so understood lacked reality and was consequently worthless. The critic was of course Plato. For Plato, the copy theory revealed the true character of painting in all its fatuousness. A painting was "nothing but" an accurate copy of the appearance of a particular thing, a make-believe, wholly wanting in existence that could be called real. This is his line of attack in the Tenth Book of the *Republic*. His strictures on painting have often been regarded as curiously unsympathetic and uncomprehending. But they are far more than the results of individual whim. They follow, or at least Plato believed them to follow, from the sharp cleavage in his system between appearance and reality, opinion and knowledge.

Plato's system takes special cognizance of the fact that things as they appear to sense are in perpetual change. Hence he argues that they have no stability, no reality; they can not form the basis of true knowledge but only of conjecture and opinion. In contrast, the real—the permanent and unchanging—is above sense; it is consti-

[25] The brilliant critic, artist, and scholar, Leon Battista Alberti, 1404–72, discusses the need of knowledge of correct mathematical proportions in both sculpture and painting. See his *Della statua* and *Della pittura*, translated from Latin into Italian by Cosimo Bartoli (Bologna, 1782). For a statement of the importance of measurement, see *Della statua*, p. 326.

Morison, *Fra Luca di Pacioli*, p. 10; since Luca was inclined to boast of connections with Leonardo, it seems probable that he exaggerated what his book owed directly to Leonardo.

Dürer, *Vier Bücher von menschlicher Proportion*.

Paule Lomatius (or Lomazzo), painter of Milan, *A Tracte Containing the Artes of Curious Paintinge Carvinge and Building*, trans. Haydocke (1598), p. 17.

tuted by the Ideas, the eternal patterns of all physical things, both natural and manufactured. Insight into these Ideas is the only knowledge worthy of the name. To achieve the most complete knowledge, a man must free himself from the trammels of opinion by understanding the limitations of sense perception, by seeing that it can never be more than superficial and deceptive. He must then go through a long and arduous training in mathematics and dialectic which will ultimately open his eyes to the vision of truth. This kind of education is obviously beyond the capacities and the devotion of the ordinary man, who must be content to live by mere opinion or by partial knowledge. As an example of a man with *partial* knowledge, Plato cites a skilled artisan, a cabinetmaker. He knows the essential character, the eternal patterns of the articles he makes; how else would he be able to make them? The cabinetmaker thereby demonstrates that he who makes a bed knows the Idea of a bed, but his real knowledge may go no farther.

The painter, for Plato, is a man wilfully preoccupied with superficialities. He is in a worse plight than the cabinetmaker, who at least knows the nature of what he creates. Not so the painter. When he paints a bed, he has no concern with its pattern laid up in heaven but only with the appearance of a particular physical object. Hence the painting of a bed is "thrice removed from reality."

Painting or drawing and imitation in general is remote from truth, and is the companion and friend and associate of a principle which is remote from reason, and has no true or healthy aim.[26]

On metaphysical grounds as well as on the moral principles of a statesman protecting civic virtue, Plato banished painting to the limbo of worthless things. He may have been the readier to condemn painters as a class because of the offensive personalities of the famous Zeuxis and Parrhasios. It is significant that he never mentions Parrhasios, and refers to Zeuxis only once, as a "painter of

[26] *Republic* vi.510; for Plato's theory of knowledge in general, see Books vi and vii; *Republic* x.

figures," [27] omissions not in line with his habit of presenting well-known contemporaries as speakers in his dialogues. He could say simply that the painter belonged on a level with the Sophist, the two equal in ignorance, superficiality, and smugness, and be confident that his implied censure would be understood without naming names.

Plato's attack on painting set the direction of the retreat from likeness. Men who were outraged by his condemnation felt constrained to refute him in his own terms, to claim values for painting that he might be expected to recognize. It is as though a *sub voce* dialogue with Plato on painting has continued through the centuries.

[27] *Gorgias* 453; *Sophist* 234–46.

# Two

## LIKENESS GENERALIZED: ARISTOTLE AND SIR JOSHUA REYNOLDS

PLATO HAD SEEN paintings as "particulars," that is to say, as things existing in isolation, from which no inference can be drawn to throw light on the character of other objects. In other words, paintings do not teach anything ultimately true; they are simply there to be looked at. For a man to whom learning is everything and seeing is nothing, painting obviously has no value. Naturally, then, an answer to Plato might well point out that painting can and does serve as a means of knowing. For Aristotle the knowledge in question had some bearing on the truths of science. He says in effect: a man can learn from a painting because the artist who made it used a kind of scientific knowledge in the process of construction. The artist has studied not one but many examples of a species, and reflects in a single figure his analysis of the whole class to which it belongs. His painting is related to his model as a universal is related to its class, as the concept, *chair*, is related to all articles of furniture bearing that name. His painting is, in a sense, universal. Put in the terminology of classicism and neo-classicism, the artist *imitates* by *generalizing*, and what he imitates is the *form of a species*.

Aristotle refers to painting and painters when he discusses the arts in general and poetry in particular. Painting is one of the arts of likeness-making which are contrasted with the practical arts or crafts that manufacture objects for use. In this characteristically Greek

division, architecture is classed with the practical arts. Again, paint-
ers are mentioned in discussions of poetry, the two arts being
similar enough so that examples from one may give concreteness to
comments on the other. In both these contexts, Aristotle's refer-
ences are brief and incidental, but nevertheless sufficient to establish
conclusions opposed to Plato's.[1]

Aristotle begins by accepting with Plato the importance in art of
the concept of imitation. It is the instinct of imitation that impels
the artist to paint, but his work is a process less of copying than of
idealizing. Aristotle praises a portrait painter who produces "a like-
ness that is true to life and yet more beautiful." Aristotle approves
of Polygnotos on the ground that he painted men better than they
were, better in being more beautiful and also nobler; in nobility he
surpassed Zeuxis, whose style was deficient in ethical quality.
Polygnotos may have been in Aristotle's mind again in the comment
that color was far less important than form. Form takes precedence
in painting as plot in tragedy. Polygnotos was renowned for putting
this principle into practice; he stressed an "exquisite perfection" of
line and a use of color far simpler than that of his younger rival.
When Aristotle gives Polygnotos the palm in painting as to

---

[1] The chief source here is Aristotle's *Poetics*. Translations consulted are those by
I. Bywater, S. H. Butcher, and D. S. Margoliouth; quotations are from Bywater's
translation unless acknowledged otherwise. Difficulties of interpretation rising from
the cryptic form of the original texts are well known; for discussion, see Gilbert
Murray's introduction to an edition of Bywater's translation (1920).

An appropriate reference on Aristotle's scientific position is *On Aristotle as a
Biologist*, by D'Arcy Wentworth Thompson (Oxford, 1913).

Aristotle may well have deliberately formulated an "answer to Plato" which Plato
seems to have invited when he represented Socrates as saying that poetry may be
restored to favor if her defenders can show that she is not only pleasant, but useful:
"We may . . . grant to those of her defenders who are lovers of poetry and yet not
poets the permission to speak in prose on her behalf: let them show not only that she
is pleasant but also useful to States and to human life, and we will listen in a kindly
spirit; for if this can be proved we shall surely be the gainers, I mean, if there is a use
in poetry as well as a delight?" *Republic* x.607. Among the "uses" of poetry put for-
ward by Aristotle, one which may be attributed to painting also will appear later in
this chapter—the portrayal of perfect examples of species.

Sophocles in tragedy, he is saying to Plato, "Don't condemn these arts because the latest popular practitioners are sometimes cheap. Forget Zeuxis and Euripides and go back to the artists who rose above a slavish copying of individuals." [2]

Aristotle answers Plato again when he denies that a man's experience of a painting simply revives his experience of its original. The two reactions may be quite unlike, as instanced by a painting of dead bodies. An actual corpse is not a pleasant sight, but the painting of one may be something we like to look at. Why? Because, even though we cannot enjoy seeing its original, we do enjoy recognizing its relation to the original. Recognition is a kind of knowledge, and men instinctively like to know—to "make a thing out." While this explanation seems curiously naïve and inadequate, it does call attention to the fact that there is a great difference between the effects of a painting and its original, a fact accepted by the many writers who have tried to define "the aesthetic experience," and illustrated by any painting of the Crucifixion.

Objecting to Plato's claim that art is concerned exclusively with particular things and persons, Aristotle points out that poetry at least is universal in its own way. Poetry tells what a man of a certain kind will do; it gives knowledge of types of human beings. The *types* which interest Aristotle here are psychological. He notes what surely holds true, not only of plays which are commonly thought to present types, such as Molière's, but of most art worthy of the name: that the artist presents characters so simplified as to reveal the structure of personality, the motives underlying action. The artist helps us understand not merely the isolated motive of a particular man in a given case, but what we can expect of human beings generally. Aristotle speaks to this point in his famous contrast between poetry and history:

Poetry is something more philosophical and of graver import than history, since its statements are of the nature of universals, whereas those of history

[2] *Poetics* 1448b. 5; 1454b. 8; 1450a. 11; 1450b. 15; 1449a. 12.

are singulars. By a universal statement I mean one as to what such or such a kind of man will probably say or do—which is the aim of poetry, though it affixes proper names to the characters; by a singular statement, one as to what, say, Alcibiades did or had done to him.[3]

Aristotle does not illustrate this point with a reference to painting, but he might have done so convincingly. A painter may represent a king in such a way as to fashion a likeness of a particular crowned head and also a revelation of the character of king as such. This is the sense in which he is said to paint the type form, the species. Tradition assigns Aristotle this view of painting.[4]

Tradition goes on to give another reason why a painter should be concerned to imitate the forms of species. He wants to show clearly the patterns which nature tries to reproduce in living things but without complete success. Artistotle's conceptions of nature and its relation to the arts need comment here.

As a biologist, Aristotle was keenly interested in processes of growth. He saw that each species of plant or animal has its "nature," φύσις, that is to say, the form which its own being impels it to bring into existence. The nature of an acorn is to become an oak; of an egg, to develop into a chicken; of a chicken, to grow into a hen or a rooster, and so on.[5] Nature here means *form of species*, but this is only one of several meanings. Nature is also *matter* or *substance*, the material which has within it the elements that lead to the generation of things. In this sense, nature denotes the physical properties

[3] *Poetics* 1451b.

[4] See an account of the seventeenth-century artists' conception of their function: "In the back of their minds they had Aristotle's conception of nature as an 'immanent force working in the refractory medium of matter, towards a central, generalized form, but invariably deflected from this ideal form by accident.' Accordingly it was the artist's function to do what nature could not do, and to produce such a tree, valley, mountain, leaf, as most perfectly expressed that aspect of nature which he had chosen to portray." Christopher Hussey, *The Picturesque*, p. 8.

[5] In the *Physics* (II. 1193b) he defines "nature" as "the distinctive form or quality of such things as have within themselves a principle of motion, such form or characteristic property not being separable from the things themselves, save conceptually." (Translation by W. D. Ross.)

of acorn, soil, air, and water which go to build an oak. A third meaning of nature is *creative or purposeful activity*, the process of growth through which the material in acorn, earth, air, and water realizes the type-form of the oak. Because matter does not lend itself perfectly to the ends of species, the process of growth never culminates in a completely realized form. Hence nature needs to be supplemented, and one means of meeting the need is art.[6]

When Aristotle discusses the arts, he does not always distinguish clearly between those which make likenesses and those which make objects for use. The general relation of both to nature is to make up for nature's deficiencies: art completes "what nature can not bring to a finish." Nature's deficiencies may be conceived practically as failure to produce houses, bridges, and clothing. To the rescue, then, with the practical arts of carpentry, bridge-building, and weaving. Or the lack may be of perfect human beings, of beasts and birds without a flaw. Then the arts to contribute are the likeness-makers: painting, sculpture, and poetry. The painter's work is understood to include the study of examples of a species, comparing them in their imperfections, learning finally to see what nature is trying to achieve. This is not the common form but the perfect form, reached by a process of thought that is both generalization and idealization. The artist must "preserve the type and yet ennoble it." Why should the artist exhibit the perfect forms of species? To give knowledge of nature's unrealized ends.[7]

If to give knowledge of the type-form is a prime requirement of a painting, then all paintings affording such knowledge should be on a par, regardless of species represented. But Aristotle had observed that some artists, Sophocles and Polygnotos, for example, had an aristocratic taste in species. They chose characters from princely families of legend and history in preference to the men and women of lesser breed represented by Euripides and Zeuxis. Aristotle's own taste ran to the árt of great characters. He might have justified this

---

[6] *Politics* VIII, v; *Physics* II. 8. 199a.    [7] *Poetics* 1454b. 8.

in terms of the type-form: quarto and folio editions of mankind reveal to the full the highest potentialities of human beings; they give a man knowledge of his most complete self-realization. But this is not the whole explanation. Aristotle's taste would seem to reflect also what he liked in human society, the ideal man he describes in the *Nicomachean Ethics*, high-minded, dignified, self-possessed almost to the point of arrogance, a very king among men.[8] Aristotle liked art that recalled human greatness. Here he has had many followers, conscious and unconscious. He and they also cling here to one element in the copy theory, the expectation that painting depends for its success partly on recalling what is admirable in real life.

One practical point in Aristotle's theory was bound to cause difficulty. If a painter is to depict forms which nature never succeeds in realizing, how can he hope to know these forms complete in beauty and perfection? Experience alone can not give this knowledge, not even the experience of selecting the most beautiful parts from several models and putting them together. The forms he seeks are not composites but unified ideals. Where can the artist find them? The answer of Philostratos, "In his imagination," satisfied only the most uncritical. Another answer, offered by Plotinus, attributed to the artist what Plato had said he could not have—a vision of the Ideas, the patterns laid up in a sphere above sense, prototypes copied imperfectly in material objects. Years later, when the empiricism of Locke and Hume had done its work, Sir Joshua Reynolds was to try to account for the "imitation of the species" strictly on the basis of experience.

During the lapse of centuries between Aristotle and Reynolds, Aristotle's theory of painting shared the fortunes of the *Poetics*.[9] It was colored by its interpreters, Stoic, Christian and Neo-Platonic; it was lost and rediscovered; finally, in the seventeenth and

[8] *Nicomachean Ethics* iv. vii, vi. (Translation by J. E. C. Welldon.)
[9] Sandys, A *History of Classical Scholarship*, II, 420.

eighteenth centuries, it had become so much a part of the heritage of cultivated artists and critics in western Europe that a painter or writer might be an Aristotelian without knowing it, and certainly without ever having read the *Poetics*.

Reynolds himself was probably one of the unconscious Aristotelians. He refers to Aristotle only once in the *Discourses*, and there in an odd context, as one of several great men whose genius was not "destroyed by attention or subjection to rules or science." [10] It is unlikely that Reynolds read the *Poetics*. His formal education ended at the Plympton Grammar School, where his father was Master, and may have given him no knowledge of Greek beyond the letters of the alphabet. After leaving school, he read seriously and widely, devoting much time to classical writers in English translations. But these could hardly have included the *Poetics*, since no intelligible English rendering of it was available until his literary career was almost over. He might have read Boileau's translation into French; there is no evidence that he did so. Reynolds was a "follower of Aristotle," as many a contemporary and predecessor in criticism had been since the sixteenth century, by absorbing the principles of the *Poetics* from the atmosphere he lived in. But Reynolds did have access to other excellent sources of neo-classic doctrine, one personal, in his friend Dr. Johnson; others literary, in many writers on painting, among whom he acknowledged a special interest in Charles Du Fresnoy and Jonathan Richardson.[11]

[10] "Seventh Discourse" (Fry's edition), p. 222.

[11] For a general account of Reynolds' education and reading, see Hilles, *Literary Career of Sir Joshua Reynolds*, Chapters I and VII. For a comment on his lack of classical attainments, see Beechcy, "Memoir" in Reynolds' *Works*, I, 35. The first intelligible English translation of the *Poetics* was that by Thomas Twining, published 1789. It is the first mentioned by I. Bywater; the first listed by Sandys, *op. cit.*, II, 420. One of the earlier translations which Reynolds might have seen (published 1775) was said to be "so very literal . . . as to be absolutely unintelligible to any person not acquainted with the original." Lowndes, *Bibliographer's Manual* (London, 1869), I, 69. For further references on the influence of the *Poetics*, see Spingarn, *Literary Criticism in the Renaissance* (New York, 1899), p. 142; J. L. Stocks, *Aristotelianism* (Boston, 1925), pp. 141, 162; G. Saintsbury, *History of Criticism* (London, 1900–1904), II, 408.

Reynolds' debt to Johnson was commonly assumed to be so great that the *Discourses* were rumored to be the Doctor's own work. This rumor irked Reynolds, who liked to think of himself as a man of letters, and made him reluctant to acknowledge, when he brought out a collected edition of the first seven discourses, that Johnson had indeed helped him by writing the dedication to George III. Beyond this, Johnson's direct contribution would seem to have been no more than to sharpen Reynolds' mind with talk and to suggest occasional verbal changes in copy before it went to print.[12] Indirectly, Johnson's view of poetry as set forth in *Rasselas* must have contributed to Reynolds' conviction that the painter also should imitate the species:

The business of a poet, said Imlac, is to examine, not the individual, but the species; to remark general properties and large appearances; he does not number the streaks of the tulip, or describe the different shades in the verdure of the forest.[13]

*Rasselas* was published in 1759, a few months before Reynolds made his first statements of aesthetic theory in three "Letters" to the *Idler*.

Charles Du Fresnoy, French painter of the seventeenth century, initiated Reynolds into the tradition of Classicism through his treatise in Latin verse, *De arte graphica*, which served as a textbook for artists of two centuries. It was published in France in 1668, and "Englished" in 1695 by "Mr. Dryden," who contributed as the preface his essay, "A Parallel between Poetry and Painting." Reynolds knew the treatise in his youth, and became even better acquainted with it later when he provided the footnotes for a new translation by his friend, William Mason.[14] The poem expounded

[12] Hilles, *op. cit.*, Introduction and Chapter VIII.

[13] Johnson, *Rasselas* (facsimile of the first edition published in 1759, London, 1884), pp. 68–70.

[14] Du Fresnoy, 1611–1668, poet and painter; his Latin poem, *De arte graphica*, was translated into French by De Piles; Dryden's translation was into English prose; Mason's was into English verse.

traditional classic doctrines: painting and poetry are rival sisters; the painter should choose subjects suitable also for glorious verse; he should study nature to discover the most perfect forms and use them in paintings that will surpass nature; he should look for inspiration to Greek art, finding in ancient statues clues to the quality of the paintings that no longer exist, those great works of Zeuxis and Apelles. These general principles Du Fresnoy recalls in his preface, going on to detailed precepts for composition, coloring, light and shade. He concludes with a eulogy of the painters who stand out for varied excellences: Raphael, for "forms celestial"; Angelo, supreme in "correct design"; Giulio Romano, master of poetic fervor; Correggio, unsurpassed in light and shade: Titian, on "the loftiest heights of coloring's power"; Annibale Carracci, combining "all their charm." These estimates helped form the taste of the young Joshua, and it is clear from his footnotes for Mason's translation that they were still approved by the Reynolds of European celebrity.

The book which most influenced him in his boyhood, so he told Dr. Johnson, was Jonathan Richardson's *Essay on the Theory of Painting.* Richardson was a portrait-painter with a cause: he wanted to gain recognition for painting as a liberal art of equal dignity with poetry and for the painter as more than the mere craftsman he was sometimes taken to be—a gentleman of cultivated and distinguished mind. Accordingly, he made a point of telling young painters how to educate themselves for the greater glory of their art. To be first-rate a painter must "not only be a Poet, an Historian, a Mathematician, etc. he must be a Mechanick"; above all, he must have in himself "Grace" and "Greatness" "in order to put those Properties into [his] Works: For . . . *Painters paint themselves.*" A young painter, then, must devote himself to hard work in many lines while seeking to make his own life noble, "as bright a Character as any he can draw. . . . The way to be an Excellent Painter is to be an Excellent Man." Given proper training and enlargement of mind, why should

not a young English painter arise who could be ranked with the greatest of antiquity? Richardson admits that no such man has yet appeared in England, but he has high hopes.[15] Young Joshua apparently took these precepts to heart and practiced them diligently to good effect. Indeed, Reynolds in his prime—high-minded, dignified and urbane, appreciative and discriminating critic and polished craftsman, incredibly hard-working yet an ornament to the most interesting groups of a brilliant age—came close to realizing Richardson's ideal.

British Empiricism contributed the conviction that experience alone was the source of all the data refashioned by the artist's imagination. Here Reynolds met the difficulty noted in Aristotle, to explain how the painter's mind could leap from the sight of the members of a species, each defective, to a concept of a form free from flaws. It was not Aristotle's own statement that troubled Reynolds, but rather the solution to his problem offered in the spirit of Neo-Platonism by the Italian critic of the seventeenth century, Giovanni Bellori. A paraphase of Bellori had been included by Dryden in his preface to Du Fresnoy's *De arte graphica*. Bellori presents here a blend of Aristotelian naturalism with a mystical conception of the artist's heavenly vision. Naturalism alone was congenial to Reynolds' mind, and bore fruit in his own writing. Anything supernatural he stoutly rejected.

This great ideal perfection and beauty are not to be sought in the heavens, but upon the earth. They are about us, and upon every side of us. But the power of discovering what is deformed in Nature, or in other words, what is particular and uncommon, can be acquired only by experience.[16]

[15] Richardson, *Essay on the Theory of Painting*, pp. 26, 27, 37, 205, 212.

[16] Giovanni Pietro Bellori, 1615–1696, art critic; the passage cited by Dryden is from the introduction to his *Vite de pittori 'scultori, et architetti moderni*.

Quotation here from "Third Discourse." Three editions of the *Discourses* have been consulted: those of Henry Williams Beechey (1835), Roger Fry (1905), Austin Dobson (1907). The last, published in "The World's Classics," is the source of quotations, unless otherwise noted.

Reynolds' interest in the theory of painting began early and continued to be strong throughout his exceedingly active life. His "Letters" appeared when he was thirty-six years old and already a popular painter of portraits. Ten years later, in 1769, as the first president of the Royal Academy, he started a custom of giving an address to members and students of the Academy on the occasion of the award of prizes. These addresses, fifteen in number, the last dated 1790, constitute the famous *Discourses*. Carefully prepared, enriched by the fruits of Reynolds' increasing wisdom and of his never-failing "relish" for painting, the *Discourses* are masterpieces of delightful critical writing well rooted in practical experience. But twenty-one years in anyone's life bring changes in taste and standards. The *Discourses* show inconsistencies which make them all the more significant of the writer's growth, though less valuable in illustrating the neo-classic or any other one theory of painting. Here the earlier "Letters" are more in point.[17]

The "Letters" were written at Johnson's urging, dashed off in a hurry, so the story goes, and fresh with enthusiasm for painting and the zest of a consciously liberal point of view. Reynolds scoffed lightly but no less earnestly at the "connoisseur" with his narrow rules and stereotyped comments, "his mouth full of nothing but the Grace of Raffaelle, the Purity of Domenichino, the Learning of Poussin, the Air of Guido, the Greatness of Taste of the Caraccis, and the Sublimity . . . of Michel Angelo"; the connoisseur who, in spite of his affected praise, was ready to lament that the painters of old "had not lived in this enlightened age, since the art has been reduced to principles." If only they had had their education "in one of the modern Academies"! Reynolds believed in principles, but he believed that they should be general and philosophical principles, not rules of practice. He would elevate painting to a lofty seat be-

---

[17] Three "Letters" published in the following numbers of *The Idler*: Number 76 (September 29, 1759); Number 79 (October 20, 1759); Number 82 (November 10, 1759).

side poetry by basing his art on no techniques of illusion but on a large-minded philosophy.[18] His immediate concern may have been to repudiate certain tenets recently made current by Hogarth and Burke.

Hogarth's *Analysis of Beauty* had come out in 1753, Burke's *Essay on the Sublime and Beautiful* in 1756. Without mentioning them by name, Reynolds politely ridiculed phrases which they had made famous: Hogarth's "flowing line, which constitutes Grace and Beauty," and his "pyramidal principle"; Burke's finding of beauty in "a particular gradation of magnitude." Reynolds also laid low that hardy perennial, the copy theory. Artists are told, he says, to *imitate nature*, and they take the command to mean that they should paint in such relief that objects seem real; they admire "a cat or a fiddle painted so finely . . . *it looks as if you could take it up.*" Here they are quite mistaken. If they imitate nature only in this mechanical way, they will never rise to the plane where painting is on a par with poetry. Imitation should mean the careful study of nature to discover in her works what is particular and accidental and what is universal and invariable. The latter forms only are in the truest sense "natural," and worthy of the brush of the greatest masters.

Reynolds contrasts the lower and the higher modes of imitation as they appear in the works of Dutch and Italian painters. The Dutch attend to the literal truth of "Nature modified by accident"; the Italian school is concerned only with "the invariable, the great, and general ideas which are fixed and inherent in universal Nature." Among the Italians, Michelangelo stands supreme with works that are "all genius," truly epic in quality. He is "the Homer of Painting."

When the artist "imitates" by "generalizing," he constructs a form that not only is common and central to a species, but also constitutes its beauty. Beauty is precisely this common form. The artist

[18] First "Letter," Number 76, pp. 250–1; Second "Letter," Number 79, p. 253.

discovers beauty empirically, through study of many individuals of a species. Reynolds points out that no one could recognize beauty in a species if he had seen only one example. Suppose a man who had been born blind were given his sight and immediately confronted with the most beautiful woman in the world. Having no basis for comparison, he would not know whether she was a paragon or a monster. Reynolds was a thoroughgoing empiricist also in finding habit at the root of our pleasure in beauty. Beautiful forms being the common ones we see most frequently, they please us because we are used to them. He calls attention to our approval of fashions of dress for no other reason than that we have seen them constantly. Moreover, it is familiarity that establishes our preference for certain racial traits—color of skin and set of features. Ethiopians would admire a Goddess of Beauty painted with a black skin, "thick lips, flat nose, and woolly hair"; Europeans demand a different form and color, reflecting what they have seen habitually. "It is absurd to say that beauty is possessed of attractive powers, which irresistibly seize the corresponding mind with love and admiration, since that argument is equally conclusive in favor of the white and black philosophers." [19]

As becomes a Classicist, Reynolds argued that color had nothing to do with beauty which belongs to form alone. The beauty of a rose, he contended, lies exclusively in its form, no more conditioned by its color than by its smell. Painters who ignored this fact, like the Venetians, and admitted an irrelevant and frivolous interest in color were doomed to rank below the right-minded Florentines who soberly exalted form. Reynolds admits that we may like a painting for its coloring, but our approval is on grounds not related to beauty. He goes on with courageous logic to conclude that if beauty equals form of species then all type-forms are equally beautiful, and consequently, that in respect to beauty, all paintings of true type-forms are on a par. It is obvious, however, that not all are equally admired,

[19] Third "Letter," Number 82, pp. 256–60.

though the grounds for preference must be non-aesthetic. One of these grounds may be color. Associations with ideas of utility may also carry weight. As between paintings of a horse and a turtle, for example, the horse is likely to be preferred for his various useful qualities, even when the two paintings are alike perfect in presenting the general form of the species. Here is an echo of Aristotle's admission that people admire, not any painting, so far as it gives knowledge of a species, but those paintings which represent certain species valued in the practical world. This is a rider to the copy theory that persistently recurs.

Reynolds concludes his last "Letter" in the spirit of Aristotle and of Dr. Johnson, who, indeed, is said to have contributed the final five words: "If it has been proved that the painter, by attending to the invariable and general ideas of Nature, produce beauty, he must, by regarding minute particularities and accidental discrimination, deviate from the universal rule, and *pollute his canvas with deformity.*" [20]

If Reynolds had said his final say in the "Letters," he would be open at once to attack on the ground that though his theory has the merit of consistency, it does not apply to the art he admired. Where do we find "average forms?" Surely not in the paintings of Michelangelo. The method Reynolds has recommended would not produce paintings in the Grand Style, though it might make good illustrations for scientific textbooks. The sculptor who followed his advice would construct something like the "block head" once used in art classes to teach beginners the broad planes of face and skull. Not average forms but those that are in some way exceptional and striking catch the eye of the gifted artist. A usually admiring younger contemporary of Reynolds, Uvedale Price, makes this point, regretting the great man's error in failing to see that painters look for forms that are "peculiarly pleasing." [21] "Beauty," whatever it means,

[20] *Ibid.* (Hilles, *op. cit.*, calls attention to the authorship of the italicized words.)

[21] Price, A *Dialogue on the Distinct Characters of the Picturesque and the Beautiful* (London, 1801), p. 64.

surely does not denote what we are accustomed to seeing. Habit notoriously makes men blind.

These justified criticisms of the "Letters" lose their force in the light of the *Discourses,* where earlier errors are modified or disappear. Reynolds probably changed unconsciously as the result of an increasing sensitivity to what makes paintings effective. He does not suggest that he is aware of a change when he sums up his position in the last Discourse, and he continues to find "generalize" a favorite term. But where "generalize" once meant to pare away accidental traits in order to lay bare the universal and common form, it comes to denote rather whatever a painter should do to make his work pre-eminent in the Grand Style. In this new sense, Reynolds urges the artist to generalize by leaving out anything "low" or "mean," by avoiding those species that have been "degraded by the vulgarism of life in any country," and by choosing characters of great and general interest. Further, the artist must be a good psychologist: he must omit whatever does not contribute to a unified and lofty impression on the mind. Omit, indeed, is too weak a word. The artist must be ready actually to falsify known facts in order to present his characters as consistently heroic.

Alexander is said to have been of a low stature: a painter ought not so to represent him. Agesilaus was low, lame, and of a mean appearance: none of these defects ought to appear in a piece of which he is the hero.

To generalize means here to suppress what is psychologically irrelevant. There is special need of this suppression in the art of painting because the painter, unlike the poet, can not unfold a complex character through a period of time but must make his effect in the limited space of his canvas. "He has but one sentence to utter, but one moment to exhibit." [22]

Generalization may apply also to the construction of form, to the elimination of details that interfere with total pattern. The artist

[22] "Fourth Discourse," pp. 39, 40.

generalizes when he makes a design that strikes the eye with a grand simplicity.

> To give a *general* air of grandeur at first view, all trifling play of little lights, or an attention to a variety of tints, is to be avoided; a quietness and simplicity must reign over the whole work; to which a breadth of uniform and simple colour will very much contribute.[23]

Reynolds' words here might describe some abstractions. He is recommending a way of painting that takes account of the composition as a whole, in contrast, for example, with Dutch and Flemish paintings that all but lose the total effect in detail—that require the observer to take an "ant's-eye view."

These several meanings of generalization seem to have blended in Reynolds' mind. He shifts from one to another, or combines them all, when he tells the young painter what to do and what to avoid. As an example of failure to generalize, in all senses, Reynolds describes the face of Bernini's statue of David. Bernini here "mistook accident for universality." He represented David as biting his underlip with an expression that is at once "far from being general, and still farther from being dignified"; it is even "mean." [24]

If the artist eliminates traits that are psychologically unimpressive and such details as interfere with formal pattern, the shape he discovers can not possibly represent an average. When Reynolds recommends painting kings as tall figures, of course he does not imply that tallness is an attribute of the average king but that it ought to be, since it universally symbolizes strength and distinction. His interest here is clearly in a figure that is appropriately striking. And when he urges the suppression of detail that might interfere with clarity of pattern, what if the average shape should turn out to be confusingly blurred? We can only suppose him to say, so much the worse for the average.

The purpose of generalization, at last, is to eliminate from like-

[23] *Ibid.*, p. 41.                          [24] *Ibid.*, p. 40.

ness everything that might stand in the way of universal impressiveness. Here the term "universal" ceases to be a bridge between art and logic. Plato had looked for such a bridge, and not finding it, had despised art because it had nothing to do with the universals that are the counters of rational thought and knowledge. Aristotle had tried to meet him on his own ground, objecting that poetry and painting were concerned with more than isolated particulars, that they set forth concepts referring to all the members of a species and consequently afforded a kind of knowledge of human nature. Reynolds, accepting at first this contrast between universal and particular, branched off into a contrast of his own between universal and unimpressive. Painting should be universal, not merely in its freedom from particularities, but in its emancipation from an appeal that is in any way restricted by time or place. A great artist hopes to build his works on "general nature" so that they will "live for ever"; "he calls upon posterity to be his spectators, and says with Zeuxis *In aeternitatem pingo*." [25]

When the artist's interest turns from knowledge of the species to the immortality of his paintings, what becomes of the relation between art and nature? Earlier, when Reynolds' concern was with type-forms, he had held that the artist corrects "nature by herself, her imperfect state by her more perfect." A work of art was "natural" in virtue of revealing "the perfect state of nature." But when universal impressiveness is at stake, the nature with which the artist must make his peace is the human mind, the "nature of man." Painting is directed to the mind, "to the best and noblest faculties," imagination under the control of "reason and good sense." The artist succeeds in so far as he understands human psychology, what makes a man admire a painting, "what it is natural for the imagination to be delighted with." A work of art is true to nature if it affects the imagination which is "the residence of truth." [26] Reynolds ap-

[25] "Third Discourse," p. 68.
[26] "Thirteenth Discourse," pp. 195, 200, 201.

parently was hardly conscious of the gulf between his earlier and later conceptions of the value of painting—then as the source of quasi-scientific knowledge, now as the key to an experience which is moving and exalting and not to be compared to anything else. Reynolds also could not have seen how this new test of value seriously threatened the exclusive pre-eminence of painting in the Grand Style. If to be moving is the end of art, then not only a Michelangelo but also a Rembrandt, a Blake, a Rouault, or a Van Gogh may be ranked with the highest.

Reynolds does not show perfect consistency in his advice to young painters. While he remains ever faithful to history paintings as the crowning poetical glory of his art and to Michelangelo as its greatest master, he is of two minds in his estimate of the lower levels —landscape, portraiture, and genre. Sometimes he urges students to attempt only the highest. Sometimes he admits that a man may well take his own measure and devote himself to the line in which he has the best chance to succeed. For example, Hogarth was right in spending most of his time on pictures ridiculing the human follies for which he had so keen an eye, wrong in occasionally attempting history painting, in which he was mediocre. Gainsborough showed sense when he found his bent for landscape and portraits that were less poetical than natural, and worked where he could become great in his own way. Reynolds modestly accepted for himself less than the loftiest sphere. As a portrait painter who "retains the individual likeness," he knew he must rank below the painter of history. "A history-painter paints man in general; a portrait painter, a particular man, and consequently a defective model." [27]

When Reynolds uses particular and individual as virtual synonyms, he overlooks a distinction which might have let him see portraiture in a better light. While it is true that *individual* and *particular* may be predicated of the same human being, the senses are very different. A certain visual object is a particular when it is

[27] "Fourth Discourse," pp. 40, 50.

identified simply as a member of the class, woman. When this same visual object is known to be the mother of two children, the widow of a World War veteran, the daughter of a Kentucky colonel, a distinguished linguist with lace-making as a hobby, she ceases to be a particular and becomes an individual, that is to say, a unique personality. A *particular* is one instance of a type, and an instance which can not be expected to exhibit the type-form completely or perfectly. The *type* includes the significant marks which identify one class. An *individual* is, or perhaps we should say possesses, a unique organization of attributes which give him membership in many classes. Every person may be regarded either as a particular of a type or as an individual, and between the two it is impossible to draw any hard line. Every character is a type in so far as his traits reveal his likeness to a class of human beings; he is an individual as in some degree unique, *this character* and no other.

A Tamburlaine, an Attila, an Arthur, a Richard the Third, a Priam, a Macbeth, or a Charlemagne is very surely an incarnation of the type, King, even while he is also on the one hand a very revealing instance of humanity as such, and on the other of a highly individualized personality.[28]

Represented by a portrait painter who understands his subject, an individual reveals some of the infinite facets of human nature, illuminating the observer's understanding. Portraits of Mona Lisa or the Duchess of Rutland or Reynolds' own Miss Nelly O'Brien help us to see something of the Cleopatra in the species, woman. Thus portraits may serve the purpose which Reynolds reserved for "history" alone.

Aristotle and Reynolds have not convinced us that the artist's prime concern is with the species, not yet that he is a kind of natural scientist. We must take issue with Aristotle's way of answering Plato; the true defense of poetry and painting is not to be found in regarding them as supplying knowledge of a kind. Reynolds also is at fault in the "Letters" where he claims that the artist creates by a scientific

[28] Parkhurst, *Beauty*, p. 118.

method. What Reynolds describes is not the creative activity of the accomplished artist, but his learning to paint. It is true that something of the scientific method is essential to the artist's apprenticeship. Reynolds as a teacher sees this. It has been recognized also by other experienced painters who were interested in helping younger men. Leonardo, for example, recommends that students keep notebooks of sketches made from nature, and that they analyze them carefully into different types so that they will know how to classify their models. This minute study was of special importance in the days when artists had to learn to paint with no models before them, from memory alone.[29] And even after an artist has become a craftsman, he must continue to use the naturalist's method in his preliminary work.

When artistic creation begins, however, the painter ceases to analyze and abstract. His previous research has undoubtedly left profound effects below the level of consciousness which help to determine what he sees and paints, but he is aware only of his own vision, and completely absorbed in it. Sometimes this awareness is so keen and concentrated as to make him mistakenly conceive it to be altogether independent of earlier study and analysis. William Blake was an artist of this stripe. His views on this point can be seen scribbled exactly where, in this connection, one would like to find them— in his copy of Reynolds' *Discourses*, now in the British Museum Library. His repudiation of the empirical method is complete and even violent:

All Forms are Perfect in the Poets Mind, but these are not abstracted nor compounded from Nature but are from Imagination.

Knowledge of Ideal Beauty is not to be Acquired. It is Born with us. Innate Ideas are in Every Man. Born with him they are truly Himself. The Man who says that we have No Innate Ideas must be a Fool & Knave. Having no Con-Science or Innate Science.

To Generalize is to be an Idiot. To Particularize is the Alone Distinc-

[29] Cf. Leonardo's *Note-Books*, trans. McCurdy, p. 179.

tion of merit—General Knowledges are those Knowledges that Idiots possess.[30]

Aristotle and Reynolds have come a long way from the copy theory with its requirement of a literal likeness. Likeness is still expected, but the correspondence between painting and original is now transmuted by the painter's experience in many fields. Indeed, when he paints history, he takes his original less from physical nature than from his knowledge of literature and of human beings generally. The process of artistic creation must be complex and difficult to explain, but has been wrongly identified with the discovery of average forms. That point has become clear. A trace of the copy theory lingers in the notion that the artist's subjects should be drawn from material antecedently judged great, good, and beautiful.

Men's theories of art are likely to reflect their taste, and in turn, to be peculiarly applicable to the painting they admire. Aristotle's taste ran to the noble and statuesque, to painting that subordinated color to drawing. Reynolds also liked heroic figures and large, simplified forms that would catch the eye of a man walking along an exhibition hall. Their theories apply well to paintings that subordinate individuality to total effect, to over-all pattern. Reynolds' favorite is appropriately Michelangelo.

[30] Second edition, 1798. These notes are included in the edition of Blake's works by E. J. Ellis and William Butler Yeats (London, 1893), II, 318–44.

# Three

## THE ARTIST AS MYSTIC: PLOTINUS AND SCHOPENHAUER

THE ROMANTICIST answers Plato by setting the artist on a pinnacle of vision commanding insight into reality beyond the reach of the physical eye. The artist is a seer. What he sees may be precisely those entities which Plato denied him, the Ideas. The romanticist may even refute Plato out of his own mouth with passages in the *Phaedrus* and the *Symposium* which praise the beauty of human beings as a rung in the ladder mounting to heights where the beauty of spiritual reality becomes visible. If natural beauty can be put to this high use, how much more the greater beauty of art! And how account for the supranatural intensity of man-created beauty except by assuming that the artist can imitate reality—the Ideas—more accurately than nature can reproduce them? The artist corrects the defects of nature, not, as Reynolds would say, by examining many examples of a species, but by direct insight into nature's models in all their divine perfection. This theory of art has been dear through the centuries to writers who base their mysticism on love of beauty. Mystics in the Indian tradition of longing to escape from the unreality and pain of the physical world may also see art as one avenue to liberation. Both types of mysticism lent something to Schopenhauer. Love-of-beauty mysticism was applied to art by Plotinus in a theory that has often been mistakenly called Platonic,

since it can be derived so readily from Plato's discussions of beauty.[1]

In the passages in question, Plato turns his back for the moment on mathematics and dialectic, and points to another way to mount to the knowledge of Ideas. This way depends upon both the sight of physical beauty and the recollection by the human soul of an existence before birth when he saw Ideas directly. Physical beauty awakens intense love, which recalls the far higher beauty and love of the Ideas. This memory turns the experience into a divine discontent, urging the soul on to the arduous self-discipline necessary to purify vision for insight into perfect beauty and goodness, the source of true knowledge. Plato can hold this view of beauty and still maintain that no access to knowledge is offered by art, because for him *beauty and art are in different spheres.* Art he held to be essentially imitation; beauty, on the other hand, was recognized by its power to excite love and was the attribute of living human beings.

It is a *person* "having a godlike face or form" who in the *Phaedrus* awakens the beauty of Ideas seen in a previous existence. Again, it is the beauty of fair *human* forms and actions which, according to the wise woman, Diotima, in the *Symposium*, stirs the love that can rise to become love of absolute beauty.

And the true order of going or being led by another to the things of love, is to use the beauties of earth as steps along which he mounts upward for the sake of that other beauty, going from one to two, and from two to all fair forms, and from fair forms to fair actions, and from fair actions to fair notions, until from fair notions he arrives at the notion of absolute beauty, and at last knows what the essence of beauty is.

Conversely, when Plato discusses art, he rarely mentions beauty. Never, so far as I can discover, does he describe a work of art as imitating the beauty of natural objects. In fact, in the *Republic* he draws a contrast between the imitation of an object and its beauty, and all but states that art can not imitate beauty. The beauty of an

[1] Cf. *The Romantic Theory of Poetry,* by A. E. Dodds.

object, he says, has reference to its use, but knowledge of this use is just what the imitative artist lacks. So beauty is not caught by imitation, and paintings are produced in ignorance of beauty. There is a contrast also between the men who love art and those who love beauty, the latter belonging to a higher order which includes philosophers as well.

And this is the distinction which I draw between the sight-loving, art-loving, practical class and those of whom I am speaking, and who are alone worthy of the name of philosophers. "How do you distinguish them?" he said. "The lovers of sounds and sights," I replied, "are, as I conceive, fond of fine tones and colors and forms, and all the artificial products that are made out of them, but their mind is incapable of seeing or loving absolute beauty." "That is true," he replied, "Few are they who are able to attain the sight of absolute beauty." [2]

Because Plato separated art from beauty, he could urge that art was nothing but the copy of appearances, while beauty gave the impulse

[2] *Phaedrus* 251; *Symposium* 211; *Republic* x. 601. The fact of this cleavage between art and beauty in Plato's thought is accepted by most critics, and by some with approval. (Cf. Collingwood, *op. cit.*, p. 38.) A different interpretation was urged by Miss Jane Harrison, who attempted to show that Plato distinguished two kinds of art, one of which imitated appearances, while the other represented the beauty of the Ideas. (*Introductory Studies in Greek Art*, Chap. V, 4.) She bases her argument in part on what seems to be an unwarranted translation of a key word, φιλόκαλος, literally "lover of beauty," which she takes to mean "ideal artist." Plato uses this word in the myth of the *Phaedrus* when he classes the souls of human beings according to the clearness with which they had seen the divine beauty in a previous existence. Among these souls he mentions both an "imitative artist," ποιητικὸς ἤ τῶν περὶ μίμησίν τις ἄλλος ἁρμόσει (*Phaedrus* 248. E), and a φιλόκαλος; the former he places low among the souls whose prenatal vision was obscure, the latter on the highest rung of most perfect vision. This distinction is perfectly in accord with Plato's characteristic separation between beauty and art. But Miss Harrison translates φιλόκαλος, "artist," and contends that Plato differentiates here between two kinds of artists and two kinds of art: one imitative of appearances, the other representative of Ideas (*op. cit.*, p. 226). Against this translation we urge: (1) that φιλόκαλος is not used in this sense by Plato in other passages (see *Critias* iii. E, where the appropriate translation is "lover of honor," the only other use of the word by Plato, according to the *Lexicon Platonicum*, 1835). It does not appear in Plato's discussions of art and artists, for which the words are τέχνη and τεχνικοί (*Laws* 696, 889, 921; *Symposium* 186. c). (2) φιλόκαλος is translated simply "lover of beauty" by A. E. Taylor (*Plato; the Man and His Work*, p. 308) and by H. N. Fowler (*Plato*, I, 248 D).

to a knowledge of reality.[3] But his account of beauty was readily ex-
tended to art by later mystics, notably by Plotinus.

Plotinus wrote on art less than a dozen pages. What he wrote "On
Beauty," and "On the Intellectual Beauty," though more extensive,
would make only a slender pamphlet. The art of which he has most
to say is sculpture. He writes of it with a concreteness that suggests a
firsthand acquaintance with a sculptor's workshop, perhaps with
that of one of the anonymous makers of portrait busts who flour-
ished in the third century A.D. Painting he mentions only in con-
nection with the picture writing of the Egyptians, but his remarks
on sculpture are throughout applicable to both arts.[4]

Plotinus took Plato as a master from whom a devoted disciple
would never differ willingly. His mission was rather to bring back the

[3] Is it the hope of finding in Plato at least a glimmer of appreciation of the painter
to whom he was so often hostile that leads a distinguished contemporary historian,
Erwin Panofsky, to make questionable use of a passage in the sixth book of the *Re-
public?* The lines in point occur in Plato's discussion of the conditions under which
his ideal city-state might be brought into existence on earth. It might be established,
he says, if one man, gifted both as a philosopher and a law-maker, could find a city
obedient to his will. Such a man, or better, such a group of philosopher-kings, would
be "artists who imitate the heavenly pattern." Plato carries the metaphor further.
These founding fathers would have to make a clean sweep of time-worn institutions
and start fresh, just as painters need a clean tablet to work on. The law-givers would
start by sketching an outline of a constitution and then fill in the details, turning their
eyes "upwards and downwards: I mean that they will first look at absolute justice and
beauty and temperance, and again at the human copy; and will mingle and temper
the various elements of life into the image of a man; and this they will conceive ac-
cording to that other image, which, when existing among men, Homer calls the form
and likeness of God." Note that this vision belongs to the founding fathers. Sur-
prisingly, Panofsky quotes this very passage out of context as Plato's description of one
type of artist at work, the artist who is "poetically gifted." Now taken literally, this
use of the lines is simply inaccurate. Rising above a literal interpretation, we may
still question whether the metaphor through which Plato describes the work of non-
existent ideal rulers can be turned to show that he thought correspondingly ideal
artists did somewhere exist. I labor this point in answer to more than one critic who
has called this passage in Panofsky to my attention, without apparently tracing it to its
source. Cf. *Republic* VI. 500–501; Panofsky, *"Idea,"* pp. 1–2.

[4] Plotinus, 205–270 A.D., Neo-Platonist. Born in Egypt, he went to Rome at the
age of forty, spending the rest of his life there as mystic and teacher of great renown.
A short account of his life was written by his disciple, Porphyry, who also edited

real Plato who had been misinterpreted by his successors in the Academy. Elements in Plotinus' doctrines which appear to be new he may have regarded as no more than an explicit rendering of what Plato had implied. This characteristic attitude of filial piety makes his divergence from Plato on the subject of art all the more marked.

Plotinus held that a work of art is not to be condemned in Plato's terms as "thrice removed from reality." Far from merely reproducing the appearances of material objects, an artist may reveal nature's patterns, the Ideas, which he can know by insight.

The arts are not to be slighted on the ground that they create by imitation of natural objects; for, to begin with, these natural objects are themselves imitations; then, we must recognize that they give no bare reproduction of the thing seen but go back to the Ideas from which Nature itself derives, and, furthermore, that much of their work is all their own; they are holders of beauty and add where nature is lacking. Thus Pheidias wrought the Zeus upon no model among things of sense but by apprehending what form Zeus must take if he chose to become manifest to sight.[5]

Beauty for Plotinus is of the Absolute, which arouses love, the desire for mystic union. From the Absolute proceeds a series of emanations constituting the universe—first reason, then the Ideas, archetypes of all physical existences, and lastly the physical world. On every level, beauty manifests itself and is recognized by the love it

---

his writings after his death, publishing them in nine parts; hence the name, *Enneads*. The translation used is that by Stephen Mackenna; Greek text consulted, that of Richard Volkmann (Teubner edition, Leipzig. 1883).

Reference to sculptor's work: *En.* i. 6; v. 8.

No great name of a sculptor is known from this period. See Faure, *Histoire de l'art:* Vol. I, "Tableaux Synoptiques," Table N. Plotinus' interest in sculpture was quite disinterested; he would not consent to having his own portrait made, refusing with a remark which was inconsistent with his own theory of art but showed the lingering influence of Plato: "Is it not enough to carry about this image in which nature has enclosed us? Do you really think I must also consent to leave, as a desirable spectacle to posterity, an image of the image?" Porphyry, "Life," in Mackenna, *op. cit.*, I, 9.

Reference to picture writing: *En.* v. 8. 6.

For commentaries, see Inge's *The Philosophy of Plotinus* (London, 1918); A. E. Taylor's *Platonism and Its Influence* (Boston, 1924).

[5] *En.* v. 8. 1.

excites. Love of beauty, be it noted, is not a passionate ecstasy but rather like Spinoza's intellectual love of God. It is the response to the powerful attraction of a higher order of being, a response through which the lover is drawn toward the beloved and grows to resemble him.

What is the character of that beauty for which men feel "wonderment and a delicious trouble, longing and love and a trembling that is all delight?" Beauty is *form*, the order imposed by reason. It shows itself in its perfection in the Ideas, which exhibit an order that is complete; they are patterns of the unity inherent in reason at its purest. Beauty shows itself also in the material world, but since matter is never wholly tractable to form, the beauty of a physical object is always imperfect.

The lover of beauty rises from lower to higher levels by perfecting the order and beauty in his own soul through a process like a sculptor's molding of a statue.

Withdraw into yourself and look. And if you do not find yourself beautiful yet, act as does the creator of a statue that is to be made beautiful: he cuts away here, he smoothes there, he makes this line lighter, this other purer, until a lovely face has grown upon his work. So do you also: cut away all that is excessive, straighten all that is crooked, bring light to all that is overcast, labour to make all one glow of beauty and never cease chiselling your statue, until there shall shine out on you from it the godlike splendour of virtue, until you shall see the perfect goodness surely established in the stainless shrine.[6]

Having seen the vision, the artist confers its form upon his material, so far as the defectiveness of a physical medium makes possible. His statue can never equal the loveliness of the Ideas, but is still more beautiful than nature in virtue of the form in the artist's mind. His statue is "twice born of the spirit" and endowed with beauty.

The form of a work of art makes a direct impact upon the observer's spirit, and consequently communicates an Idea with special

[6] *En.* i. 6. 9.

force. Plotinus develops this point in his comments on the Egyptian use of picture writing to express the attributes of deity. Images have an immediacy of effect lacking in the words and statements of rational discourse.

The wise of Egypt . . . left aside the writing forms that take in the detail of words and sentences . . . and drew pictures instead, engraving in the temple-inscriptions a separate image for every separate item; thus they exhibited the mode in which the Supreme goes forth.[7]

That pictures do have an appeal that is direct and strong is overwhelmingly attested in the twentieth century by the effects of movies, advertising, comics, and magazines like *Life*.

The Ideas of human beings which the artist sees and represents are patterns ordered by reason, what men would be if they were perfect in goodness and beauty. "We ourselves possess beauty when we are true to our own being." Plotinus raises the question whether there is one Idea for all mankind, and decides that there must be an Idea for each individual human being: how else account for the variety of personalities?

As Ideas are ideals, there can be no Ideas of deformity or of any kind of evil. The Idea of a criminal, as of a saint, must consist of the image of that harmony of spirit toward which a man moves when he renounces the world of matter and devotes himself to ascetic self-discipline. This means that the sculptor's model for a portrait must always be, not the character of the man before him as it actually is, but his character as it would be if he had realized his individual potentialities of sainthood. Hence arises a limitation which few modern critics would accept: evil and deformity have no place in art.

Plotinus has rescued art and the artist from the metaphysical outer darkness into which they had been cast by Plato. The artist is a saint with an important revelation to share. Indeed, he is exalted to such

[7] *En.* v. 8.

a position by Plotinus as to make one wonder how many persons who are accepted as artists could possibly pass his heroic test. Artists who are giants of rational mysticism have at all times been rare, likewise artists who are saints!

Those who love Plotinus for his sweetness of spirit may resent coupling his name with Schopenhauer, the philosopher of frustration and gloom. The two men are as unlike in their temperament as in their conceptions of ultimate reality. For Plotinus, reality is a unity of divine goodness, beauty, and reason. Even the world of appearances he does not condemn; it is not *bad*, but only *less good* than the blessed world yonder.

And indeed if the divine did not exist, the transcendently beautiful, in a beauty beyond all thought, what could be lovelier than the things we see? Certainly no reproach can rightly be brought against this world save only that it is not That.[8]

Schopenhauer, in contrast, is a mystic in the Indian tradition that finds the world of appearances evil and painful, the only hope in escape. Reality itself he conceives as a sinister force, "blind, ceaseless striving" which he calls the Will. In ordinary life a human being is "constantly stretched on the revolving wheel of Ixion, pours water into the sieve of the Danaid, is the ever-longing Tantalus." Happiness is freedom from willing.

[It] is the painless state which Epicurus prized as the highest good and as the state of the gods; for we are for the moment set free from the miserable striving of the will; we keep the Sabbath of the penal servitude of willing; the wheel of Ixion stands still.[9]

Another important difference lies in the place assigned by the two to art. The discussions of art in the *Enneads* are extremely brief; statues and paintings simply illustrate points too abstract for easy

[8] *Idem.*
[9] *The World as Will and Idea*, trans. Haldane and Kemp, I, 253. The texts consulted are the translation by Haldane and Kemp, and the German of the Leipzig edition, 1873.

comprehension. In Schopenhauer's system the place of art is central. The experience of art is not merely one way of knowing reality but, except for men of genius, the only way. This emphasis suggests that Schopenhauer himself may have found in art a peculiar release from his unhappy egoism, and that psychologically he devised a system to account for his moments of peace.

On many other points, although Schopenhauer never refers to Plotinus as a source of his theory of art, the two agree so extensively that one can almost see Schopenhauer writing with the *Enneads* at hand, finding in their packed pages many pregnant suggestions. One point of agreement is clear and basic: Schopenhauer in his turn admits a great debt to Plato, but refuses to accept Plato's belief that the artist can not have access to the Ideas.

Plato teaches (*De rep.*, x., p. 288) that the object which art tries to express, the ideal of painting and poetry, is not the Idea but the particular thing. Our whole exposition hitherto has maintained exactly the opposite, and Plato's opinion is the less likely to lead us astray, inasmuch as it is the source of one of the greatest and best known errors of this great man, his depreciation and rejection of art.[10]

For Schopenhauer the artist's prime function is to make the Ideas known. The artist himself knows them through the process of "pure perception," a condition of mystical absorption in the object seen. The knower loses himself in seeing, so that "it is as if the object alone were there."

Pure perception is like the intimate awareness a man has of his own states of consciousness. It is contrasted with another kind of awareness of himself, his knowledge of his body as an object extended in space related to other objects. This is the product of rea-

[10] On Schopenhauer's references to Plotinus: as neither the German edition nor the English translation by Haldane and Kemp has an index, I rely for a list of references on the *Encyklopädisches Register zu Schopenhauers Werken*, by Gustav Friedrich Wagner (Karlsruhe, 1909). The references there are not to passages related to art, but to the relation of Plotinus to Indian mysticism, to Neo-Platonism, and to his part in the introduction of idealism to the Occident (p. 329). Quotation here: W.W.I., I, 274.

son, which orders sense experience in the relations of space and time, cause and effect, and belongs to common sense and science, useful in practical life, but entirely inadequate to afford insight into things as they are in themselves. The latter comes exclusively through pure perception.

Unfortunately for the ordinary man, pure perception is a way of knowing for which he has little aptitude. It is all he can do to cope with the superficial aspects of things as they thwart and aid him. Insight into essences requires the particular gifts of a genius. If the genius be at the same time an artist, he may record his vision so that an ordinary man may share it.

What is the relation between genius, art, nature and the experience of ordinary human beings? The genius is the man with an innate power of detachment by virtue of which he can renounce all interest in knowing things in their relations to each other and to his will, and see them as they are in themselves, not by studying many examples of a species, but by insight into a single form.

[He] understands the half-uttered speech of Nature, and articulates clearly what she only stammered forth. He expresses . . . that beauty of form which in a thousand attempts she failed to produce, he presents it to Nature, saying, as it were, to her, "that is what you wanted to say." And whoever is able to judge replies, "Yes, that is it." [11]

How is it possible for the artist to anticipate nature's aims? Schopenhauer gives the mystic's answer: It is possible because the artist and nature are one, "like can only be known by like: only nature can understand itself: but only spirit can understand spirit."

The artist's "pure perception" of the Ideas shows them in their essential perfection, purged of "disturbing accidents." Thus he is able to communicate them to the ordinary man. Communication of this sort is possible, just as the artist's insight into nature has been shown possible, because artist and beholder are aspects of the same Will. It is upon the degree of likeness between artist and spectator

[11] See W.W.I., I, 231–321.

that the completeness of their communication depends; if the spectator himself is far from a genius, his grasp of the Idea interpreted by genius will be relatively incomplete, though still prized for the insight it does make possible.

Art has a further value for the ordinary man: it grants him relief from the painful activity of his own restless will. While he contemplates the Platonic Ideas, he is detached from the struggle for existence and enjoys moments of that peace which constitutes the highest human happiness. He is no longer Tantalus, nor Ixion on the wheel, nor a Danaid drawing water with a sieve.

Since everything in the physical world is patterned after a Platonic Idea, it follows that all things may be sources of knowledge and of blessed contemplation to the genius who is able to look at them with detachment. Everything is beautiful if seen in the right light.[12] Here Schopenhauer breaks away from the familiar but mistaken belief that the merit of a work of art is in large part a reflection of the merit of its original. The worth of art is derived not from any model, but from the way the artist sees it. And if he has the genius' gift of seeing *sub specie aeternitatis,* he may find material suitable for art wherever he looks.

Schopenhauer deals with the difficult problem of explaining how a painting which seems to imitate a single model can nevertheless have a reference extending beyond this one original. Aristotle and Reynolds took over Plato's conception of the single model as a particular, and maintained that when the artist seems to be imitating a particular, he is in point of fact exhibiting the traits common to all the particulars in a class; his likeness is generalized, and hence, universal. Schopenhauer sees the artist's original as at once a member of the class, human being, and a unique individual. The artist is to regard his model's individuality not as mere idiosyncrasy, but as a revelation of some of the manifold potentialities of human nature.

Thus the character, although as such it is individual, must yet be Ideal, that is, its significance in relation to the Idea of humanity generally . . . must be comprehended and expressed with special prominence.[13]

Schopenhauer would say, we may suppose, that when Leonardo painted the *Mona Lisa*, he showed regard for the Idea of the species, woman, in his way of modeling the delicate cast of features, the shape of the head, and the set of the shoulders. But he also treated the eyes and the coloring of the face so that they would express an individuality, enigmatic and unique. This distinctive personality, however, he viewed not as unrelated to the personalities of other women, but as revealing in rare combination traits that appear again and again, as throwing light on the possibilities of essential woman-hood. The *Mona Lisa* in her very uniqueness extends the concep-tion of what a woman can be. The painting is universal in its in-tensity.

The mystic's answer to Plato claims for art a value of first im-portance in communicating knowledge of the highest kind; the artist shares with less gifted men both his special way of seeing and the content of his vision, reality. Hence this value is twofold: it is knowl-edge of reality and an experience of seeing. To distinguish between the two may be significant if one should carry conviction without the other.

Assume for the moment that the merit in an artist's work lies in its revelation of reality. Then when two artists differ in their concep-tion of ultimate truth, it is clear that one—if not both—must be a false prophet and, by the same token, a bad artist. It is also clear that before a critic can form an aesthetic judgment of their work, he must attempt to evaluate their revelations. There have been Buddhist, Hindu, and Byzantine artists, each of whom was presum-ably attempting to embody in his art the view taken by his own people of ultimate truth. Of their success it will be impossible to judge until the critic knows which of these outlooks, if any, can

[13] W.W.I., I, 290.

never be challenged successfully. But on this condition he must be condemned to a perpetually suspended judgment. That critics make their criticism wait upon their metaphysics is palpably false.

A similar difficulty arises if we try to apply the mystic view to art under the joint guidance of Plotinus and Schopenhauer. Art is valuable to both in the measure of its revelation of ultimate truth, that is, in the degree to which it makes clear that reality is on the one hand, as Plotinus conceives it, a realm of completely intelligible ideals of beauty and goodness; on the other hand, as Schopenhauer sees it, a realm from which intelligence is wholly excluded, mere will "going it blind." As critics, we might hope for a revelation of our own to correct the other two, but with our confidence in its probable validity somewhat shaken!

The mystic's theory can be applied with complete satisfaction to the work of such an artist as William Blake. He was a man who saw visions and dreamed dreams, whose writings show that in his paintings he was trying to record and communicate what he had seen. Another whom the theory brings to mind is Fra Angelico. His paintings of angels celebrate a happy sense of welcoming heavenly visitors to his monastery cell. Some painters of religious subjects in the Renaissance would seem to have been blessed with insight, others simply to be following the fashion. Among our contemporaries, Rouault may exemplify the mystic's view of painting. But what of Sir Joshua Reynolds, who states categorically that the artist needs no transcendent vision? What of many others who have impressed men's eyes and imaginations without giving them the slightest glimmer of revelation? Holbein and Rubens, Velasquez and Titian have something to say in terms of pigments, but rarely if ever draw men's minds toward heaven. In poetry also, the mystic's view applies primarily within the limits of the Romantic tradition. Even a writer who claims that most English poets have been mystics, Professor Caroline Spurgeon, admits as notable exceptions Chaucer, Dryden, Pope, and Byron, with Shakespeare as a probable fifth.[14]

[14] Spurgeon, *Mysticism in English Literature*, p. 13.

By no means all artists find their originals in Ideas, if these are to mean aspects of ultimate reality inaccessible to ordinary experience or imagination. But Idea has a further connotation; at times it meant for Schopenhauer *essential character*, the core of individuality. The unique specificity of a human being, the special quality of his inner life, is what the artist must portray if his work is to have any value. No doubt this would be widely accepted today in the fields of poetry and fiction. Many recent writers of distinction, for example, T. S. Eliot and Virginia Woolf, owe their eminence to skill in plumbing the depths of individual life. Bergson, a philosopher who is also a literary artist, holds that the very function of all the arts, of painting and sculpture as well as poetry, is to reveal the individuality smoldering beneath the crust of convention.[15]

It is true also of many great painters that they have concentrated upon the essential individuality of their models: witness Holbein and Rembrandt. But here again exceptions are plentiful. There are many superb paintings in which individual characterization is wholly absent, in which interest is centered on figures arranged in patterns of color and shape. Such are Byzantine mosaics and frescoes, such the paintings of Cézanne, also the Mexican style of mural painting developing today. Here the artist is concerned with his model not at all as a unique individual, but merely as a figure that fits into his pattern or stimulates his vision. Matisse, for example, may be struck by the triangularity of some woman's figure and set it down, seeming not to care in the least whether she is Columbine or the Madonna. In the light of the actual history of painting, then, we cannot identify the artist's original with the Idea, as the wholly specific or individual. To seize the unique in this sense is admittedly the aim of some great painting, but clearly not of all. Plotinus and Schopenhauer have interpreted art in a way that reflects taste for art in a certain temper.

They have done this, and something more. Their account of the experience of a work of art, and of a painting as the means of com-

15 Bergson, *Laughter*, Chap. III, pp. 150–67.

municating this experience, would seem to illumine more than such
paintings as exemplify the revelation theory. We may look at the
work of other than mystics and recognize in our "vision" some of
the marks of Schopenhauer's "pure perception."

"Pure perception" has the qualities of immediacy, intensity, and
passivity. Can these be held to belong to a wide range of aesthetic
experience? Immediacy and intensity, without a doubt; passivity
only in a restricted sense.

"Pure perception" is *immediate* in that perceiver and perceived
object are one, "the whole consciousness is filled and occupied with
one single sensuous picture." This is the state of one who is "lost
to the world" in seeing, who is "all eyes." These quoted phrases are
common enough, and recall a state that we recognize. It is a state
in which nothing holds the spectator aloof from a painting, as ques-
tions about technique and subject, story and moral, might hold him.
Such questions, legitimate enough, may precede or follow pure per-
ception; until they vanish from the spectator's attention, he is not
"lost in seeing." While this last way of seeing is normally distinctive
of art, it may belong also to the sight of a landscape or person when
regarded as though each were a work of art. This is presumably how
the painter himself sees them. Such immediate absorption in the
object must be an experience of heightened intensity. All the ob-
server's energy is canalized in his awareness of color and form and,
it may be, of the essential quality, the inner life of the object before
him. To make this last statement is not to reopen the case for
mysticism; it is simply to acknowledge that painters may be con-
cerned with more than pattern. So, we may suppose, are all good
painters of portraits. And for a painter like Cézanne, a teacup, every
object, had its own vitality open to his intense concentration.

For Schopenhauer pure perception was immediate, intense, and,
at the same time, passive—passive in its freedom from willing. We
agree that the observer sunk in pure perception does not wish to do
anything to the picture that enthralls him, not even to possess it

except with his eyes. Even when he emerges into a less absorbed con-
centration, he is not left with a compulsion to sign a check or to
join something, the effect attributed by Virginia Woolf to what is
good propaganda but imperfect art. But suppose that passivity de-
notes also complete inactivity, a kind of trance? Passive in this sense
does not apply to the experience of some creative artists. A descrip-
tion of one sculptor at work shows that he concentrated on his model
in an active, lively way.

He was utterly absorbed with the head he was modeling, and his excite-
ment about it was manifest at every stage—first, when he was sketching
the head each successive bit of clay was dabbed on to the growing shape,
as if he were indulging in a violent pugilistic encounter with it, a gymnastic
display which testified to his intentness on the exact delivery of each in-
crement; and later when, the general form being modelled, the smaller
knife was used to perfect the detailed structure, here removing clay or in-
denting lines, here adding tiny portions of liquid clay with as much deli-
cacy as the painter uses his brush, the sculptor's face marked the strenu-
ous effort to transfer his subject into the clay.[16]

It might be urged that this excitement is characteristic of the artist
only when he is at work, that it follows after a period of passive con-
templation. But we are told that the sculptor described here was
actually seeing his model for the first time. That an artist's pre-
liminary vision in point of fact has a characteristic excitement is
attested by Roger Fry. He describes the state of mind which shows
a picture to be "brewing" as "detached and *impassion*ed vis-
ion."

The . . . chaotic and accidental conjunction of forms and colours be-
gins to crystallise into a harmony; and as this harmony becomes clear to
the artist, his actual vision becomes distorted by the emphasis of the
rhythm which has been set up within him. Certain relations of directions
of line become for him full of meaning; he apprehends them no longer
casually or merely curiously, but passionately.[17]

[16] Alexander, *Beauty and Other Forms of Value*, p. 64.
[17] *Vision and Design* (edition of 1925), p. 51.

Detached from practical concerns and from self-consciousness the artist certainly is, but far from passive.

Plotinus and Schopenhauer have not convinced us that artists should be expected to communicate a vision of reality, nor that "pure perception" can be completely identified with the experience of art. But they leave a suggestion that caught the attention of later writers, that the value of painting may involve communication of some kind, having to do with experience of special depth or importance. They also extend further the almost infinitely flexible concept of likeness, which they still hold on their own terms. Plotinus uses the classical term [18] "imitation" ($\mu\acute{\iota}\mu\eta\sigma\iota\varsigma$) to denote the process by which Phidias made his statue of Zeus. Schopenhauer describes artistic construction sometimes as imitation (*Nachahmung*), sometimes as representation (*Darstellung*).[19] For both men, the relation of likeness obtains between an Idea, the artist's vision of the Idea, and the form of his work of art. Likeness is the repetition of pattern in three media, only one of which is directly perceived by the physical eye. There is anticipation here of a point made by the Gestalt psychologists, that the same form can be recognized in media of very different kinds. They give this concept of likeness the name "isomorphism," from the Greek words that mean *like* or *equal* ($\acute{\iota}\sigma o\varsigma$), and form ($\mu o\rho\phi\acute{\eta}$).

When the artist constructs a sensuous object which stands for an original which is not sensuously perceptible, he is creating a symbol. "Symbol" has been defined precisely as a "presentation to sense of a principle that is not sensuous." The relation between painting and original emerges here as that of a symbol to a referent.

[18] *En.* v. 8, 1.

[19] Examples of Schopenhauer's use of "imitation," *Nachahmung*, and "representation," *Darstellung*: "Man meint, durch Nachahmung der Natur" (Leipzig edition, 1873), § 45, p. 261; Der Künstler "die Natur in seiner Darstellung übertrifft." *Ibid.*, p. 262.

# Four

## FROM LIKENESS TO EXPRESSION

SCHOPENHAUER had said that in art there are no "great subjects." Any original will serve if the artist sees it in its own peculiar essence. The character and quality of the artist's vision are all-important. This position, reinterpreted without reference to Platonic Ideas, appealed to critics who were struck with the contribution to painting of the artist's personality. Set a dozen painters before the same model, and they will produce such different compositions as to make you believe they had not one model but twelve. The artist creates a likeness of himself. This point was stressed by a French writer, Eugène Véron,[1] whose *L'Esthétique*, published in 1878, voiced a new humanism in standards for art. He attacked the "Platonism" still popular with the academies, and claimed that art in the modern temper should be, above all, expressive.

The Platonism with which Véron found fault was Plotinian—the theory of beauty, derived from the *Symposium* and the *Phaedrus*, which Plotinus and other Platonists had extended to art. Véron does not recognize his own mistake in attributing this theory to Plato himself, though he criticizes his contemporaries for citing Plato without troubling to read him. Véron complains that they talk of Ideal Beauty as the required original for the artist, not knowing what is involved in accepting such a model. They do not understand that, for Plato, the conception of beauty in the physical world as a

---

[1] Eugène Véron (1825–1889).

stimulus to draw men to a vision of Ideal Beauty is bound up with his doctrine of reminiscence and his belief in a supersensuous realm of Ideas. Cut off from this background, the conception of Ideal Beauty loses its meaning and force. It becomes a rigid, lifeless ideal that prompts artists to produce what is "academic" in the worst sense, stereotyped and remote from human concerns. Véron welcomes the new attempt of some of his contemporaries to make art human: "Instead of . . . representing divine beings or of devoting itself to a symbolism condemned to end in dryness and subtlety, art is making a visible effort to return to a purely human domain." Artists are beginning to recognize that their function is neither to go back to the copy theory nor to seek for Ideal Beauty, but to make their work expressive. They must make it doubly expressive: first, of the feelings and ideas of their originals, and secondly, of their own attitudes toward those originals. The artist's own attitudes, his own personality, are all important, since it is himself primarily that he expresses. Véron quotes Bürger on this point:

In the works that interest us, the authors substitute themselves in some way for nature. However vulgar their original may be, they have perceived it in a way that is individual and rare. It is Chardin that we admire in the glass he has painted. It is the genius of Rembrandt that we admire in the character, profound and singular, that he has imprinted on the head of whatever model was before him. Well, they have seen like that! and hence comes what is simple or fantastic in the expression and in the execution.[2]

To see that a painting owes much to the individuality of its maker was of course no discovery of Bürger. Plato implied something of the sort when he condemned the whole art of painting as tarred with the brush that had left Zeuxis and Parrhasios superficial and fatuous. Longinus had laid upon young men who would write great poetry the injunction to become great themselves; a masterpiece is an echo of a great soul.[3] More recently Jonathan Richardson had given

[2] Véron, L'Esthétique, p. 131 (translation mine).
[3] Longinus, On the Sublime, p. 61. Reference is to the edition by W. Rhys Roberts, Cambridge, 1907.

similar advice to painters: "The way to be an Excellent Painter is to be an Excellent Man," for "Painters paint themselves." All these writers knew, as the man of the street knows when he stops to think, that materials of many kinds besides pigments on canvas—clothes, furniture, paper and ink, dishes and silver set for a meal—take the imprint of the person who arranges and uses them. A man's checked suit and loud tie "express" his personality. A woman's way of placing her furniture, even her special touch in mixing a salad, "express" something of her individuality. Expression here denotes a process that may be hardly conscious. Similarly, when Chardin painted a glass of water, although absorbed in seeing and painting the glass, he "expressed" himself at the same time unintentionally and because he could not help it.

Schopenhauer's idea of art as a means of communication was placed in a new context by Leo Tolstoy.[4] In his essay, *What is Art?* he showed how earlier writers and artists also had gone astray through believing that art should aim at nothing more than to give sensuous pleasure through beauty. Artists had lost contact with genuine feeling, had tried to reach only a frivolous élite, and had produced an art that was insincere and superficial when not positively demoralizing. Tolstoy urged that the true function of art is to communicate feeling, indeed, certain particular feelings which would bind men together. Artists must recognize their mission to unite men in an Early Christian brotherhood, and must abjure the expression of any feeling or idea that could not easily be shared by the simplest peasant. Tolstoy the novelist had produced works far more complex and subtle than the art which Tolstoy the reformer could approve. But in obedience to his new vision, he was ready to see his masterpieces cast into the discard.

The terms "communication" and "expression" presented to Tolstoy and Véron no difficulties beyond the power of common

[4] Lyov Nikolayevitch Tolstoy (1828–1910), *What is Art?* (1896), translation by Aylmer Maude, 1905.

sense to solve. Both words became associated with new problems in the writings of Benedetto Croce.

Croce published his *Estetica* in 1900. As a reinterpreter of Hegel's rationalism, Croce was interested in distinguishing kinds of knowledge, among them the immediate awareness of individual entities: a person, a landscape, a portrait, a tree, or a state of mind. This kind of knowledge he held to be central in the creation and appreciation of art.

The initial material of an artist's experience is a jumble of brute sensations and impressions, disturbing, yet so much a part of himself that he can not yet name them. He reacts to them with an activity of the spirit which attempts to subject them to some kind of form by finding an appropriate image. The image may be a word or other sound, a color or shape, each with its own emotional tone. When the artist has found an image that satisfies him, he has achieved intuition and expression.[5]

Croce uses these two terms for a single cognitive process because neither is adequate alone. Intuition alone may denote an awareness so vague that it can not be put into words, the very experience described by the mystic as ineffable. Again, intuition does not normally connote an element of feeling. Expression makes good these defects. Expression is commonly expected to be *in words or other symbols, of feeling.* But expression lacks any connotation of knowledge. Intuition and expression used jointly bring together both elements: knowledge of an individual in terms of a definite image, and a warm glow of illumination. No intuition can exist except in words or other images. Sad doctrine for those who think themselves mute Miltons with their minds full of great and wonderful thoughts for which mere words are inadequate! According to Croce, lack of words proclaims nothing but confusion in the mind.

*Image* for Croce has nothing to do with *likeness.* An image is charged with emotion, yet regarded with objectivity, a symbol ef-

[5] Croce, *Aesthetic*; translation by Douglas Ainslee, Chap. I.

fective in bringing insight and a certain peace. Take the case of a painter who feels a nameless uneasiness, an urgent need to look this way and that for something, he knows not what. All sorts of images may flash before his mind, including one of an island, a small rocky cliff in the sea. He feels a rush of emotion toward the island; it *is* his feeling; it stands for loneliness. It helps him know his early uneasiness; he is no longer at its mercy.

When the artist holds an image before his mind, finding in it the expression of feeling, his aesthetic act is consummated. Since art is expression, and his expression is complete, he has created art simply in his mind. Croce holds that the artist adds nothing aesthetic if he goes on to make his image public by writing a poem or painting a picture. Then he turns from aesthetic to practical activity in the process of "externalization." [6] Using physical means—sounds, colors, shapes—he records the epic, symphony, or heroic mural already inscribed on the tablets of his mind. His work of art may become part of other men's raw material of experience which they may intuit and find expressive. If they do so, the artist communicates his intuition by means of his poem or picture. But communication is not essential to the aesthetic act of expression. The artist's prime concern is to make something clear to himself.

Can we accept Croce's sharp line between expressive image and externalized work of art? If we push his distinction to its logical limits, we must believe that Beethoven had an entire symphony in his mind, note for note, before writing a bar; that Michelangelo envisioned an intricate pattern of color and form completely before beginning to paint; that Shakespeare had every word in a five-act tragedy selected before putting pen to paper. This simply does not make sense. A poet might compose a sonnet, or a musician a simple lyric, and then take it down, but not a larger and complicated work. Critics of Croce on this point,[7] Samuel Alexander and R. G. Colling-

---

[6] *Ibid.*, Chap. XV.
[7] Alexander, *op. cit.*, p. 59; Collingwood, *op. cit.*, pp. 303–4.

wood among them, hold that the processes of forming an image and
of externalizing it go on together, mutually interacting to the bene-
fit of both. An artist discovers his image more and more definitely
as he paints; until he has finished his picture, he can not be wholly
certain of what he was trying to do. This account rings true to the
humble student whose artistic activities are limited to the drawing
in a course in laboratory science. There, as he draws what he sees
through a microscope, he becomes aware of seeing more and more;
until he has drawn, he is only half aware of what he is looking at.
Or again, painting is a kind of handwriting. When a man writes a
letter, he usually becomes aware of what he has to say only as his
pen forms the words. The act of writing in turn stimulates him to go
on with inner and outer processes of expression. There is some wis-
dom in the child who objected to being told to think before she
spoke. "How do I know what I think till I hear what I say?"

Another question to put to Croce has to do with communication.
He holds that a work of art, expressing the artist's feeling, provides
an image which the spectator may also find expressive. A painting
then becomes a means of communication between artist and spec-
tator, and an important source of insight. The difficulty on Croce's
terms is to see how any such communication is possible. How can the
observer's experience of a painting repeat the experience of the artist
if each intuition is a unique act of expressing specific feelings of a
particular person at a particular moment? No two persons' feelings
and circumstances will ever be precisely the same. Therefore no one
will ever find a painting expressive in precisely the way it served its
creator. But some degree of communication is possible, says Croce,
depending upon the degree to which the observer shares the passions
which served as the artist's raw material. A man can prepare to enter
into communication with Michelangelo by studying the painter's
life and projecting himself imaginatively into the feelings that were
expressed in the picture. Before reading Coleridge's "Kubla Khan,"
a man should steep himself in the account of the growth of the poet's

mind offered by John Livingston Lowes in the *Road to Xanadu*.

Croce's explanation makes full enjoyment of art depend upon laborious historical research which few spectators would have the time, skill, or patience to undertake. Furthermore, such study, while putting the spectator more nearly in the artist's place, with a resulting richness and extension of his imagination, could not be guaranteed to meet the spectator's original needs. He began by searching for an image that would express feelings battering away at himself, John Jones. If he tries to turn himself into a faint shadow of Michelangelo or Coleridge, he may be simply diverting attention for the moment from his original turmoil, which will still be waiting. Hope of easier and surer use of other men's works of art is offered in the suggestion that the spectator should regard a painting with a "wise passiveness," to allow it to become his image for expression if it can. If it speaks to his condition, it is for him expressive. Whether or not his experience resembles that of the artist is a question of little importance. There is a bond of sympathy between the two men in sharing an expressive image, a bond which the spectator recognizes. This might be called communication, but the term can hardly mean more.

To achieve intuition and expression is to attain beauty. For Croce there is no beauty in art except expression, and all expression is on the same aesthetic plane. The right word, a perfect quatrain, an eloquent sonnet, a masterpiece of epic poetry, each is expressive, each is beautiful, and all are aesthetically on a par. An attempt at expression which fails produces ugliness.[8] The artist may fail because the raw material of his passion is too strong to be expressed by any image he can find; the result, a feeling of lingering disquiet, of something only half said. Or he may fail because he overreaches himself with an image too grand for his needs; the result, bombast or other insincerity. Again, the artist may not give himself wholly to the spiritual activity of intuitive knowledge; he may have a mind half intent on

[8] Croce, *op cit.*, Chap. X.

practical concerns, perhaps to stir men to action. Then his work
lacks the unity of perfect expression.

Failure to express must admit of degree as an artist, dissatisfied
with what he has created, goes on working and feels that he is ap-
proaching more complete fashioning of his impressions into form.
Hence we are left with degrees of ugliness but not with degrees of
beauty. This is more than a verbal paradox. Croce insists that beauty
is expression satisfyingly complete; anything less belongs in a dif-
ferent category. And among expressions that succeed, there are no
grades or classifications. To accept this point is to free discussions of
art at a stroke from academic attempts to analyze different kinds of
beauties.[9]

This freedom has been achieved so completely in twentieth-
century aesthetics that we no longer recognize what we have es-
caped. We are no longer affronted with "literary chatter" about
divisions and definitions of *kinds* which used to dominate aesthetics,
"the true definition of pastoral and heroic poem . . . the proper
distinction of beauty and sublimity, of symbolism, classicism and
romanticism, of realism and idealism." We no longer hear anyone
beginning to discuss a work of art by determining its genus and
species: is it "a religious painting or a portrait, a problem play or a
melodrama, post-cubist or pre-futurist?" [10] These questions Croce
has helped to spare us by carrying conviction that the aesthetic
value is expression, and that every human feeling and emotion can
be expressed in art.

One effect of Croce's doctrines has been to give currency to *expres-
sion* as a central aesthetic term. There is need of a term to denote
the *value peculiar to art*, free from the confusion of the traditional
term, *beauty*. Beauty still carries associations with what is sensuously
pleasing and wholly agreeable. It can refer appropriately to the

[9] Croce, *op. cit.*, Chap. IV.
[10] Carritt, *The Theory of Beauty*, pp. 204–5. I have found this whole chapter most
helpful.

aesthetic success of a Botticelli Venus, a Gainsborough portrait, a landscape by Corot, or one of Renoir's smiling girls. But what of an El Greco Crucifixion, or one of Breughel's paintings of peasants? Aesthetically successful, surely, but who would naturally call them beautiful? Only someone highly sophisticated in the vocabulary of art. The refusal to call Picasso's distortions beautiful is more emphatic still, in spite of willingness to concede that a painting like *Guernica* has great emotional power. The need for a word with which to praise a work of art without suggesting that it must be a work of a particular kind has tended to replace *beautiful* with *expressive*.

The term *expression* too has turned out to be ambiguous. As now used, it has taken from Freud a coloring which may be misleading. Freud's *Die Traumdeutung* came out in 1900, the year when Croce's *Estetica* first appeared in the proceedings of a learned society, *Atti dell'Accademia Portaniana*. Ideas from both, gaining currency at the same time, were not unnaturally blended, even though the fundamental philosophical positions of the two men were profoundly different, Croce's primary interest being in knowledge and Freud's in emotion. The commonly accepted Freudian notion that deep irrational forces, sinister when suppressed, can find a harmless outlet in art has lent a special meaning to expression as *release from tension*. This meaning was indeed always present, but for Croce the release was rather from confusion and ignorance into the fuller immediate knowledge of individuals. For the Freudians the business of art is not to give intuitive knowledge but to liberate emotions in a world where they are warped and frustrated. There is danger here of misunderstanding the kind of outlet which art can properly supply.

Art may be used simply as a means of working off emotional steam. A man who is full of helpless rage at injustice which he can not attack directly may find relief in the physical violence of chopping wood, in a torrent of abusive words, or in a savage bout of painting. Any one of these activities may serve as a catharsis of his emotions. He is relieved, feels better, may even forget what had troubled him.

But in this case, painting is on a par with chopping, and neither is
genuinely expressive. The experience of painting may, however, turn
into something more. A painter may find as he paints a pattern of
colors that he releases his feelings by giving them form, and that
through this release he is able to see them for what they are. It is to
this objective insight into one's own emotions that E. F. Carritt,
R. G. Collingwood, and other contemporary writers would give the
name *expression*. What art offers is not only an outlet for feeling,
but self-knowledge. The artist knows himself through painting; the
spectator who responds to the painting thereby brings into objec-
tivity some of his own passions, hitherto disturbing and unacknowl-
edged. Expression civilizes feeling by making one face it. Good art,
created honestly and bravely, is a means of saving a man from the in-
sincerity and cowardice of what Collingwood calls the "corruption
of consciousness." [11] Bad art, made by men not strong enough to face
their own feelings, who wish rather to avoid a clear view and to
escape into the self-deception of sentimentality, carries the taint of
their corruption and is the root of serious evil for other men. Col-
lingwood's concept of corruption has a Freudian slant. A man is cor-
rupt who allows his emotional life to become a welter of repressions
and evasions. If all art were good in Collingwood's sense, and all men
knew how to make or to see it expressively, the psychoanalyst's oc-
cupation would be gone.

Croce's way of conceiving art represents a long stride in the retreat
from likeness. There is scarcely a trace of likeness left in the whole
process of creation and enjoyment. To be sure, the artist seeks for
an image by which to express his impressions, but his image makes
its effect not through resembling anything. Rather, it serves as a
catalyst in whose presence chaotic inner impressions are resolved into
form. And though the artist externalizes his image on canvas by a
kind of copying, this activity for Croce is essentially non-aesthetic.
When Croce draws his clear-cut division between image-making and

[11] Collingwood, *op. cit.*, pp. 282–85.

externalizing, he may indeed be mistaken. But whether correct or not, so far as his theory carries conviction, it puts likeness outside the aesthetic pale. Moreover, likeness does not enter into his concept of communication, since this process involves no known repetition by the spectator of the experience of the artist. Above all, the values furthered by expression do not lie in its mirroring any other values whatever. They belong unequivocally to the experience of art.

Although Croce wrote his *Estetica* when abstraction was still to come, his tenets helped establish tolerance of a theory of art by which likeness would be repudiated.

# Five

## THE HERITAGE OF ABSTRACT PAINTING

THE RETREAT from likeness so far has been gradual and virtually unconscious. Artists have continued to assume that they must reproduce natural appearances, even when expecting to modify them in the interest of heightened beauty, knowledge of the species, revelation of ideas, or simply self-expression. But the retreat becomes a self-conscious revolt in the theories and practices of artists of this century who have developed abstract painting. These paintings present simple patterns of colors and shapes without reference to appearances and values beyond the canvas. Indeed, the intrusion of any such reference is regarded as at best irrelevant and at worst an insuperable obstacle to the attainment of genuinely aesthetic ends.

In strict logic, we should turn at once to the theory of abstract painting. But in discussions of theory, abstraction seems a relatively natural outgrowth of past thinking. What makes abstraction still seem strange has less to do with its purposes than with its materials, the novel forms and colors which the painter finds ready for use, and the attitudes which he feels the need to express toward a world in which much is disturbingly new. Moreover, some of the common ways of accounting for the advent of abstraction do little to dispel confusion, and need to be studied.

Probably the most familiar of these explanations refers to the development of photography and the painter's desire not to be eclipsed by a camera. The story goes that when the camera came into general

use, the artist recognized that he was outdone at the game of likeness-making and turned to invent an art in which likeness played no part. This account oversimplifies and distorts what actually happened. First, consider the lapse of time between the early vogue of photography and the rise of abstract art. Cameras were attracting wide attention in the 1850s; no "pure abstractions" antedate the present century. While photography from the start interested artists, to be sure, not all of them responded in the same way. Some did feel that the camera would put them out of business, and were ready to exclaim with Delaroche, "Painting is dead!" Others, like Ruskin in his youth, found photographs a stimulus to new attempts to reproduce exact details.[1] The Impressionists learned from the mobility of the camera the value to a painter of free choice of an angle of vision.[2] As artists came to understand precisely what a camera does, that is, to record degrees of light and shade, they were less afraid of its rivalry. They knew that so much else, impossible for a machine, was within the scope of human beings. They could select, modify, and create form.

There was greater uniformity in the early years of the camera in a docile acceptance by photographers of fashions in painting. Almost with one accord, photographers placed their subjects in positions that recalled a painter's way of posing his models:[3] a girl with shoulders in a Greuze-like droop, a woman against a backdrop of palace and shrubbery, an old man in an armchair of architectural proportions. Robinson's print, *Fading Away* (1858), which recalls to readers of *Little Women* the death of Beth, also brings to mind the popular painting by Sir Luke Feldes, *The Doctor's Visit*. In a stage of photography closer to the beginnings of abstraction, the influence

[1] Freund, *La Photographie en France au dix-neuvième siècle*, p. 119; Wilenski, *The Modern Movement in Art*, p. 91.

[2] See below, p. 88.

[3] For admirable accounts, see the two works just mentioned and also Wilenski's *Modern French Painters*. An excellent history of photography is Beaumont Newhall's *Photography: a Short Critical History*: the following references to photographs are to plates in this book (Plates 6, 5, 31, 37, 71, 46, 47).

of painting was no less marked. The work of Man Ray, for example, shows a camera in the hands of an artist who arranges material for reproduction in an abstract design. An early experiment with motion pictures also, *The Cabinet of Dr. Caligari*, shows a taste for Expressionist painting; indeed, there are scenes that look like some of Kandinsky's abstractions. But the influence here has not been all in one direction. Painters have studied moving pictures at high speed to see the simplifying effect of movement on form. One kind of photograph, the X ray, has revealed the fresh plastic qualities of a solid object regarded as transparent.

Close cooperation between painters and photographers was cordially approved by the Bauhaus. Years earlier, the great American photographer, Alfred Stieglitz, saw his profession as an art in its own right, not a rival of painting nor an imitator, but a supplementary vehicle of expression. He encouraged both arts by opening his galleries to exhibits of modern painting.[4] His quarterly, *Camera Work*, also gave very nearly equal attention to both.

It is fair to conclude that painting and photography proved mutually stimulating; photographer and artist exchanged new kinds of effective arrangement. Moreover, the artist was moved to analyze the character of his work, to realize that likeness-making as such was not and had never been a good painter's first business. The qualifier *good* is important here. No doubt painters whose only claim was to catch a resemblance did find their occupation threatened by the less costly, speedier, and more accurate camera.

Another explanation needing scrutiny cites the influence of music: painters were impelled to paint abstractly by the nineteenth-century exaltation of music as the supreme art. Through the centuries when the art par excellence had been poetry (and poetry taken to be tragedy and epic), the painter held a mirror up to striking scenes in

[4] First exhibitions held in America (*America & Alfred Stieglitz*, edited by Waldo Frank and others, pp. 313–14): Matisse, 1908; Henri Rousseau, 1910; Picasso, 1911; Brancusi, 1914; Picabia, 1913; Negro Sculpture, 1914 (first exhibition of its kind anywhere).

drama or history. When poetry gave place to music, the painter tried to rival the composer in creating an art of "pure form." This account, though familiar and plausible, must be taken with reservations.

There is no want of abstract artists who have acclaimed music as their model. The painter should learn from the composer, they say; he should use colors so that they will affect the eye as immediately as tones affect the ear. Except in "program music" the composer has no interest in reproducing the sounds of the real world. As program music to the music of Bach, so a "speaking likeness" to an abstraction. The best painting, like the best music, must be an art of "pure form."

But consider dates again. Music had been assigned first place among the arts years before artists tried to paint abstractly. It was in 1818 that Schopenhauer gave pre-eminence to music in *The World as Will and Idea*. In 1873, a quarter of a century before painters had taken up the cudgels against likeness, Pater published his famous line, "All art constantly aspires to the condition of music." He goes on to explain that in "music . . . rather than in poetry, is to be found the true type or measure of perfected art." The superiority of music lies in its being "a matter of pure perception," in its getting rid *"of its responsibilities to its subject or material."* Painting is most like music when it can be regarded as "a thing for the eye, a space of colour on the wall, only more dexterously blent than the marking of its precious stone or the chance interchange of sun and shade upon it." Pater wrote with his eyes on painters so little abstract as the School of Giorgione.[5] He published this essay three years after Ruskin had given his *Lectures on Art*, characteristically praising art for its records of human nobility. With these famous words in his ears, Pater would seem to attack, not the overfaithful copyist but the moralizer—the critic who, like Ruskin, praises art for inculcating religious truths and ethical ideals. Pater is opposed to the reflection

[5] Pater, *The Renaissance*, "The School of Giorgione."

in painting, not of natural appearances, but of the values of the real world. Accordingly, he exalts music as the ideal art less for its non-representative character than for its immunity from censorship.

There are two other ways in which music has been taken as a model for abstract painting. One is in virtue of its immediacy of effect. Music acts directly upon the perceiver; it engenders an experience almost wholly free from associations outside its own sphere, an experience of hearing for hearing's sake. Painters have aspired to similar achievement. Again, from the point of view of the composer, music represents relations of sound that are mathematically precise. Here the composer's position seems to the painter to be enviable but not unattainable by his own art.[6]

More significant to account for a persistent feeling that abstraction is a strange way of painting is the novelty of materials presented for the painter's use. The twentieth-century artist has inherited from his predecessors, beginning with the Impressionists,[7] a range and variety of color and form that have hardly yet been assimilated.

Impressionist color was something new under the sun. Paintings by Pissarro, Monet, Renoir, and Sisley dazzled the eye. Breaking away from the tradition of academic studio paintings in which tree trunks were brown, leaves and grass green, shadows black, these artists went out of doors to see how colors appear in the light, how tones change with changes of light. Discovering how quickly light changes, they grew skillful in making hasty sketches of instantaneous effects. They tried to "recapture the innocent eye," to forget conventional statements about objects and simply to let their eyes record freshly what came to them. What they saw and set down was so out of the ordinary as to baffle the uninitiated and to bring forth criticisms that appeared self-contradictory. On the one hand, they were "mere photographers of sunshine"; on the other, they were perpetra-

---

[6] See below, p. 110.

[7] Rewald, *The History of Impressionism*, is one of the best sources of accurate information.

tors of canvases of "monstrous unreality" that "made as little sense right side up as upside down." [8] Unmoved by such charges, the Impressionists continued their tireless study. Monet painted the same object at different hours of the day, in different seasons and weathers, seeming hardly to notice or care whether what he observed was a haystack, a cathedral, or water lilies in his garden. Monet and Renoir, working side by side in Argenteuil, adopted a brush stroke that was peculiarly successful in giving their canvases the effect of dancing light. Impressionist color, like anything so novel, was heartily disliked by some critics who were ready to think the innovators quite mad. Albert Wolff wrote in the *Figaro* after the second Impressionist exhibition:

Try to make M. Pissarro understand that trees are not violet, that the sky is not the color of fresh butter, that in no country do we see the things he paints and that no intelligence can accept such aberrations! . . . Or try to explain to M. Renoir that a woman's torso is not a mass of flesh in the process of decomposition with green and violet spots which denote the state of complete putrefaction of a corpse! [9]

This was in 1876, when Kandinsky in Russia was ten years old, eleven years before Georgia O'Keeffe was born in Sun Prairie. By 1890, before those who were to make pure abstractions were old enough to notice paintings, Impressionist color had been accepted, had even become popular, and still seemed exciting.

The Impressionists taught another fruitful lesson through their indifference to subject. To a public used to pictured stories from myth and history, they offered the colors and patterns of daily life, or landscapes almost without interest in human beings. Color being the Impressionists' concern, when they did study human figures, they saw arrangements of color. Witness Whistler's title for his series of three paintings of a woman in a white dress: *Symphony in*

[8] This point and the quotations that support it appear in an excellent article, "Nature of Abstract Art," by Meyer Shapiro, *Marxist Quarterly,* I (Jan.–March, 1937), 77–98.

[9] Rewald, *op. cit.,* pp. 295, 299.

*White.* Monet, Pissarro, and Sisley found landscapes all-important. In them color, undiluted by "human appeal," could make its immediate impact and speak for itself alone.

On the debit side, Impressionists have been charged with sacrificing form, with producing a sense of satiety with color and an almost perverted hunger for solid structure. This hunger has been held ultimately accountable for painting that was form and nothing else, and indeed this account carries some weight. It is true that *form*, conceived in terms of distinct outline and solid modeling, was wanting in much Impressionist painting. It is true also that this lack drove away painters like Cézanne and Seurat, Cézanne turning to an untiring interest in defining color and plane; Seurat, to constructing objects of a rock-like weight. Furthermore, Cézanne was subsequently acclaimed as leader by many pure painters. It is a fact that in the field of art criticism, as early as 1890, Maurice Denis attacked the Impressionist formlessness and cried out for a new classicism.[10] But to take the Impressionists simply as awful warnings is to limit the conception of form too narrowly and to forget one of their notable contributions. *Form* is not confined to the delineation of objects; it includes the total arrangement of color and shape, the design of the picture space as a whole. Form in this wider sense was handled by some of the Impressionists with striking originality.

Impressionist novelty of design, especially in paintings of Degas and Monet, owed much to the combined influences of photography and of Japanese prints.[11] The photograph of a landscape could be taken from a great variety of points of view. The camera could be placed on an upstairs window ledge, focused down toward the street; it could be moved from side to side, from the front to the back of an

[10] Denis wrote that his confrères were tired of Impressionism; they wanted "an art that should be nobler, more considered, better organized, more cultivated." *Théories, 1890–1910*, p. 259.

[11] The discussion here owes much to the suggestions of Professor George Heard Hamilton of the department of the History of Art, Yale University. The paintings referred to are reproduced by Rewald, *op. cit.*, pp. 133, 258, 264.

object, with results that showed amazing differences in effectiveness. Japanese prints, newly discovered, also gave evidence of great freedom in the artist's choice of stance. Sometimes he had placed himself below a bridge; sometimes he had seen it as a diagonal dividing the picture space obliquely in a way that fascinated unaccustomed Western eyes. Furthermore, the perspective of a Japanese print was something new in its relative flatness. Remember now that the arrangement of a Renaissance painting, still popular in the middle nineteenth century, strictly followed the laws of geometrical perspective. The background was almost like a box-set on the stage, constructed by a painter who worked from a point at about the center, looking with a level gaze directly before him. How stiff, how circumscribed his position in comparison with that of the camera or the inventive Oriental! Monet had learned to climb and to flatten before he painted *The Garden of the Princess* in 1866. He gives us a more striking feeling of height in *Boulevard des Capucines* (1873). This latter painting, exhibited in the first Impressionist show of 1874, could not have failed to startle eyes used to traditional form. Degas in the same show in his *Carriage at the Races* (1873), took his stand at the lower right-hand corner of a scene, looking diagonally toward the upper left-hand corner. Degas in other paintings shows a shift from right to left; but his characteristic choice of an angle of vision would seem to be oblique, and gives an effect that is unquestionably Japanese. These examples could be multiplied indefinitely, and from the work of other Impressionist painters also. The new variety of points of view, the new flattening in two dimensions introducing variations of form that proved virtually inexhaustible, must have led to a fresh appreciation of form for its own sake and a desire to create it.

Another characteristic of Impressionist painting, extreme objectivity, merits attention. Painting what the eye sees,[12] making a faith-

[12] Cézanne said, "Monet is only an eye, but, good Lord, what an eye!" Quoted by Loran, *Cézanne's Composition*, p. 28.

ful record of sensations that were purely visual, involved ignoring the artist's personal reaction. He was not to express what he felt in the presence of nature, nor yet to choose a scene which should serve to communicate his mood. The ideal Impressionist artist was to be as detached an instrument as a camera left in a desert. Of course, the elimination of the artist's personal feelings and bias can never be complete, and not all Impressionists even tried to achieve it. Renoir, for one, made no secret of his love for the warmth and sweetness of women and children, of gardens drenched in sunshine. But by and large, Impressionism represented as extreme a withdrawal from the personality of the artist as from a "great subject." A painting was to stand alone, recording an experience that was strictly visual, and presumably communicating to the observer an experience similarly limited. This austerity seemed an outrage to artists who needed to find in painting an outlet for their feelings, who indeed claimed that painting denied its very nature if it failed to be expressive. They were confident that colors made an immediate impact not only upon the eyes but upon the emotions of the observer. They turned to study color in its direct emotional effects and eventually contributed to the research of such an abstract Expressionist as Kandinsky.

When the Impressionist painter focused attention on the vision of his physical eye, he obviously wanted to paint no more than things as they looked on the surface. Appearances were his reality. He was no mystic, seeking spiritual vision. While his attitude delighted the scientifically minded, he seemed a crass materialist to romantic souls. Their reaction to Impressionism was to demand an art in which color and form were symbols bringing insight into a higher reality. This was a demand of Gauguin's, echoed eventually by Kandinsky and Mondrian.

So much for the long-range legacy of Impressionism to abstract painting: an interest in color for its own sake, an awareness of effective new ways of arranging picture space, an example of inexhaustible

research rewarded by fresh vitality in painting. Add also the stimulus of dissatisfaction with weaknesses: lack of firm local form, denial of individual expressiveness, absence of spiritual depth. Before these influences, positive and negative, reached the present century, they had passed through the minds and hands of the artists loosely called "Post-Impressionists."

The name was given by Roger Fry when he helped arrange the first exhibition in England of these artists' work.[13] The group included painters as individual as Cézanne and Seurat, Gauguin, Rousseau the Douanier, and Van Gogh. What they had in common was little more than the desire to improve on some aspect of Impressionism. The first three—Cézanne, Seurat, and Gauguin—have been discussed with Degas and Renoir as significant contributors to a renaissance of Classicism, in a study by Robert Rey. Rey points out that these artists had reacted against an ephemeral quality in Impressionism, and had shown a "unanimity of effort toward composition, order and poetry." While the Impressionists sought to "fix on the canvas the freshness of dawn, the rustic grace of a field where one goes strolling, the touching vacuity of a child's look in the sun," the other group tried to record what was more enduring: to "arouse in the spectator an emotion independent of the limits of a particular time, place or subject." Rey stresses the difference: "A painting with classic inspiration is as unlike an Impressionist painting as a house . . . is like a field." Indeed, an architectonic quality is essential to Classicism: the "painter animated by classic sentiment is a kind of architect." [14] These definitions apply with special force to Cézanne and to Seurat, whose work shows similar strength of structure. But Degas, Renoir, and Gauguin also, each in his own way, relieved the hunger for form which Impressionism did not satisfy. Furthermore, they created form so original as to attract attention to itself, to make

[13] Virginia Woolf, *Roger Fry; a Biography* (New York, 1940), p. 153.
[14] Rey: *La Renaissance du sentiment classique dans la peinture française à la fin du XIXe siècle*, pp. 137, 135, 4, 6.

clear that in itself it aroused an experience that had nothing to do with the subject and that brought its own peculiar satisfaction.

Among the Post-Impressionists, Cézanne stood out at the beginning of this century as the idol of younger artists who "discovered" him after his years of solitary work. One particular group of admirers was recorded by Maurice Denis in a painting of himself and six other men [15] gathered before a still-life of Cézanne's: the title *Hommage à Cézanne*. Exhibited first in 1901, it now hangs in the Louvre. Roger Fry's discovery of Cézanne and his crusade to make the painter known in England are commonplaces of recent art history. Cézanne's influence reached far, but has sometimes been misunderstood. Cézanne has sometimes been hailed mistakenly as a John the Baptist of abstraction. The truth of the matter is that when he reacted against the Impressionists he did not preach withdrawal from nature; quite the contrary. These points are established by his own letters and by the comments of Ambroise Vollard.[16]

Cézanne's feeling that his former colleagues in Impressionism were on the wrong track made him sympathize, oddly enough, with the Emperor William II, who had pronounced an interdict against them. "He's right," cried Cézanne, "everybody's going crazy over the Impressionists; what art needs is nature made over according to Poussin. There you have it in a nutshell!" [17] Again and again he urged the artist to study nature. He wrote to Émile Bernard, "But I must always come back to this: painters must devote themselves entirely to the study of nature." [18] He said in criticism of a painter, Gustave Moreau, that he had spent too much time in the museums; what he needed was "contact with Nature."

Cézanne made clear that his devotion to nature was not in the least subservient. The artist was man added to nature: *homo additus naturae*. Cézanne wrote to Bernard, "One is neither too scrupulous

---

[15] Wilenski, *Modern French Painters*, p. 166; the group of painters: Redon, Bonnard, Vuillard, Roussel, Serusier, Denis, Vollard.

[16] Vollard, art dealer and author of *Paul Cézanne; His Life and Art*.

[17] Vollard, *op. cit.*, p. 105.                [18] *Letters* (ed. John Rewald), p. 236.

nor too sincere nor too submissive to nature; but one is more or less master of one's model, and above all, of the means of expression."

To "see nature" was, for Cézanne, nothing like the immediate impact of color on an "innocent eye," praised by the Impressionists, but a laborious process of comprehending forms which he found very complex and puzzling.

I am progressing very slowly, for nature reveals herself to me in very complex forms; and the progress needed is incessant. One must see one's model correctly and experience it in the right way; and furthermore, express oneself forcibly and with distinction.[19]

This process of seeing had a new quality. Cézanne was not inspired by nature, but looked to nature for forms that would express what was in his own mind. The contrast between his attack and that of the Impressionists is described by Ozenfant:

While the Impressionists were translating the sensations that came to them from without, Cézanne was seeking in nature's vocabulary the means of expressing his interior world: something very different therefore. Cézanne chooses from nature what best expresses Cézanne.

. . .

Cézanne supplied the spirit and the method, and that spirit was so rich that every artist since has been in his debt. A conception new in the twentieth century: *painting as independent of exterior reality.*[20]

In a sense it might be said of virtually every artist that he "chooses from nature what best expresses" himself. The novelty in Cézanne's choosing was that it was not a half-conscious selection of a scene that harmonized with his mood, but an agonized searching for appropriate means of externalizing his vision. Cézanne describes the artist's need to find images for his personal experience:

Let us go forth to study beautiful nature . . . let us strive to express ourselves according to our personal temperaments. Time and reflection,

[19] Vollard, *op. cit.*, pp. 100, 50; *Letters*, pp. 237, 250.
[20] Ozenfant, *Foundations of Modern Art*, pp. 61, 70.

moreover, modify little by little our vision, and at last comprehension comes to us.

Now the theme to develop is that—whatever our temperament or power in the presence of nature may be—we must render the image of what we see, forgetting everything that existed before us. Which, I believe, must permit the artist to give his entire personality whether great or small.

It has seemed worth while to quote at some length from Cézanne to make clear that he never intentionally "abstracted." He might have been surprised at his reputation for inspiring the near-abstractions of Cubism. Certainly his statement often quoted as a slogan for the school justifies no such use when read in context. He simply urges painters to plan their perspective with the utmost care when he writes:

May I repeat what I told you here: treat nature by the cylinder, the sphere, the cone, everything in proper perspective so that each side of an object or plane is directed toward a central point.[21]

He is not recommending the simplification of natural forms into cylinders, cubes, and cones. But there is no doubt that he did stir the Cubists and other younger artists by his courage in working alone and in seeing for himself, and by his use of nature as a source of forms to express his inner world. The logic of this last point, carried to extreme consistency, eventually led some of his followers to claim for painting a total independence of external reality.

While Cézanne's words have had their influence, his actual practice opened men's eyes to a kind of subject that had hitherto received little attention, still life, and above all, to a distinctive use of color and form.

Still life before Cézanne had been rated low by French painters, partly because the Academy had placed it at the bottom of the hierarchy of "kinds" submitted for prizes—the highest being history painting, the second rank including portraits, landscapes, and genre. Chardin alone before Cézanne had achieved monumental effects

[21] *Letters*, pp. 251, 254.

with still life. One of Chardin's paintings of glass bottles, a sign-board to hang outside an apothecary's shop, impressed Roger Fry so profoundly that he likened his reaction to his feeling for Michelangelo's frescoes of the Creation in the Sistine Chapel.[22] This was after Fry had learned from Cézanne how still life should be regarded. It is obvious that apples and bottles tell no story, have little or no value except as patterns of color and shape, but this limitation is precisely what endows them with importance for a painter whose passion is form. They are almost as far withdrawn from non-pictorial concerns as *pure painting* itself.

What was Cézanne's distinctive way of constructing form? His method was very different from the Impressionists'. Where they made quick sketches of momentary effects of color in light, Cézanne studied a landscape or a model through innumerable sittings until he saw what was permanent and abiding. This he recorded through a complex and subtle organization of planes and colors so arranged as to fill and balance the picture space as a whole, and to create an internal equilibrium that held the eyes. There were no lines or volumes that carried the observer's imagination away from the picture space. Each painting was a little world in itself.

Cézanne's composition has been studied minutely by an American painter, Erle Loran, who explored the countryside of Aix-en-Provence to identify and photograph the scenes that had provided Cézanne with some of his motifs. Reproducing photograph and painting side by side, Mr. Loran shows graphically how Cézanne used his material, how faithfully he retained some aspects of his originals, supplementing them with such colors and shapes as seemed required by the whole composition. In this whole, the space between objects played an important part. This was something relatively new, and in harmony with principles of the new architecture of "space expression." Cézanne abandoned scientific perspective, that is to say, he had no concern for convergence of lines toward a

---

[22] Fry, *The Artist and Psychoanalysis*, p. 16.

vanishing point, or for diminishing the size of objects in the distance. The scale of objects he determined, not by their distance from the spectator, but by their formal relation to other motifs and by their emotional significance. An object associated with very little feeling would be small even in the foreground of a picture. He disregarded the usual demand for a single standpoint for the artist and observer, and drew from several eye levels and from different points of view. He made no use of the aerial perspective beloved of the Impressionists, namely, the fading away of distant hills and mountains. In a painting of his mountain, Ste. Victoire, the color at the summit might be quite as clear and bright as that of an object in the foreground.

Cézanne found his own way of creating a new and exciting illusion of space which was as vibrant with incipient movement as Impressionist color had been dazzling with light. The Impressionists had observed that local colors were altered by juxtaposition; Cézanne observed that something similar happened to forms. Objects placed together set up tensions of forms in the artist's visual experience, tensions requiring distortions for their recording. These distortions, balancing each other, created a lively kind of equilibrium. Take for example a painting of a jar and a plate of apples; the side of the jar away from the mass of apples is swollen, while the side near them is contracted, as though the jar were trying to escape from the apples. The two shapes balance so well that the distortion seems an inevitable element in a pattern that is anything but "still."

Equally striking was Cézanne's use of form and color inseparably. He modeled objects with planes of color. He "modulated a volume from its cool dark side to its light warm parts in chromatic nuances— a series of steps or planes." As Cézanne himself said, "Drawing and color are not separate. . . . During the process of painting one draws." He used colors with some regard for those he found in nature —Mr. Loran says that his paintings are drenched in the characteristic tones of the Provence country—but having chosen a particular red

in a landscape, Cézanne lets balance and harmony guide his further choice, and creates "an abstract orchestration of warm and cool, light and heavy, saturated and neutral elements of color, transcending the appearances of the objective world and giving us a new vision, a new reality." [23] Whether Cézanne painted apples, a mountain, or a human figure, he was constructing an arrangement of color and form complete in itself, a kind of abstract design.

As Cézanne conspicuously rejected the Impressionist imperfections of form, so Gauguin and Van Gogh were dissatisfied with their restricted use of color, simply to record effects on the eye and not to express the artist's emotions. Gauguin and Van Gogh took little interest in the light coming from objects. Their concern was to make color the source of a moving spiritual experience.

For Gauguin, colors rightly used became expressive, not through associations, but in themselves. This meant that when he wanted to revive the joy of a scene, he did not try to reproduce its particular greens or blues in the hope that they might recall the effect of their original. Rather, he searched for such colors as gave him immediately an equivalent joy. The colors with greatest power to move he found to be pure: violet, vermilion, green, each as it came from the tube. "How do you see this tree?" Gauguin had asked in a corner of the Bois d'Amour. "It's green, isn't it? Then paint it green, the most beautiful green on your palette. And the shadows there. Aren't they blue, above all? Then don't be afraid to paint them as blue as possible." Every work of art for Gauguin was "a transposition, a caricature, the impassioned equivalent of a sensation." Colors served to suggest what was beyond immediate visual experience. It followed that to work directly from a model was unnecessary, not to say hampering. A model was for periods of study, but when creation began, the artist must concentrate upon the vision of his inner eye. "It is good for young people to have a model," wrote Gauguin in 1888, "but let them draw the curtain on it while they are painting!

[23] Loran, *Cézanne's Composition*, pp. 28, 31, 32, 25, 129, 131.

Better paint from memory; then your work will be your own. Your sensation, your intelligence and your soul will live again in the eye of one who loves your painting." [24]

Gauguin's patterns of color were hardly more moving to the spirit than pleasing to the eye as decorative design. Their double effectiveness gave some critics a new notion of "decoration" as an aspect of art that should be belittled no longer. "Mere decoration" had been a common term of abuse (and continues to be so in some conservative circles). One early critic who learned from Gauguin to take decoration seriously was André Fontainas. On this point, though not on all other matters artistic, the two saw eye to eye. Fontainas wrote of Gauguin's work:

What impresses the beholder at once is the careful study of arrangements in his canvases, which are primarily decorative. The landscapes that compose their profound, subdued harmony are organized not so much for crude picturesque effect as for the purpose, almost always achieved, of creating warm, brooding well springs for the surging emotions.[25]

Van Gogh also in his writings and paintings helped to carry conviction that color had a strongly moving force. He wrote:

It is color not locally true from the point of view of the stereoscopic realist, but color to suggest any emotion of an ardent temperament.

When Paul Mantz saw at the exhibition the violent and inspired sketch of Delacroix . . . the "Barque of Christ"—he turned away from it exclaiming: "I did not know that one could be so terrible with a little blue and green." . . . Well, if you make the color exact or the drawing exact, it won't give you sensations like that.[26]

Both Van Gogh and Gauguin gave life to the interest in experiment-

[24] Chassé, *Le Mouvement symboliste dans l'art du XIXe siècle*, pp. 75, 76, 73. (Translation mine.)

[25] Gauguin, *Letters to Ambroise Vollard and André Fontainas*, ed. Rewald, p. 19. The quotation is from a letter by Fontainas that was published in the *Mercure de France*, January, 1899.

[26] *Further Letters of Vincent van Gogh to His Brother, 1886–1889*, Summer, 1888; Letter 504.

ing with color which led the Synchromists and Kandinsky to try to work with color alone.

On the side of theory, Gauguin corrected Impressionism in the light of doctrines which he shared with his contemporary poets, the Symbolists. He knew the Symbolist leader, Stéphane Mallarmé, well enough to make his portrait in etching, and to grieve at his death, calling him a "martyr of art." The two men may have influenced each other, or they may simply have been sympathetic spirits reacting alike to conceptions of art that were in the air. These conceptions showed the strong influence of Schopenhauer.[27]

For Schopenhauer, reality lay beyond the physical world in Platonic Ideas. The artist's function was to see these Ideas and to communicate his insight. Music, which communicated Ideas most directly, stood supreme among the arts. Schopenhauer's writings became known in France through Ribot's study, published in 1874, and through Burdeau's translation of *The World as Will and Idea* which appeared in 1888. *La Revue wagnérienne* also, from 1885, began to spread Schopenhauer's doctrines among the younger generation, as Edouard Dujardin has pointed out. Schopenhauer taught young artists to look for reality in dreams, and to try to express the "unconscious," the "night side of the soul." Music and the symbol they took to be the effective means of expressing the subconscious.[28]

In this vein, Gauguin regarded color as a kind of music, pointing out that both color and sound made a direct impact on the senses. He wrote: "Think . . . of the musical role color will henceforth play in modern painting. Color, which is vibration just as music is, is able to attain what is most universal yet at the same time most elusive in nature, its inner force." A painting should not be explained, but should be allowed to make its own effect: "My dream is intangible, it comprises no allegory; as Mallarmé said, 'It is a

[27] For an enlightening, documented account of the relations between Gauguin and Mallarmé, see Chassé, *op. cit.*, Chap. IV.

[28] Arthur Symons, *The Symbolist Movement in Literature* (London, 1899); Charles Baudouin, *Psychoanalysis and Aesthetics* (London, 1924).

musical poem, it needs no libretto.' " [29] Mallarmé in turn cites a parallel from music when he gives an account of the aim of his group, variously called Decadent, Mystic and finally, Symbolist:

> Decadent and Mystic . . . adopt as their meeting place the stand-point of an Idealism which (like fugues, like sonatas) rejects natural materials and an exact thought ordering them as too brutal—to keep nothing except suggestion . . . Abolished the attempt, aesthetically wrong even though it rules some masterpieces, to hold within the subtle paper of a book anything except the horror of the forest or the silent thunder scattered among the leaves: not the wood, intrinsic and dense, of the trees.[30]

Mallarmé was "a painter who wished to paint the face of thought."

Gauguin and Mallarmé both put into practice Schopenhauer's belief that the only spiritual well-being lay in escape from everyday reality. Gauguin's flights to the South Seas were hardly more complete withdrawals from contemporary Paris than Mallarmé's carefully cherished solitude. Though he had to earn his living as professor in a lycée, after hours he made his own little Tahiti in his apartment on the Rue de Rome. There "only initiates were admitted, and he talked in monologue as if he had been on a desert island." He rarely put in an appearance at the cafés where other poets and artists delighted to meet.

In spite of the depth of sympathy between Gauguin and Mallarmé, they stood at opposite poles in one point, their taste in color. The poet's preference was for white; he liked to describe snow, swans, lilies, frozen lakes, a virgin sheet of paper. Gauguin's liking for gorgeous colors, intense and unmixed, produced canvases that left Mallarmé stunned. In an admirable account of the relations between the two men, Charles Chassé tells how Mallarmé came away from the Gauguin exposition of 1893, asking how it was possible for a painter to combine such mystery with such violence.[31]

[29] Gauguin, *Letters*, pp. 22, 23.
[30] Mallarmé, *Divagations*, p. 245. (Translation mine).
[31] Chassé, *op. cit.*, pp. 86, 76.

Mallarmé's death in 1898 put the Symbolist literary movement into eclipse, but the principles he shared with Gauguin lived in the paintings of the Fauves and the Cubists. They abjured "all direct transcriptions of nature, all copies of reality, to admit only decorative interpretations, arbitrary transpositions, syntheses of lines and of colored planes harmonized according to the free will of the imagination." [32] It is significant that one expounder of Cubist aesthetics, Guillaume Apollinaire, had been associated with the Symbolists. He claimed that the aim of painting was to provide a source of insight into spiritual reality.

The Cubists, following the Fauves, were the immediate influences on abstraction in France. These were not two mutually exclusive groups. Some painters who were Fauves in their youth turned to Cubism later on—among them, Derain and Braque. On the other hand, each had a special allegiance—the Fauves to Gauguin and, in lesser degree, to Van Gogh; the Cubists to Cézanne. The Fauves stressed color and a violent expressiveness; the Cubists were intellectualists, preoccupied with form. The two were the Romantics and Classicists of their period. Each had descendants among the schools of pure abstraction, though individual artists owed much to both. Kandinsky, for example, was expressionist in his "soft" and most characteristic periods, and recalled Cubist preoccupation with geometry when he became temporarily "hard." Mondrian, on the contrary, showed an unmixed Cubist ancestry.

Exuberant brightness of color and what seemed wildly exaggerated distortion marked the paintings of the Fauves, who first came to public notice in the Salon d'Automne of 1905. Their gallery of paintings was described as a *cage des fauves* (cage of wild beasts) by the critic, Louis Vauxcelles, and the name stuck.[33] With Matisse as their leader, they took Gauguin and Van Gogh as masters, and became intoxicated with color and freedom. Their

[32] Mauclair, *L'Art indépendant*, pp. 94, 130.
[33] Wilenski, *Modern French Painters*, p. 213.

new use of distortion came partly from the "discovery" of the aesthetic quality of Negro sculpture. Its free adaptation of natural forms and heightened intensity "spoke to their condition." It gave them what Japanese prints had given the Impressionists, a new way of seeing, a fresh impetus to try out their material in new ways. In spite of what seemed their absurd extravagance, or perhaps because of it, they contributed to the spirit of independence that was in the air. They proclaimed that no limit should be set to experiments in painting other than those dictated by an artist's own taste and vision. Interest in the Fauves as a group was short-lived. Their novelty having paled before the more striking innovations of Cubism, individual Fauve artists outgrew their early wildness and helped to develop the more disciplined new school. The Cubists, a more articulate group, had the the advantage of apologists to explain and defend them.

But before Cubism came on the scene, at about the time when the Fauves were seeking violent expression in Paris, a trio of young painters [34] in Dresden showed a like impulse. They called themselves *Die Brücke* (The Bridge), and were known as Expressionists. Like the Fauves, they found inspiration in the primitive art of Africa and the South Seas, and in Gauguin and Van Gogh. According to Robert J. Goldwater's excellent study, *Primitivism in Modern Painting*, the German group went beyond the Fauves in accepting Primitivism as the attitude toward life that should be embodied in their painting. They denounced civilized life for its superficiality, and "went native" in order to penetrate into what was solid and real. Human nature in the remote wilds they took to be real, though they found it rough and unpleasant, and expressed their distaste in harsh contrasts of "unnatural" color.[35]

A second group of Expressionists, *Der blaue Reiter* (The Blue

[34] Kirchner, Schmidt-Rottluff, and Heckel; see Barr, *German Painting and Sculpture*, p. 10.

[35] My account is based on Goldwater, *Primitivism in Modern Painting*, pp. 98–99.

Rider),[36] was organized in 1911 in Munich, including Kandinsky among its founders. This group also acknowledged Primitivist influences. Kandinsky with Franz Marc published a manifesto [37] which paid tribute, through its illustrations, to Chinese paintings, statues from South Borneo and from Easter Island, children's drawings, a Malayan woodcarving, a mosaic from Saint Mark's in Venice, Russian folk art, and paintings by Picasso, El Greco, DeLaunay, Cézanne, and Matisse. The two Expressionist groups drew attention to the intensified power over the emotions of strong colors and simplified and distorted forms. It was not surprising that some of them later took to painting abstractly.

The Cubists marched in the vanguard of revolutionary painting in the years before the first World War. The name Cubist, first applied by Henri Matisse as a joke, was accepted for the group by Guillaume Apollinaire, when he wrote the preface to the catalogue of their first exhibition outside France, held in Brussels in 1911.[38] Apollinaire, poet-journalist closely associated with the Cubist painters, helped them to gain recognition and also to formulate their theory of painting.

While willing to be called Cubists, these painters were less concerned with cubes than with arrangements of planes. They owed much to Cézanne's new use of planes, though they developed their own distinctive style. They deliberately abstracted from nature, as Cézanne had not done, and used two different methods. The first was analysis: the artist had an original—an object, figure, or landscape—which he broke up into planes, arranging them in an expressive design. The second method was construction: the artist had no original in nature, but built up an object that existed in its own right, using as his materials bits of recognizable forms—violins, letters of the alphabet, and such—and also actual pieces of paper

[36] Barr, *op. cit.*, pp. 10 and ff; Goldwater, *op. cit.*, pp. 102 and ff.
[37] I saw the second German edition, 1915.
[38] Apollinaire, *The Cubist Painters*, p. 14.

and fabric which he pasted on his canvas. This pasting (*collage*) was a symbol of the independent reality of a painting; it *was* an object, not a likeness but a real thing. The two methods represent two very different meanings of abstraction: withdrawal from nature, and independent construction. The latter, carried to the logical conclusion that the painter should work in complete independence of all recognizable forms, led to pure abstraction. Both methods are illustrated in familiar paintings by Picasso. What has been called the first Cubist picture was his *Demoiselles d'Avignon* (1906-7) which may have been suggested by one of Cézanne's bather paintings. Picasso's analysis of objects into planes is apparent here, but grows more pronounced in *Woman with a Mandolin* (1910), where the objects have all but disappeared. His *Standing Figure* could hardly be identified without the title. He used new Cubist techniques in 1911-12, introducing letters of the alphabet and collage as in *Still Life with Chair Caning*.[39]

Preoccupied with form as the Cubists were, it is not surprising that they did little that was startling with color. Their color range was muted, if not somber, returning to the browns and grays rejected by the Impressionists. The point to note here is that Cubist color bore virtually no relation to the natural color of the objects analyzed. The Cubist painter selected his colors solely for their relations to each other and to his conception. He bequeathed to abstraction the results of research in color that was completely free, as well as in form that was all but cut off from representation.

Materials so new that the twentieth-century artist is only beginning to understand them are the plastics of varied textures, the transparencies, the devices for "painting with light" and for setting myriad shapes in motion. The artist can now paint with a spray gun or a brush as he chooses. Moholy-Nagy was one who rejoiced in all these fresh sources of aesthetic effect, and urged artists to tap

[39] Paintings mentioned here are reproduced in Barr, *Picasso; Forty Years of His Art*.
[40] *The New Vision; and, Abstract of an Artist*, pp. 74-75.

them to the full.[40] A wealth of fascinating forms has been added to the painter's riches from the machinery by which we live surrounded. To mention only the most common: automobiles, stoves, refrigerators and vacuum cleaners, radios and telephones, bicycles, locomotives, ships, and airplanes. Each is in itself a geometrical pattern of straight lines and accurate curves, of wheels, cylinders, disks, and bars. Our eyes have grown sensitive to these forms; we have a background for enjoying them in art. This point is made by the French painter, Amédée Ozenfant: "Our senses are accustomed to scenes where geometry reigns; our very spirit, satisfied to find geometry everywhere, has become rebellious against aspects of painting that are inconsistently geometrical." [41] Machines in general have taught us an extended new visual language. Certain particular machines have brought into existence forms that surprise and delight the artist's eye: the X ray showing overlapping transparencies; the motion picture and speeding cars and planes presenting curious distortions.

The dominance of machinery in the modern world, and of the sciences, mathematics and physics, which have made machines possible, add to what have not always been recognized as painter's "materials"—current emotions and attitudes which strive for expression in art.

Physics and mathematics, unlike biology, make human life seem relatively unimportant. For the biologist, the human animal is a particularly complex and fascinating form of life. Even though the theory of evolution dethroned man from his status as God's immediate handiwork, it left him at the pinnacle toward which all creation had been moving through the ages. Physics and mathematics have no such exalting effect. What is man but a speck in a universe of astronomical space and time! When these sciences are in the saddle, the artist may express dehumanized values through forms that do not recall human life, and particularly through the forms of geometry.

41 Ozenfant and Jeanneret, *La Peinture moderne*, pp. 166–67.

One new scientific concept known to have excited the imagination of the Cubists in the early 1900s was the fourth dimension, space-time. The Cubists were painting precisely this, according to Guillaume Apollinaire.[42] They depicted objects from several points of view simultaneously, as though seen from above, below, inside, and outside at the same moment. The result: to add to the three dimensions of Renaissance painting a new one, time, and to construct forms so far removed from the usual appearances of objects as to be, for most observers, abstract. A younger artist, Moholy-Nagy, also recognized the emotional stimulus of the new concept: "Whether we use rightly or wrongly the terms 'space-time' or 'motion and speed,' they designate for us a new dynamic and kinetic existence freed from the static, fixed relationships of the past." [43]

Another new idea in science was a frightful blow to one artist, Kandinsky—the discovery in 1904 by Rutherford and Soddy that the atom was not indestructible. Kandinsky tells us that he felt the world falling to pieces because his confidence in science as a source of intellectual certainty was shattered. Scientists had given the atom a name which meant that it could not be divided. They had been wrong. They could no longer be trusted. So Kandinsky rejected science and, with it, materialism, and art representing material objects. He turned to the realm of spirit for his personal security, and to the painting that seemed least earth-bound—abstraction.[44]

Machines, with their increasing power and importance, have been storm centers of very different emotions. Hated at first as a menace to the security of workingmen and to established values of civilized life, feared for their superhuman power to crush feeble flesh and bone, they have also been adored as instruments for national aggrandizement and revered as symbols of a civilization freed from

[42] *The Cubist Painters*, p. 12.
[43] "Space-Time Problems in Art," in Morris, ed., *American Abstract Artists*.
[44] See below, p. 129.

hard labor. These and other feelings toward machines have appeared in art, at first in art that was far from abstract.

William Morris and his brother Pre-Raphaelites saw machines as enemies of what was fine and sensitive in human life, and as a vulgar threat to delicate individual craftsmanship.[45] The machines they knew were in the clumsy stage before the day of precision instruments. William Morris proposed to meet a bad situation by retreating from it into the Middle Ages. Hence paintings like tapestries, furniture and textiles made by hand, the arts and crafts movement, and the revival of medieval architecture. There is an ironical propriety in finding one of the best collections of Pre-Raphaelite painting as a little oasis in the industrial city of Birmingham.

A more subtle antagonism toward machines springs from the conviction that they are antithetical to the flexible, free adaptation of the life force. This is Bergson's position. In his analysis of laughter, he finds the characteristically comic in a human being who behaves like a machine—rigid, inelastic, automatic. We laugh when we see "something mechanical encrusted on the living." [46] Our laughter chides the person who is acting like a thing, warns him that he is for the moment alienating himself from society, even from life itself, which requires its creatures to be supple. Laughter is society's instinctive weapon against slight encroachments of the mechanical, catching them before they have gone so far as to be sinister. Bergson's position here lends strength to the artist who finds machines a portent that terrifies. This feeling is expressed effectively in one of Orozco's murals at Dartmouth College. It has been made famous in the theater in Capek's play, R.U.R., portraying mechanized men, powerful, unfeeling and destructive.

Fierce love of machinery for its superhuman strength characterized the Italian painters who developed Futurism. They gloried in the power and beauty of a great engine, and took it as a symbol of

[45] J. W. Mackail, *Life of William Morris* (London, 1899).
[46] Bergson, *Laughter*.

ruthless irresistible conquest by supermen. See their Manifesto of
1909:

A Racing Motor-Car, its frame adorned with great pipes, like snakes
with explosive breath, a Roaring Motor-Car which seems to be running
on shrapnel—is more beautiful than the Victory of Samothrace.

.   .   .

We shall sing of great crowds in the excitement of Labour, Pleasure, or
Rebellion; of the nocturnal vibration of arsenals and workshops beneath
their electric moons; of greedy stations swallowing smoking snakes; of
factories suspended from the clouds by strings of smoke; of adventurous
liners scenting the horizon; of broad-chested locomotives galloping on
rails—giant steel horses bridled with long tubes; of aeroplanes with screws
whose sound is like the flapping of flags and the cheers of a roaring crowd.[47]

Observe that Futurism developed at a time when Italy had lagged
behind many countries in methods of manufacture and was rela-
tively unimportant politically. To the Futurists, machines were
symbols of the kind of progress needed to ensure economic success
and nationalistic prestige. Their painting was only one element in
a movement for social reform which rejected Italian complacency
toward the past, and pushed forward toward Nietzschean glory.
They expressed what they took to be the potential value of machines
in their immediate social environment. This is what painters in
other countries also have tended to do, according to Meyer Shapiro.
He points out that mechanical [48] abstraction developed early, not in
the highly industrial countries where machines were taken for
granted, such as England and the United States, but in those that
were at the time less advanced, like Italy, Russia, Holland, and
France. The style appeared in Germany in the years of industrial
difficulties after the first World War.

Pleasure in the smooth efficiency of a machine, satisfaction in its
"functionalism," are relatively recent attitudes belonging to the

[47] Wilenski, *Modern French Painters*, p. 223.
[48] "Nature of Abstract Art," pp. 94–95.

period when the once alarming monster has grown meek and tame, even domesticated. The artist now delights in the visible mechanical economy of means to ends. Indirectly, this pleasure in functionalism has affected painting by way of architecture.

In the 1890s, in Brussels, a man who was to become a distinguished architect, Henry van de Velde, saw in machinery the perfect adaptation of means to ends that should serve as the ideal in architecture. Buildings should be machines for living, constructed of new materials to meet new needs. He felt strongly that architecture as it existed, in eclectic styles all gimcracks and falseness, was not only inefficient and ugly; it was positively immoral. He wrote of the situation in 1890, "The real forms of things were covered over. In this period the revolt against the falsification of forms was a moral revolt." His moment of supreme revulsion came when he wanted to marry and could not face the horror of a typical house of the period. He declared he would never allow his wife and family to find themselves in "immoral" surroundings. Accordingly, he designed a house for himself, including everything from cutlery to doorknobs, and made what we should still call today a modern house, though built in 1896. One of the means of freeing architecture from evil was to do away with all ornament, for ornament was the root of all sham. Van de Velde helped to strengthen the new aesthetics that demanded purity, "pure forms and objects shorn of ornament." [49]

What was said in Brussels in those years carried weight because that city had become a recognized center of new styles of art. In the eighties it had been the one place "in the entire cultural world that gave a welcome to artists despised elsewhere," such as Seurat, Cézanne, and Van Gogh. So the new aesthetic Puritanism in archi-

[49] On Van de Velde, see S. Giedion, *Space, Time and Architecture* (Cambridge, Mass., 1941); Osthaus, *Van de Velde Leben und Schaffen des Künstler*; his own contribution to a discussion of "L'Architecture contemporaine en regard des architectures du passé," in the proceedings of the Fifteenth International Congress of Architects, to have been held in Washington, Sept. 24–30, 1939, *Report*, I, 149–56.

tecture was bound to be widely known and to affect other arts. Paint-
ers, learning that deference to past traditions in building was im-
moral, that beauty resided in form perfectly adapted to function,
might naturally look to their own need of a similar purge and re-
direction. Here is a root of the new love of functionalism and purity
that has expressed itself in abstraction: "Pure painting should do
what it alone can."

One machine, the precision instrument, has inspired some art-
ists with the ambition to construct paintings that are as calculable in
their effects as this delicately exact mechanism. Ozenfant attributes
this aim to his school of painting, Purism. The Purist painter uses
geometrical forms because they move all men with a scientific exact-
ness that can be measured. With these forms he can "create a picture
like a machine." [50] Another painter, Hilaire Hiler, admits a like
hope of painting scientifically, taking from chemistry a new palette
of brilliant colors, and from psychology and optics the measure-
ments of the impacts of colors and forms on the eye and the emo-
tions. With an assimilation of all this new data, an artist who suc-
ceeds also in freeing himself from an emotional, subjective attitude
and in becoming as rational as a scientist can hope to paint with com-
plete precision. Painting "should be as precise as the architecture
and industrially designed objects which surround us. The form exact
to a tiny fraction of an inch. . . . Color relationships must share
the accuracy of form." [51] Both Ozenfant and Hiler show a touch-
ing faith in the application of science to art, not yet justified by
the outcome. These attempts to translate the qualities of art
into mathematical quantities offer a modern parallel to the old
search for the Pythagorean Analogy and for tables of perfect pro-
portions.

What attitudes toward other aspects of modern life may have
found appropriate expression in abstraction? A sense of alienation

[50] Ozenfant and Jeanneret, *La Peinture moderne*, pp. 166–67.
[51] *Why Abstract?* pp. 60–61.

from the physical world; the spirit of revolt against the established social order.

Housman speaks poignantly for the alien spirit:

> I, a stranger and afraid
> In a world I never made.

This feeling of estrangement and fear is as old as human consciousness. It has appeared over and over, and in painting it has characteristically found expression in abstraction. The point is made by Wilhelm Worringer and his English interpreter, T. E. Hulme. Worringer cites evidence from primitive and Oriental art, both dominated by the expression of fear. Primitive man, says Worringer, has reason to be afraid of a world he can not understand. He creates art as a means of magic: it is "an exorcism and negation of life," a "refuge in the inanimate."

He begins with the rigid line, which is essentially abstract and alien to life . . . its freedom from representation he dimly realises . . . to be a part of an inorganic order superior to all that is living. He seeks further geometrical possibilities of line, creates triangles, squares, circles, places similarities together, discovers the advantages of regularity, in short, creates a primitive ornament which provides him not only with a mere delight in decoration and play, but with a table of symbolic absolute values, and therefore with the appeasement of his condition of deep spiritual distress.

Oriental art also springs from fear of the world.

It expresses no joyful affirmation of sensuous vitality, but belongs rather entirely to the other domain, which through all the transitoriness and changes of life strives for a better world, freed from all illusions of the senses, from all false impressions . . . The Art of the East, like that of primeval man, is strictly abstract and bound to the rigid, expressionless line and its correlate, the plane surface.[52]

This desire to escape through abstraction contrasts with the Greek

[52] Worringer, *Form in Gothic*, pp. 17, 45. (Reference is to the authorized English translation, 1927; first German edition, 1907).

love of life, appropriately expressed in naturalism. The Greeks in their great period were in a state of spiritual equilibrium, completely at home in the world of nature, eager to reproduce its forms in art, to experience through this second nature the pleasure of heightened vitality. In the present century, a shift in world view from the Greek to one nearer the primitive and Oriental has introduced a change in European art and taste.

If Worringer is right, he helps to explain the "discovery" of art in traditions that have never stressed likeness, the African and Polynesian. As men's feelings toward the world changed, they became sensitive to a different kind of plastic form. They "discovered" not objects newly imported, but the aesthetic quality of familiar curios, no longer misclassified as naïve and unskillful. Now these same objects suddenly seemed intensely expressive and admirably contrived by men who in their time and place had anticipated twentieth-century European alienation from the physical world. This "discovery" was made almost simultaneously in Germany by Kirchner of Die Brücke and in France by the Fauves in 1904. Three years later, in 1907, Worringer published his book, and in the same year Picasso completed what has already been referred to as the first Cubist painting, *Les Demoiselles d'Avignon*. Surely the *Zeitgeist* noted by Worringer was manifesting itself in the new-found enthusiasm of Kirchner and other expressionists, in the paintings of Picasso, in the passion for Cézanne, and in the "rediscovery" of artists in the European tradition with whom abstract artists feel special sympathy: the Byzantine masters of mosaic, Giotto, El Greco, Poussin, and William Blake. These too shared a spirit remote from the Greek delight in natural forms. These new trends in taste, together with Worringer's explanation, were presented in penetrating essays by the British writer, T. E. Hulme, whose work was brought to a premature end by his death in the first World War.

An alien spirit in early abstraction may have expressed the per-

sonal sense of isolation of artists who lived as strangers in strange lands. Many of these painters were "displaced persons," "internationalists," with the advantages and disadvantages of not feeling completely rooted anywhere. They could never be parochial, but they were eternally "foreigners." Consider some of the great names of the first fifteen years of abstract painting, 1910-1925. Wassily Kandinsky, Russian-born, worked in Germany before the first World War and, after a brief interval in Russia, joined the Bauhaus staff in Weimar. From 1934 until his death ten years later he painted in Paris. The Hollander, Piet Mondrian, spent much of his active life in Paris, moving to London for a short stay and finally to New York. The Bauhaus was a miniature UNESCO, bringing together as teachers in its early years the Russian, Kandinsky; the American, Lyonel Feininger; the Austrian, Herbert Bayer; two Hungarians, Marcel Breuer and László Moholy-Nagy; two Swiss, Johannes Itten and Paul Klee; three Germans, Josef Albers and Gerhard Marcks, with the director, Walter Gropius.[53] One school of abstract painting, Synchromism, was founded in Paris by two Americans, Morgan Russell and S. MacDonald Wright. Only Vorticism, established by Wyndham Lewis in London in 1914, was chiefly the work of the native-born.

Revolution against the social order is one of the materials of modern painting, according to some critics. They attribute this revolt to the evils of capitalism, with its stultifying bourgeois standards of economic and moral conformity. Under capitalism, they say, artists can hope for freedom and integrity only by retreating within themselves, by building up their private worlds, shutting off the cramping life around them.[54] To express the vision of the eye turned inward, something other than naturalism is needed, and a not inappropriate medium has proved to be abstract form. This explanation carries some weight. Certainly abstraction has been popular

[53] Bayer, ed., *Bauhaus 1918–1928*, pp. 220–21.
[54] Shapiro, *op. cit.*, pp. 82–83.

with left-wing groups, and proved to be a serious threat to Hitler's peace of mind. His purge of painting is almost as notorious as his burning of the books.

A "hint of menace" in modern painting is also acknowledged by a discriminating writer, Sir Michael Sadler, but he refuses to be disturbed by the portent, and helps to make it intelligible in his little pamphlet, *Modern Art and Revolution*. Artists have always seemed revolutionary and alarming, he says, so far as they have lived up to their age-old mission of uncovering truth that is hidden from other men not yet prepared to see it without flinching. Sir Michael imagines that the Bushmen were alarmed when they came back from hunting and found new marks on their caves; they wondered "what harm this magic would do . . . before [they] could get it safely under the thumb of the soviet community of [their] cave." The truth is that the artist is "the revealer. At his word, at his touch something is drawn back from our eyes . . . he is a formidable person, at least when his hour is on him. We stand not a little in awe of his gift and instinctively feel alarmed when we see him possessed by it." Sir Michael tells of one of Kandinsky's paintings, sent to him eight months before the first World War, that plainly foretold a great catastrophe.

It was a non-representational picture, a free pattern of coloured arabesque, explosive and ballistic in its design. We gave it the title of "War in the Air." A year later by which time we had got only too familiar with bombs and fighting planes, I wrote to Kandinsky in Sweden to ask whether, when he painted the picture, he had foreboded war. "Not this war," he replied, "I had no premonition of that. But I knew what a terrible struggle was going on in the spiritual sphere, and that made me paint the picture I sent you." [55]

This incident recalls what needs repeating: attitudes that found expression in abstraction had grown strong befre the first World War and cannot be discounted as "postwar madness."

[55] Sadler, *Modern Art and Revolution* (London, 1932), pp. 18–19.

While this inquiry into the heritage of abstraction is by no means exhaustive, it should suffice to show that there is no single, simple explanation of the origin of pure painting and that it did not spring full-grown from anyone's palette. Some of the materials, notably those bequeathed from experiments in technique, were recognized and acknowledged by painters themselves: Kandinsky points to his debt to Impressionism; Mondrian and many others urge the importance of Cubist analysis. Other influences, no less potent, worked partly below the level of consciousness: the temper of the times, the emotional and spiritual atmosphere in which the artist breathes. Both new techniques and new needs for expression promoted at once the retreat from likeness and an advance toward ways of painting that should be more completely satisfying to artists themselves. On the side of technique, take for example the relative indifference of painters, beginning with the Impressionists, to *local* color and *natural* form. Color in sunlight, color contributing to harmonious design, color directly expressive of feeling; form as recorded in a shimmer of color, form distorted to meet the exigencies of total pattern, form distorted to intensify expressiveness: these usages constituted withdrawals from nature—techniques ready for the hands of the pure painter.

But to consider these experiments only as withdrawals is to give them an unduly negative emphasis. They were prompted also by a new sensitivity to color and form derived in part from Oriental and primitive art, and by a new consciousness of pleasure in the immediate impact of design. One point in abstracting was to heighten this enjoyment. Again, the moral passion for functionalism—which transferred an ideal from machinery to the arts and pushed architects to construct "machines for living"—stimulated painters to ask what precisely was their function, what were the ends belonging to painting and to no other art? The answer to these questions brought the rejection of ends that had been shared traditionally by painting and poetry: description, illustration, and edification. These

should be confined to the province of the verbal arts. Painting should be exclusively plastic. To discover what could be done with color and form alone was more than to abandon recognizable objects; it was to push back the frontiers of a new territory. Finally, prevailing attitudes toward the world included such as alienated some artists from nature and human beings, from materialism and mechanization, leaving them in no mood to duplicate scenes, creatures, and inventions associated with fear and pain. These artists were ready to create forms that provided an escape. Others, however, gloried in the new possibilities of science and machinery, in exhilarating concepts of space and motion. They in turn sought for a new art that should express their attitude toward a world newly understood. All together moved away from likeness toward abstraction.

# Six

## THE THEORY OF ABSTRACT PAINTING

THE PAINTERS who turned to abstraction had found themselves confronted with new techniques, materials, and attitudes toward the world that made natural forms unattractive. These painters had inherited also an eagerness to experiment and a current preoccupation with functionalism in all the arts. What was painting's appropriate function? What could an artist do with color and form, and with nothing else? He could at least refuse to do what was not his special business: he would not tell stories or preach sermons; he would not even duplicate the beauties that could be seen at first hand in nature. In traditional art, what has caused the observer to look mistakenly to painting for values which belong to literature? Representation: the painter's use of objects associated with remembered facts and feelings which distract attention from what is distinctively plastic. Painting can fulfill its special function only if the artist gives up representation.

There is agreement so far. But differences begin when the new painting must be named. Abstract, the most common name, has gained ground in spite of serious difficulties. An unavoidable ambiguity discussed by an eminent critic, Alfred H. Barr, Jr., is derived from the double relation of the adjective to the verb, *abstract*, and to the noun, *abstraction*. The verb denotes a *process*: "to draw out of" or "away from." In this sense, abstract may be applied legitimately to the works of artists who are at various stages of withdrawal

from nature, that is to say, to paintings that retain more or less clear
vestiges of recognizable objects. These are the paintings which Barr
classes as "near abstractions." The noun, on the other hand, denotes
a *fait accompli*: "something already drawn out of or away from—so
much so that like a geometrical figure or an amorphous silhouette it
may have no relation to concrete reality." [1] Here belong abstractions
that are as complete as can be, that is to say, "pure."

But ambiguity is not the only charge. There is another difficulty
in setting a limit to "near" abstractions. Consider the point that
every painting shows some degree of withdrawal from nature. Even
the Dutch painter who may pride himself on the exactness of his
copies does not produce every detail that would be recorded by a
camera. The human eye can not perceive without simplifying, elimi-
nating, arranging sense data in stable patterns; of this fact, new and
important evidence has been furnished by Gestalt psychologists. [2]
Every painting is, in a sense, abstract. If the paintings to be called
"near abstractions" are defined as those that show a "marked" dis-
tortion, how set the point at which a distortion should be called
marked? A painting might seem fantastically distorted to someone
accustomed to traditional art, and yet appear almost naturalistic to
a devotee of Picasso. A further problem: at the other extreme, how
draw a clear line between "near" abstractions and those that are
"pure"? Take, for example, Picasso's *Standing Figure*.[3] The title
makes it a near abstraction; without the title, it might still retain
vestiges of recognizable objects for a sharp-eyed and sympathetic
critic, but for many it would not suggest a figure in any position. Is
it, then, "pure" abstraction for some and "near" for others? Does
classification turn into a guessing game?

Protests with a different slant have been raised by artists them-
selves. Some say that abstract is colored with associations that are
the very negation of art. Abstract has a grim connection with logic:

[1] *Cubism and Abstract Art*, p. 11.          [2] See above, pp. 25–26.
[3] See Barr, *Picasso; Forty Years of His Art*, p. 73, Plate 94.

there it denotes the process of analyzing members of a class in order
to formulate a definition—a process dry and dull, in no way creative.
To apply the term with this connotation to a painting would be to
condemn it utterly.

Again, "abstract" stands in contrast to "real." But reality of an
important kind is precisely what abstract painters claim for their
works, the reality of an object that exists in its own right, not as a
reflection or copy of something. Naum Gabo makes this point in
writing of his school of abstraction, Constructivism, and gives his
defense the title, *Realistic Manifesto*. Piet Mondrian in the same
spirit calls his essay on his art of rectangles and primary colors, "A
New Realism."

Another objection: "abstract" may mean the opposite of "con-
crete," referring to something that lacks substance, or that exists
only in the mind and not in an object present to sense. But this
meaning can not possibly hold for such a thing as a painting, which
is essentially a concrete, sensuous object. And among paintings,
abstractions are claimed to stand out for their concreteness. Indeed,
"concrete art" is precisely the title adopted at times by Kandinsky,
Arp, and others, for the purest of pure painting and sculpture.
Arp states a distinction between concrete and abstract that would
be accepted by many of his confrères. Abstract he reserves for a
Cubist painting which does not depict a complete object: "parts
have been subtracted from the object which has served as a model
for this picture." Arp goes on to explain what work is properly called
concrete: "I find that a picture or a piece of sculpture that has had
no object for a model is as concrete and as sensuous an object as a
leaf or a stone." [4]

The substitutes for abstract suggested by Gabo and Arp would
hardly usher in a new clarity. The general adoption of "realistic" and

[4] For Kandinsky's use of "L'Art Concret," see *XXe siècle*, I (July–Sept., 1938),
9 ff. Arp and Kandinsky were among a group exhibiting under the name, "Art Con-
cret." This quotation from Arp is in the catalogue of the exhibition, Galérie Drouin,
Paris, June 15–July 13, 1945.

"concrete" would seem whimsical to the point of paradox. A term that has succeeded in gaining some currency is "non-objective." This is the name used by the Solomon R. Guggenheim Foundation for paintings that appear to owe nothing to objects. But another possible meaning of non-objective puts it out of favor with some painters: "lacking in objectivity, devoid of reality." Mondrian calls attention to this inappropriate sense, saying that his aim in painting is to gain objectivity, to reach a kind of reality that transcends subjectivity and change. He suggests and uses the substitute, *non-figurative*,[5] admitting, however, that this also has a serious defect. In all strictness, it excludes too much, not merely the figures of natural objects, but all figures, even geometrical, even his own precious rectangles. "Non-representational," a term with some vogue, is not open to weighty objection. Clearly, a non-representational painting is one which does not stand for anything apart from itself. But all these terms beginning with "non-" have the weakness of implying a negative definition and, worse still, a pallid negativity of the art denoted. Paintings distinguished chiefly by what they avoid do not arouse eager expectation.

A substitute for abstract proposed by Josef Albers is "presentational," his positive equivalent of "*non-re*presentational." *Non* and *re* he says cancel each other; to hold that something does not refer to anything is to affirm that it makes a direct and immediate impression. This last statement surely holds of an abstraction: it exists in itself and is directly apprehended.[6]

All these terms, however awkward or unsatisfactory, have been used in scientific spirit, that is to say, without emotional coloring. This is not invariably true of "pure" and "absolute." *Pure* is used scientifically as an adjective modifying abstraction, distinguishing paintings without recognizable objects from all others, but espe-

[5] *Plastic Art and Pure Plastic Art*, p. 17; p. 50.

[6] *American Abstract Artists*. Morris, ed. The pages are not numbered, but Albers' discussion is near the end of the book.

cially from near abstractions. The meaning of pure is "complete."
Again, painting is pure if it fulfills a function exclusively its own.
Here a coloring of approval may creep in, a sense that painting which
serves an end of its own has special virtue. This shade of meaning
harks back to the theories of architects, such as Berlage and Van de
Velde, who instituted a purge of what was irrelevant to the fulfill-
ment of the function of a building and used "pure" with moral-
aesthetic approval.[7] Pure architecture was aesthetically sound and
morally acceptable because its forms followed function, without
hypocrisy or subterfuge. Similarly, painting can and should be pure;
it is impure, "a bastard art," if it fulfills functions that are not its
own, if it is "an agglomeration of literature, religion, photography
and decoration."

"Absolute" is sometimes used scientifically, as in contrast to
"relative," to denote painting that exists without reference to other
objects and is prized for itself alone. This is Gabo's meaning when
he writes: "The shapes we are creating are not abstract, they are
absolute. They are released from any already existing thing in nature
and their content lies in themselves." [8] But absolute has also a Teu-
tonic connotation with fixed ends of ultimate value: absolute paint-
ing, that toward which all creation has been moving, and once
reached, is to be cherished unchanged. A further likeness between
pure and absolute: they are commonly applied not only to painting
and sculpture, but also to poetry, music, and the dance. This wider
use throws light on tendencies in contemporary aesthetics. There is
a strong concern to discover the distinctive character of every art,
and to impute aesthetic merit to its fulfilling its peculiar function.
Pure poetry, pure music, the pure dance—each keeps its skirts
aesthetically clean. There is an insistence also that a creation in any
art is an individual with a life of its own; it is to be considered on its
own merits, as an absolute entity.

Since all proposed terms are open to objection on some score, the

---

[7] See above, pp. 108–10.              [8] *Circle*, p. 109.

one preferred here is the most familiar "abstract"; it has the merit of being not negative in form, and not eulogistic. But sometimes there is virtue in using non-objective, non-representational, pure, for the sake of variety. To insist on one term to the exclusion of all others seems unnecessarily pedantic.

Theories of abstraction, however original they seem to their inventors, are not presented as entirely self-made. Their lineage is sometimes traced to two names of philosophic dignity, Plato and Kant. While it is true that each of these men said something important to abstraction, neither one urged artists to renounce likeness.

The debt to Plato, both alleged and actual, depends upon a certain passage in the *Philebus*. Socrates is discussing pleasures, pointing out that some are relative to the satisfaction of a need—such as the pleasure of eating when you are hungry, or of scratching an itching spot. There are also pleasures that are mixed with pain, such as the feeling you have when you witness the misfortune of someone whom you envy; you sympathize with the pain of his distress in the very act of gloating over him. Are there any pleasures that are neither relative to a want nor mixed? Yes, says Socrates, there are such pleasures in the immediate awareness of certain colors and forms that we call beautiful, of certain sounds and smells. The forms and colors in question are not those of "animals or pictures." They are the forms of plane and solid geometry, "straight lines and circles and the plane or solid figures which are formed out of them by turning-lathes and rulers and measurers of angles; for these I affirm to be not only relatively beautiful, like other things, but they are eternally and absolutely beautiful, and they have peculiar pleasures, quite unlike the pleasures of scratching. And there are colors which are of the same character and have similar pleasures." [9] Can this passage be taken rightly to prophesy geometrical abstraction? Socrates, we must remember, is discussing not art but pleasure.

[9] *Philebus* 51.

He is not suggesting that an artist should imitate the figures made by the lathe or the ruler. Indeed, he draws a definite contrast between the beauty he is discussing and the beauty of pictures, implying that the beauty of geometrical figures can not be rivaled by the painter. Whence then the ground for Herbert Read's conclusion that in this passage "we have a definite abandonment of the unfortunate theory of mimesis, or art conceived as a technique for the direct imitation of the appearance of things"? [10] This statement by a respected critic has unfortunately gained fairly common acceptance. But Socrates is concerned here with a higher order of pleasure, not with a way of painting. Since he says that smells also are sources of pure pleasure, as well argue that he is recommending an art of odors! At the same time, we must not overlook a fact of basic importance in abstraction to which Socrates calls attention: patterns are effective in themselves; there is an aesthetic pleasure in pure form. But for this fact, abstract art would not be tolerated.

Kant, also, has contributed something to the understanding of abstraction, but here again the purpose of pertinent passages needs study. It is true that Kant points to a non-representative pattern, the arabesque, as an appropriate object for the exercise of what he calls the pure judgment of taste. This is the judgment by which men affirm that an object is beautiful. In the context, Kant's interest turns out to be not in kinds of art but in ways of judging.[11] Among possible judgments there is this one that has the sole function of registering the beauty of an object, with no regard for its function or use. To place his specimen judgment in complete isolation, Kant conceives it at work on an object that can not be judged for anything except beauty—that is to say, an object with no known function which might draw forth the judgment that belongs to science. A non-representative design, the arabesque, is such an object, purged of

[10] *Art Now*, p. 102.
[11] *Critique of the Aesthetic Judgment*, edited by James Creed Meredith, sections 14 and 16.

sources of confusion in thinking. Kant did not go on to say that artists should paint nothing but arabesques, nor that the art which elicits the clearest example of the judgment of taste is, *ipso facto*, the best art. He did not equate purity with both abstraction and greatness, as has sometimes been alleged. But he did call attention to non-representative pattern as a means of understanding something essential about art, that the awareness of form in itself contributes largely to the aesthetic experience.

A philosopher to whom the theory of abstraction owes a debt rarely noted is Schopenhauer. Failure to recognize it may be evidence of its indirectness and its depth. Schopenhauer's tenets have come down through the Symbolist poets, Bergson, and the Cubists. Furthermore, the acceptance of his points has been so general that they hardly seem to have any one author. Writers repeat him, not conscious of quoting; they feel simply that they are talking good aesthetic sense. "The aesthetic experience affords direct insight into reality; it is an experience in which the impact of the work of art is immediate: observer and object are one. A painting is an entity with a life of its own. Its vitality derives from the quality of the artist's vision." These echoes of Schopenhauer sound in the writings of Kandinsky and Mondrian, to mention only two. It is possible that they may have read him, but I doubt this, partly because they are men inclined to pay tribute where they know it to be due.

One more influence, and this the most powerful, is the aesthetics of Cubism. Formulated to support near abstraction, when carried to its logical conclusion it becomes rather a defense of pure painting. The chief early expositors of Cubism, in addition to Guillaume Apollinaire, were two painters, Albert Gleizes and Jean Metzinger, joint authors of the book, *Cubism*. Though their debt to Schopenhauer will be manifest, they dissented from his irrationalism and were in their way thoroughgoing intellectualists.

Defenders of Cubism take the trouble to renounce the copy theory, thereby admitting that it must still be reckoned with. "Let the

picture imitate nothing; let it nakedly present its motive, and we should indeed be ungrateful were we to deplore the absence of all those things—flowers or landscapes, or faces—whose mere reflection it might have been." The naturalistic conception of truth as resemblance must give way to a new kind of truth. "Real resemblance no longer has any importance, since everything is sacrificed by the artist to truth, to the necessities of a higher nature whose existence he assumes but does not lay bare." The old concept of beauty as the sensuously pleasing is also renounced by the Cubist who "wants to visualize beauty disengaged from whatever charm man has for man, and until now, no European artist has dared attempt this. The new artists demand ideal beauty, which will be, not merely the proud expression of the species, but the expression of the universe." [12] High words for high aims.

The Cubist painter's purpose is a lofty one. He wants to become more than human, to use his intellectual power to penetrate beyond the sensuous appearance of things to reality. "Inhuman," "cerebral," "metaphysical," are adjectives which Apollinaire applies to the new painting. Relying on geometry and on the new concept of space-time, of "space eternalizing itself in all directions at any given moment," young painters are trying to produce art with new plastic virtues: purity, unity, and truth. The "pure" painter is one who sees for himself, who is not bound by the art of the past: "Purity is a forgetting after study . . . You cannot carry around on your back the corpse of your father. You leave him with the other dead." A painting is "unified" when it is complete in itself, experienced without reference to anything else, expressive simply of the relation of the creator to his creation. The painter is a kind of god in his power to originate. "Each god creates in his own image; and so do painters. Only photographers manufacture duplicates of nature." [13] Neither purity nor unity counts without truth. A painting is "true" if it gives insight into reality, reality which transcends the material world and can be

[12] *Cubism*, p. 27.          [13] Apollinaire, *The Cubist Painters*, pp. 9, 10.

known only by artists who have escaped from the prison of physical nature. Artists must free themselves from human limitations in order to find traces of the truth that is more than human. Their quest for truth, when it succeeds, always brings them something new, since reality can never be discovered once and for all, and continually reveals itself in fresh insights. The picture that meets Cubist standards is described by Gleizes and Metzinger as difficult to grasp, a self-subsistent entity, with a life of its own: "Essentially independent, necessarily complete, it need not immediately satisfy the imagination; on the contrary it should lead it, little by little, toward the fictitious depths in which the coordinative light resides. It does not harmonize with this or that environment; it harmonizes with things in general, with the universe: it is an organism."

The painter constructs his work of art to communicate his own experience. "When he succeeds he forces the crowd to assume, in respect to his integrated plastic consciousness, the attitude that he himself assumed in respect to nature." Communication is difficult because a natural image has a different value for artist and for observer. The artist prizes it only as a symbol; the observer dwells upon it for its own sake. "The painter, eager to create, rejects the natural image directly he has made use of it, the crowd long remains the slave of the painted image. . . . That is why any new form seems monstrous, and why the most slavish imitations are admired." The painter knows the aesthetic weakness of "the crowd," but must steadfastly refuse to compromise. "Painting must not address the crowd in the language of the crowd; it must employ its own language, in order to move, dominate and direct the crowd, not in order to be understood." He remains true to his calling, knowing that he is in good company. "It is so with religions and philosophies. The artist who concedes nothing, who does not explain himself and relates nothing, accumulates an internal strength whose radiance shines in every hand." There is more than a touch of arrogance in the Cubist. In his account of his work we begin to

hear that refusal to make one's art anything but difficult which has become familiar in many defenses of modern art—of poetry and music, as well as of painting.

What the Cubists say of painting applies so well to pure abstraction as to leave us wondering why they retained even vestiges of recognizable objects. They themselves half-acknowledged that the retention might be only temporary. "Let us admit that the reminiscence of natural forms cannot be absolutely banished; as yet at all events. An art cannot be raised to the level of a pure effusion at the first step." [14] In admitting that their painting might represent a transitional stage in the retreat toward pure abstraction, they said what was reaffirmed by many who followed them. One was Kandinsky. In the Cubist destruction of natural forms as a preliminary to putting bits of them together, he saw a convincing demonstration that even such use of natural forms was nonessential. He criticizes the Cubists for retaining traces of materialism, for their concentration upon physical means—in other words, for their failure to make their art spiritual in his own sense. Mondrian, though more in sympathy with the Cubists, finding them the only painters before him who were on the right track, also took exception to their retaining the naturalism of three-dimensional space. All painters in Paris during the first war and the postwar period, according to Ozenfant, found in Cubism a dominant influence, a source of freedom in the construction of form.

Cubism bequeathed a classicist-intellectualist strain to abstraction, apparent in the writings of Mondrian. There was also a romanticist-expressionist strain coming from the Fauves and the German Expressionists, represented by Kandinsky. Kandinsky and Mondrian were both painters of distinction who wrote extensively to explain their conceptions of art. To select them for special study here presents certain difficulties. There is the obvious barrier of language for anyone who reads neither Russian nor Dutch. While

[14] *Cubism*, pp. 19, 23, 62, 27.

Kandinsky's German and French writings are intelligible, it is open to question whether a man ever expresses his own meaning adequately in a foreign language. Some of Kandinsky's works have been translated into English, but there is an even more pressing question whether a translator may not be unconsciously guided by his own preconceptions. The fact that there are already three translations of Kandinsky's most important writing, *Concerning the Spiritual in Art,* suggests that the barrier of language in his case may be peculiarly great. Mondrian wrote some essays in English but with an obscurity at some points that may show lack of complete ease (or, more serious, an inability to draw sharp distinctions). Furthermore, both men have died relatively recently after careers extending through so many countries that as yet there are no definitive lists of their writings. But in spite of these hazards, Kandinsky and Mondrian can not be passed by. They are the "grand old men" of abstraction. As they differ more than they agree, they supplement each other well.

Kandinsky has been mentioned many times—as one of the first painters of abstractions, as a founder of the *Blaue Reiter* group of Expressionists, and as a member of the Bauhaus staff. When the Bauhaus was forced to close in 1934, he went to Paris, where he worked until his death in 1944. He was then seventy-eight years old, renowned on two continents for his painting and his theory of art. He painted in different styles, first using soft, organic forms, later, sharp lines and geometrical shapes, and finally combining the two (see plates, following page 158). The great American collection of his work belongs to the Solomon R. Guggenheim Foundation, which has also brought him wide attention by publishing translations of some of his writings.[15]

According to Kandinsky's own theory,[16] the personality of artist or writer, his inner life, primarily determines the quality of his work.

[15] The volume, *In Memory of Wassily Kandinsky,* edited by Hilla Rebay, contains useful material, including his "Autobiography."

[16] Stated in *Concerning the Spiritual in Art;* subsequent references are to the translation published by Wittenborn, Schultz, Inc., 1947.

Hence we may properly ask what kind of man was he. Two of his associates at the Bauhaus, Julia and Lyonel Feininger, describe him as an Olympian character. His "outstanding features seem to have been his poise, his innate dignity resulting from a supremely balanced mind and nobility of character. He was in command of the most admirable self-control. Though his attitude was always reserved, we had the feeling in his presence of being enveloped in a kind and wise benevolence." [17] He was the member of the staff whom everyone trusted to arbitrate serious disputes. Then and then only did he display a touch of human frailty; he smiled with pleasure in being consulted and in having his words carry great weight.

Another source of information, Kandinsky's own writings, shows plainly why he thought representation in art must be rejected. Kandinsky identified representative painting with the dominance of science and materialism to which he was profoundly hostile. He was opposed to men of science as "positivists, recognizing only those things which can be weighed and measured." Even in their own province, scientists can not be trusted; what they hold true today they may deny tomorrow. Witness their shocking mistake about the atom. This, by definition the ultimately indivisible, they had found in their power to destroy.

This discovery struck me with terrific impact, comparable to that of the end of the world. In the twinkling of an eye, the mighty arches of science lay shattered before me. All things became flimsy, with no strength or certainty. I would hardly have been surprised if the stones had risen in the air and disappeared. To me, science had been destroyed. In its place—a mere delusion, guesswork by the scientists, who, instead of erecting, stone by stone, a divine and unshakable edifice, had—or so it then seemed to me—gropingly, as if in the dark, fumbled for the scientific verities, often —in their blindness—mistaking one thing for another.[18]

Fundamentally, Kandinsky's distrust of science was rooted in his

[17] Lyonel Feininger was one of the painters invited to the Bauhaus when it opened. He and his wife wrote after Kandinsky's death a short tribute, "Wassily Kandinsky," *Magazine of Art*, XXXVIII (May, 1945), 174–75. This has been reprinted in the Wittenborn edition of *Concerning the Spiritual in Art*, pp. 12–14.

[18] *In Memory of Wassily Kandinsky*, p. 55.

mystical temper and in the attraction he felt in theosophy. He hungered for insight into the life of the spirit to which scientists were blind. The theosophists, in contrast, spoke words of hope. He praises especially Helena Petrovna Blavatsky for starting "a fundamentally spiritual movement," "a strong agent in the general atmosphere, presaging deliverance to oppressed and gloomy hearts." [19]

Mme. Blavatsky was a compatriot of Kandinsky's, thirty-five years his senior. Although she lived until he was twenty-five years old, she had been so long away from Russia that they probably never met. Her voluminous writings do not show to cursory inspection any tenets about art that Kandinsky may have taken directly, but he makes obvious use of theosophical conceptions and symbols.

In the life of the spirit, Kandinsky saw art as one of the "mightiest agents," art not as it was but as it ought to be. Art actually was failing to perform its function, as a result of the inadequacies of representation which placed it in low esteem. Kandinsky describes the usual conglomerate exhibition of naturalistic paintings, "animals in sunlight or shadow, or drinking, standing in water, or lying on grass; close by, a Crucifixion, by a painter who does not believe in Christ; then flowers, and human figures sitting, standing, or walking, and often naked; there are many naked women fore-shortened from behind; apples and silver dishes; a portrait of Mister So-and-So"; and so on. The people who come to see the paintings go about with catalogues, reading titles and the names of artists, not touched by what their eyes rest on. "They depart, neither richer nor poorer, again absorbed by their affairs . . . The connoisseurs admire 'technique' as one might admire a tight-rope walker, or enjoy the 'painting quality' as one might enjoy a cake. But hungry souls go hungry away." Both artists and public must be stirred to realize that

[19] Helena Petrovna Blavatsky, 1831–1891, born in Ekaterinoslav; traveled over the world, speaking and writing on theosophy; references to her in *Concerning the Spiritual in Art*, pp. 32, 33.

paintings, rightly constructed and observed, would so strengthen the souls of men as to bring about the spiritual regeneration of society.

For Kandinsky the end of art is to express the artist's spiritual insight and thereby to provide nourishment for men of lesser vision. Echoing theosophy, Kandinsky represents mankind at a given period by a triangle standing on its base, the lower segments moving upward when there are spiritual leaders to show the way. At the apex stands the true artist who has reached the point where he can help other men to rise. But when they in turn approach this point, it has broadened to become the base of still another triangle, and so the process goes on indefinitely. Hence every cultural period must create its own art.[20]

Kandinsky did not see at once that the art of his era should be abstract. Before reaching this conviction, he went through a period of apprenticeship in which he learned much from Impressionism, from Cézanne, Matisse, and Picasso. He recalls his delight in his first Impressionist show in Moscow, and in realizing the effectiveness of one of Monet's *Haystacks*, even though he could not recognize the subject:

For the first time in my life, I found myself looking at a real painting. It seemed to me, that without a catalogue in my hand, it would have been impossible to recognize what the painting was meant to represent. This irked me, and I kept thinking that no artist has the right to paint in such a manner. But at the same time, and to my surprise and confusion, I discovered that it captivated and troubled me, imprinting itself indelibly on my mind and memory down to its smallest detail. But on the whole, I could make neither head nor tail of it, and was, therefore, quite incapable of arriving at the conclusions which later appeared so simple.

But what did become clear to me, was the previously unimagined unrevealed and all-surprising power of the palette. Painting showed itself to me in all its fantasy and enchantment. And deep inside of me, there was born the first faint doubt as to the importance of an "object" as the necessary element in a painting.[21]

[20] *Ibid.*, p. 25, 26, 27, 23.          [21] "Autobiography," pp. 53, 54.

Kandinsky admired Cézanne for skill in representing the life of inanimate objects. "He made a living thing out of a teacup, or rather, in a teacup he realized the existence of something alive." Matisse was the great colorist. Kandinsky criticized him for being carried away with color at times, but at his best, Matisse uses color to express "great internal vitality." Kandinsky described Picasso in 1911 in terms that still ring true:

Torn by the need for self expression, Picasso hurries from means to means. A gulf appears between consecutive modes of expression, because Picasso leaps; he is continually found by his bewildered followers at a point different from that where they last saw him. . . . Picasso . . . shrinks from no innovation, and when color distracts him, he throws it overboard, painting a picture in ochre and white.[22]

Strength and originality of form were Picasso's contributions to Kandinsky's knowledge of the materials of painting.

Until Kandinsky was thirty years old, he considered painting only a fascinating hobby. When he began to study seriously, he worked in studios from the usual nude models, but never felt at home there.

The naked body, its lines and movement, sometimes interested me but often merely repelled me. Some poses in particular were repugnant to me, and I had to force myself to copy them. I could really breathe freely only when I was out of the studio door and in the street once again.[23]

A psychiatrist might find here a clue to an unconscious motive for abstraction.

Consciously, Kandinsky moved toward abstraction through his experience of Monet's *Haystacks;* more surprisingly, through the study of political economy, which he says made him at home in the sphere of the non-objective; again, through an unexpected view of one of his own works which seemed peculiarly dazzling when lying on its side. This last experience is not without parallel. Picasso also,

[22] *Concerning the Spiritual in Art,* pp. 36, 39.
[23] "Autobiography," p. 65.

according to Ozenfant,[24] saw that one of his paintings was more effective when turned, and took to deciding which should be the top and which the bottom of a picture after it was finished. Both artists were confirmed in the belief that aesthetic quality had nothing to do with likeness.

Another influence came from Kandinsky's own attempts at composition. He found that the "inner necessity" of the composition of the whole picture required him to modify individual forms to such a degree that they lost their identity. So he gradually "acquired the gift of no longer noticing the given object, or at least of overlooking it." [25]

No more external reality—dogs, vases, naked women—but instead, the "material" reality of pictural means and resources which calls for the complete transformation of all vehicles of expression, and even technique itself. A picture is the synthetic unity of all its parts.[26]

Having reached this stage as a painter, he was ready as a theorist to maintain that painting was rightly tending toward abstraction. First, because there is a new understanding that color and form are effective in themselves, and all the more so when free from associations with objects in nature. Colors and forms produce a physiological effect upon the eye, and an incalculably more important psychical effect upon the soul, setting up spiritual vibrations. Artists are only beginning to know how to use color and form, and must school themselves by careful study, especially of the effects of form on color and of one form on another. Blue in the form of a circle is not the same as blue in a triangle or a square. One form changes completely according to its place among other forms; "every form is as sensitive as smoke." All these subtle relationships are more completely within the artist's control if not complicated by associations with material objects.

[24] Ozenfant, *Foundations of Modern Art*, p. 73; Kandinsky, "Autobiography," p. 60.
[25] "Autobiography," p. 60.
[26] "Toile Vide, etc.," *Cahiers d'art*, p. 56.

Again, the artist does well to abstract in order to strengthen the eternal aesthetic quality of his work. There are three necessary factors in a work of art: the artist's own personality, the spirit of his age, and art as such, pure and eternal. This last and most important is in a way retarded by the other two. The more a painting is stamped with the character of a particular individual and a particular age, the less it partakes of the timeless objectivity of great art. A sloughing off of the subjective and the dated may be the result of abstraction.

Kandinsky warns the artist that he must go through a period of learning; he cannot simply abandon natural forms at one step. If he moves too fast, he paints designs that are decoration and not art. Learning to abstract is at once a process of spiritual self-discipline and the mastering of a new language of insight. On the one hand, the artist refines his soul by ceasing to care for material things. On the other, he becomes expert in understanding what is hidden from the eye, the inner life of objects and persons, their qualities of spirit. He looks at all things as a man enters into conversation with an interesting person, not concerned with the physics of sound or with the letters that make up words, but rather with the impalpable ideas, feelings, and emotions that are being expressed. This must be his way of looking at an abstraction if he receives its direct, absolute effect. As he becomes more and more spiritual and increasingly adept in the language of insight, his paintings come closer to being pure abstractions. At every point, however, he must choose his forms freely, guided only by "inner necessity." [27]

"Inner necessity" is central in Kandinsky's theory of art, as central as "inner light" in Quaker doctrine. Indeed the two concepts have something in common. "Inner necessity" in a painter's own soul directs his choice of color and form to give his spiritual insight appropriate expression. A painting also has its "inner necessity," which dictates what can be added, subtracted, or moved in a com-

[27] *Concerning the Spiritual in Art*, pp. 51, 52, 53, 70.

position. A perfect drawing is one in which "nothing can be changed without destroying the essential inner life." Again, "inner necessity" refers to the objective spiritual force in the world that reveals itself in painting when it is pure and eternal. "The inevitable desire for expression of the objective is the impulse here defined as 'internal necessity.' This impulse is the lever or spring driving the artist forward."

Inner necessity and inner light, the spark of the divine that gives each man his share of spiritual life. For Kandinsky, with a theosophist's belief that there is life everywhere, this spark animates not only human beings, but the raindrops that tease him, the bubbling colors on his palette. "Large, round raindrops would settle on my palette. Trembling and shaking, they would pause, then suddenly stretch toward each other, run forward and mingle into thin, agile threads that trickled hither and thither amongst my colors, or would suddenly jump down my sleeve." And of his paints themselves: "The impression of colors strewn over the palette: of colors—alive, waiting, as yet unseen and hidden in their little tubes—all this acquired for me an inner spiritual life and meaning." [28] There was something of the poet in Kandinsky.

Inner necessity is a force with a definite mission; it works for harmony in the soul, in a painting, in the whole spiritual world. Harmony, so important to Kandinsky, is a term in music, the art in which he found guidance for painting. He felt the two arts to be very close, partly because he was convinced that colors and sounds had similar effects, partly because he was confident that the freedom from materialism already won by music could be attained by painting likewise. A performance of *Lohengrin* in his youth had startled him into a sense of the relation between music and painting. He heard the opera at a time when he was obsessed with a passion to put on canvas the colors of the Moscow sunset, and suddenly perceived in *Lohengrin* his "evening hour" incarnate.

[28] "Autobiography," pp. 50, 51, 63.

I could see all my colors, as they came to life before my eyes . . . I did not dare admit to myself that Wagner had musically drawn "my hour." But it became totally clear to me that art in general possessed a far greater power than I had ever imagined. I also realized that painting possesses the same power as music.

On another occasion, the light and shade in a painting by Rembrandt recalled the double vibration of Wagner's horns.[29] The idea became fixed in his mind that "painting possesses the same power as music," though he felt this power to be still only latent. With the greatest pains he worked out correspondences between certain colors and sounds:

Light, warm red . . . gives a feeling of strength, vigor, determination, triumph. In music, it is a sound of trumpets, strong, harsh and ringing. . . . Vermilion . . . rings like a great trumpet or thunders like a drum . . . Warm red, intensified by a kindred yellow, is *orange*. . . . Orange is like a man convinced of his own powers. Its note is that of a church bell (the Angelus bell), a strong contralto voice, or the *largo* of an old violin.[30]

The scientific basis for the association of a color with a sound Kandinsky finds in the dependence of both upon vibrations; these physical vibrations set up corresponding disturbances in the human soul.

Music enjoyed an advantage over painting in being traditionally free from associations with material things. The chief exception, program music, was virtually always admitted to be inferior to pure music. Naturally, then, Kandinsky urged painters to learn from composers how to work purely. It was natural also for him to draw analogies from music and to adopt its terms. When he wished to explain how color and form set up vibrations in the soul, he used the analogy of a piano.

Color is the keyboard, the eyes are the hammers, the soul is the piano with many strings. The artist is the hand that plays, touching one key or another purposively, to cause vibrations in the soul.

[29] "Autobiography," pp. 54, 56.        [30] *Concerning the Spiritual in Art*, pp. 61–63.

To use again the metaphor of the piano, and substituting form for color, the artist is the hand which, by playing this or that key (i.e., form), purposely vibrates the human soul in this or that way.

Painting should have its "counterpoint," its science of the precise relation of forms to each other. "Melodic" was the term for his simple compositions, "symphonic," for the more complex. *Composition* and *Improvisation* were frequent titles for his paintings.[31]

The relation of painting to the arts of sculpture and architecture Kandinsky discussed in his plans for an art institute in Moscow, plans never to be carried out.[32] He said that at the moment the relative functions of the arts were not clear and the fullness of their possible cooperation not yet imagined. He was writing in 1920. He proposed research in the coordinate use of painting, sculpture, and architecture to build up a unified "monumental art." Indeed, he would admit musicians and dancers also to a union of the arts which should produce a joint psychological effect of new depth and force.

In all the arts as in all thought, all life, Kandinsky looked toward a future in which the spirit would grow strong. He writes:

I think that all future philosophy will devote itself not only to the essence of things, but also to their spirit. It will then become possible to feel, if only subconsciously, the spirit of all things, in the same way as now is felt the outward essence, a feeling which explains the pleasure derived from purely objective art. With growing realization of the spiritual, it will be easier for man to comprehend—first the spiritual meaning of material things, and later, that of abstraction in phenomena.

And through this new aptitude, which is "of the spirit," there shall be born the joy in the purely Absolute Art.[33]

Kandinsky was a rare soul with a touch of the saintliness of Plotinus. Some of his paintings communicate a mood of exaltation even to those who find his theosophical imagery uncongenial. A striking tribute to his power came from a painter of a very different stamp, Diego Rivera. In a passage quoted by Hilla Rebay, he says:

[31] *Ibid.*, pp. 45, 47, 65, 71, 76, 77.
[32] *In Memory of Wassily Kandinsky*, pp. 75 ff.    [33] "Autobiography," p. 71.

I know of nothing more real than the painting of Kandinsky—nor anything more true and nothing more beautiful. A painting of Kandinsky gives no image of the earthly life—it is life itself. If one painter deserves the name "creator" it is he. He organizes matter as matter was organized, otherwise the Universe would not exist. He opened a new window to look inside of the All. Some day Kandinsky will be the best known and the best loved by men.[34]

Kandinsky's theory merits the same criticism that was brought against Plotinus and Schopenhauer; they were defending art in one temper as though it were the whole of art, as though all painters worthy of the name must belong to the brotherhood of William Blake. There may be other mystics of abstraction to whom Kandinsky's doctrines apply, point by point, but they must be few. There may be also a prophetic value in Kandinsky's pronouncements on the immediate effectiveness of colors and forms, and on what might be called the distortion of color by form. That forms do indeed affect us directly and profoundly has been ascertained by Gestalt psychologists. It may be true that forms also distort a color, that the same blue pigment evokes a different color-response when it is shaped now as a circle, now a triangle, now a square, but where is the proof? Kandinsky's assertions are hypotheses needing to be tested by the careful scientific method which he held of little worth.

In less exalted vein is the writing of our second advocate of abstraction, Mondrian. The two men differ as much in temper as in art. Mondrian is nothing of a poet. In painting, he owed his original interest in rectangular design, according to George L. K. Morris, to the sight of "buildings from which the adjoining houses had been demolished; colored squares were left where the rooms had formerly joined on." [35] This in contrast to the "Choir of Colors" in the Moscow sunset which inspired Kandinsky! Kandinsky painted intricate and varied compositions of many tints and hues; Mondrian is famous for simple patterns of rectangles in which he uses only

[34] *In Memory of Wassily Kandinsky*, p. 100.
[35] "Aspects of Picture-Making," *American Abstract Artists*, no page numbers.

primary colors. Mondrian should have found a congenial point of view in the classicism of Sir Joshua Reynolds, and might have accepted certain phrases of Reynolds as applying to his own abstractions in the "Grand Style," marked by "breadth of uniform, simple colour," over which reign "quietness and simplicity."

Pieter Cornelis Mondriaan (his name before he shortened it), six years younger than Kandinsky, was born in 1872 in Amersfoort, the Netherlands.[36] The two artists died in the same year, 1944. By training in Holland, Mondrian was a naturalistic painter of old churches and water scenes and of flowers that he liked to represent singly. To earn money, he made bacteriological drawings for textbooks and schoolrooms; he painted portraits and copies of pictures in museums. Through the years, his work began to deviate more and more from nature, not because he was influenced by other experimenters in art, of whom he knew very little, but because he was trying to find a line of his own. His Dutch patrons did not take to his new ventures. So at the age of thirty-eight he set out for Paris. It was in 1910, when Cubism was causing a furor. Mondrian was attracted by analytical Cubism, especially by the paintings of Léger and Picasso, whose influence is clear on his painting, *Eucalyptus* (1910). But Mondrian soon became his independent self again, and returned to his solitary experiments.

The course of his life was not uneventful. After four years in Paris, he went back to Holland for a visit in 1914, and was detained by the outbreak of war. During his stay there, he collaborated with Theo van Doesburg to found the magazine, *De Stijl*, with the aim of promoting the use of primary colors and rectangular form in the three arts of painting, sculpture, and architecture. Van Doesburg carried the influence of *De Stijl* to the Bauhaus, with which Mondrian was in full sympathy.[37] Returning to Paris, Mondrian

[36] For a brief biographical sketch, see Jay Bradley, "Piet Mondrian, 1872–1944," *Knickerbocker Weekly*, III (Feb. 14, 1944), pp. 16–24.

[37] Van Doesburg eventually struck out his own line by turning his rectangles to a forty-five degree angle; he called his way of painting Elementarism. The difference be-

published there in 1920 a manifesto for his way of painting which he called Neo-Plasticism. During the second World War, Mondrian moved first to London and then to New York. He loved American city life and American music. Even at the age of seventy he liked to dance and was reported by Max Ernst [38] to be a perfect dancer, creating abstract patterns as he moved.

In Mondrian's account of his own development in *Plastic Art and Pure Plastic Art,* he admits the attraction of the Cubists, but finds them wanting in thoroughgoing consistency. "Cubism did not accept the logical consequences of its own discoveries; it was not developing abstraction toward its ultimate goal, the expression of pure reality." Cubism remained intrinsically naturalistic, because it never gave up the intention to express volume. Art that is truly abstract can not keep this intention, but rather "attempts to destroy the corporeal expression of volume; to be a reflection of the universal aspect of reality."

Reality, for Mondrian, included two aspects of the universe which remain constant in spite of changes in the surface of things: space and vitality. Space here is not "the void," nor yet "the background of a picture," but infinite extension pulsating with movement. Space is dynamic, alive with lines of force, sometimes in conflict, sometimes in equilibrium. Reality so conceived appears also in human nature. Beneath particular existences and the opposition of individuals, there is a sea of energies moving through conflict to harmony. Conflict shows itself in war and the class struggle: the resolution of conflict will be complete only in a society free from competition, wholly cooperative. Some degree of resolution, a kind of token ordering of vital human energies, is what the painter sees in his vision of reality. "Art is *not the expression of the appearance of reality such as we see it, nor of the life which we live,* but . . . *it*

---

tween this and Mondrian's style is greater than the description suggests. Mondrian's designs are in a solid position of rest, while Van Doesburg's seem always on the point of turning to rest, thus giving an effect of movement and instability.

[38] Bradley, *op. cit.,* p. 25.

*is the expression of true reality and true life . . . indefinable but realizable in plastics."* [39]

The artist presents his vision symbolically in his painting. As the plastic equivalent of the constants underlying change, he uses the plastic constants, rectangles and primary colors. Primary colors are unmixed and unvariable. The rectangle is a constant in that its position is stable. Looking at it, the observer does not tend to move it in imagination to a position of greater rest, as he might move a diamond, for example, to the stronger stance of a square. A simple rectangle alone might look not only stable but static, as though it had never moved, as though it had no life. But reality is not static; its equilibrium is dynamic, vibrantly poised. Of this relationship the plastic equivalent is a visual opposition of rectangles of different sizes, an arrangement of lines that divides the canvas into parts that are unequal but equivalent. A painting so constructed gives insight into the unity that would be possible in a cooperative society. Such unity constitutes a vision of reality which serves at once as a model and a spur; men see what they should work for, and thereby renew their strength to accelerate human progress.

This value of painting, though significant now, will prove not to be permanent. When the perfect society is established, art will disappear.

"Art" is only a substitute as long as the beauty of life is deficient. It will disappear in proportion as life gains in equilibrium. Today art is still of the greatest importance because it demonstrates plastically in a direct way, liberated of individual conceptions, the laws of equilibrium.

The importance of painting is temporary on a second count. Although at the moment painting atones for deficiencies in architecture, it will no longer be needed when builders reach the point of using color rightly. This conclusion has some force so far as Mondrian's own style is concerned. Designs not unlike his may be achieved by an architect who makes proper use of colors and of the

[39] *Plastic Art and Pure Plastic Art.*

spatial relationships of walls, doors, and windows. In a house rightly constructed, easel paintings that are abstract may prove dispensable. It is true also that painting with the sole function of expressing dynamic equilibrium will cease to be important in a social order that is perfectly cooperative. The question remains, however, whether other painting than Mondrian's will be useless in the future, whether Mondrian himself may not have underestimated the efficacy of his own in contributing to individual peace of mind. No matter what the organization of society or the skill of the architect, will there not always be turmoil of spirit at human pain and sorrow that will need art for relief and release?

Painting which can perform its functions in an imperfect world must be free from the limitations of forms as they exist in nature. Bound up as these are with "subjective" feelings about particular things, natural forms of hills and trees can not fail to block insight into the everlasting.

The principal problem in plastic art is not to avoid the representations of objects, but to be as objective as possible . . . Objective vision—as far as possible—is the principal claim of all plastic art. If objective vision were possible, it would give us a true image of reality.

In an essay entitled "A New Realism," Mondrian summarizes his position:

The expression of pure vitality which reality reveals through the manifestation of dynamic movement is the real content of art. The expression of life in the surrounding reality makes us feel living and from this feeling art arises. But a work of art is only "art" in so far as it establishes life in its unchangeable aspect: as pure vitality. After centuries of culture this fact produced Abstract Art in modern times.[40]

Artists are warned that they have not done their whole duty when they have simply omitted natural forms; they must have genuine insight that requires abstraction for its expression. This insight depends in part upon the artist's emancipation from "subjectivity,"

[40] *Ibid.*, pp. 60, 32, 28, 20.

from the stresses and strains and the limitations of his own ego. So freed and "objective," the true artist constructs form which has its own special content, "universal thought." This content is inseparable from its form in Mondrian's work; there is no content apart from form. Moreover, the content can not be described in words, because its character is such as to lend itself precisely to expression through "pure plastics" and through no other means.

Kandinsky and Mondrian, first-generation abstract painters, established styles whose influence has been noteworthy. For example, a clear debt to one or the other is apparent in works by younger artists, reproduced in *American Abstract Artists* (1946). There is a trace of Kandinsky in Joseph Meierhaus' *Composition* and in John Xceron's *Composition No. 275* (the similarity goes deeper than the titles). Painters who had never seen Mondrian's work could hardly have produced *Triangular Movement*, by Albert Swindern, and *Arctic Concretion*, by Ilya Bolotowsky. This is not to say that these artists are imitative, but simply that they learned their respective idioms partly from their two famous elders. Moreover, Mondrian's patterns of rectangles have affected much commercial art, in the designs for posters, furniture, textiles, and linoleum. On the side of theory, also, his influence is appreciable; his essays are accepted as good doctrine by many younger theorists. Witness the inclusion of "A New Realism" in *American Abstract Artists*.

Mondrian's emphasis on the complete unity of form and content in abstract art is repeated in the writings of Naum Gabo. Mondrian's conception of dynamic space would seem to have contributed to Moholy-Nagy's discussions of space-time problems in art. Both writers share Mondrian's hope that art may contribute much to a new society. Both were among the founders of Constructivism, a school of abstraction with which Mondrian expressed sympathy, and by which he was claimed as a leader. His essay, "Plastic Art and Pure Plastic Art," appears in the international sur-

vey of Constructivism, entitled *Circle*, to which Gabo and Moholy-Nagy also contributed. Gabo served as one of its three editors, and gave the basic account of "The Constructive Idea in Art."

The Constructive Idea, according to Gabo, originated in a reaction against the destructive havoc wrought by Cubism. Cubism had destroyed the old view of the unified world of art as effectively as the conceptions of relativity and space-time in physics had destroyed the old view of the material world. This parallel was natural, since the science and art of a period are likely to be closely related, both expressing the same *Zeitgeist*. In this instance, Cubism and physics represent the same spirit of fearless analysis. The destruction left by Cubism was so violent and thorough as to stimulate artists to build anew, to be constructive. They propose to establish not only a new art but a new society of which the new art should be a symbol and an instrument. The new art should be one in which form and content are the same thing; they "live and act as a unit," neither predominating.[41] This perfect unity is not possible in representational art because its content is always some external aspect of the world, an aspect with its own form which must partly determine the form of a painting. As Gabo put it, "In representational art there was obedience of form to content." In abstract art, however, there is no such subservience. The content *is* the form, that is to say, the only content consists of lines, colors, and shapes recognized to be expressive in themselves apart from associations. Here is the perfect unity, the cooperation of elements so fused as to be indistinguishable; it is the quality of Mondrian's society freed from aggressions. Art so unified helps to bring Utopia by strengthening the emotions that dispose men to work together and build anew. "Art prepares a state of mind which will be able only to construct, coordinate and perfect instead of to destroy, disintegrate and deteriorate." [42]

Moholy-Nagy helped to establish Constructivism in Germany,

[41] *Circle*, p. 6.                    [42] *Ibid.*, p. 9.

and was one of those responsible for calling the Constructivist Congress in Weimar in 1922. He was then a brilliant young artist and writer who had left his native Hungary for the exciting art centers of Germany. He is best known for his long connection with the Bauhaus, where he was professor and co-editor with Walter Gropius of the Bauhaus publications. In 1937, Moholy-Nagy came to Chicago to direct the Institute of Design. His interests were so versatile, his scope so wide that his contribution to the visual arts was described by Gropius as "Leonardian." [43] It included the first photograms (cameraless photographs); experiments with many kinds of new materials; striking designs in typography and stage settings; a moving picture, *Lobsters*, which ranked among the best films of 1936; the making of delicately balanced, movable constructions called "mobiles," and so on. His death in 1946 cut off tragically early a source of vitality in the practice and theory of art.

According to Moholy-Nagy, the painter of today should accept gladly new materials and techniques and see what he can do with them. These materials include plastics, some of which have a transparency that lends itself to wonderful effects of light which constitute a kind of "painting with light." Among new techniques, the use of airbrush and spray gun make possible interesting surfaces and, from the practical standpoint, mass production that may extend generously the supply of art objects available for human enjoyment. The painter finds also certain ideas current in very different spheres that affect his work: the architect's precept, "form follows function"; the physicist's concept of space-time; the technologist's belief in the glorious future of a machine age; the humanitarian's dream of more creative life in a cooperative society. The architect's precept convinces the painter that painting should cease to be literary, giving up representation, and should extend its range as a purely plastic art. To emphasize the values of painting as "plastic" is to acknowledge no clear line between paintings and the plastic

[43] *The New Vision; and, Abstract of an Artist*, p. 89.

art of sculpture. The two arts are indeed little separated by Moholy-Nagy and other Constructivists. The painter conceives his present function to lie partly in exploring new materials to see how they lend themselves to forms never before envisaged. These forms combine a wealth of sense experience, tactile and kinesthetic as well as visual. New materials have new surfaces to touch. Forms in motion, as in a construction that pivots on a standard or is set turning by electricity or currents of air, express and satisfy the fascination of the physicist's concept of space-time. Forms that are geometrical express enthusiasm for machines that are beneficent. The new creativity of art gives hope of rounding out lives made narrow by overspecialization in an industrialized society. And abstract art, rightly ordered, symbolizes in its harmonious pattern a new and better social order. "Abstract art . . . creates new spatial relationships, new inventions of forms, new visual laws—basic and simple—as the visual counterpart to a more purposeful, cooperative human society." [44] Forms in art communicate the artist's feelings to the observer's consciousness and subconsciousness, preparing him to banish competition and destruction, and to work for a new brotherhood of man.

Among these writers, Kandinsky stands alone in his antiscientific spirit, in his romantic devotion to music, in his conception of art as the expression of spiritual forces. At the opposite extreme is Moholy-Nagy, as much an experimental scientist as an artist. Between the two, Mondrian shows a kind of mysticism in his conception of reality, a reality which recalls Bergson's vitalism rather than Blavatsky's theosophy. Gabo, nearer Moholy-Nagy, has much to say of science without being, we may suppose, a scientist in any marked degree. All four relate painting to architecture, conceiving some combination of the two arts with sculpture to constitute the art of the future. Kandinsky adds music and dancing also. All agree in assigning to art a social function. Art helps to build a new society: according to Kandinsky, by making men more spiritual;

[44] *Ibid.*; for the last point, see p. 76.

according to Mondrian, by ridding them of competitive in-
dividuality; according to Gabo, by instilling the will to construct;
according to Moholy-Nagy, by providing a symbol of ideally
cooperative relationships.

These claims for abstraction seem unconvincing to many lay ob-
servers who nevertheless admit a liking for this way of painting.
Speaking as one of them, I confess to having asked myself whether
a Kandinsky has made me more spiritual, a Mondrian less com-
petitive, a Moholy-Nagy or a Gabo more socially constructive. I
find regretfully that the answer is No. To ask such questions may
seem naïve, but how otherwise can one put these theories to the
test? My answer may be an admission of personal inadequacy, since
"like is known by like," but it is a failing shared by many who urge
that they enjoy abstractions and find them expressive although
hardly sources of magical regeneration.

There is another possible objection to these high claims. May
they represent a lingering unconscious doubt of the power of paint-
ing to stand alone and a desire to enhance its worth through associa-
tion with something prized apart from a work of art? In a world in
desperate need of weapons against materialism, conflict, and de-
struction, to urge that art may provide such weapons is perhaps to
defer to the copy theory in new, insidious form.

A less exalted but more uncompromising account of abstraction
is offered by the painter, Hilaire Hiler, when he describes his own
impulse to begin to paint with color and form alone. When he was
in charge of decorating the Aquatic Building in San Francisco, he
was struck one day by a scene that made a pattern of different tones
of white. House painters in white overalls were applying a second
coat of white paint to a wall, above a floor covered with a white
cloth strewn with papers from the men's luncheons. Everything
was white except the men's hands and faces, and each white had a
subtly different tint. Hiler painted the scene, putting in the house
painters and naturally using flesh color for their hands and faces.

These little areas that were not white broke his pattern of color. He tried painting hands and faces white also. The result proved to be comically disturbing to those who saw the painting.

People who saw the picture with the house painters sitting there eating their lunch with their white hands and faces said:

a. "The poor men contracted painter's colic from not washing their hands before eating lunch. Very informative!"

b. "He's making out the proletariat as clowns!"

c. "Modern working conditions lead to T.B."

Hiler concluded that the only way to avoid interfering with the effect of the pattern of whites was to leave out hands and faces and painters.

I found out that if I was so interested in all this wonderful color and wanted to handle it for its own sake, and in its relation to form, I'd better let myself be as free as possible from the associations and limitations of representation. The white face won't work any better than the blue horse or the pink tree.[45]

Hiler writes as an artist familiar with many ways of painting—among them abstraction—who paints what interests him for its color and form, and finds that sometimes the effect for which he is working requires the elimination of recognizable objects. He is one artist among the many who bear witness to the fact that abstraction is one effective way to paint.

The effectiveness of abstractions is placed in a new light by findings of Gestalt psychologists. Rudolf Arnheim in a recently published article on "Perceptual Abstraction and Art" shows that certain abstract forms are among the elements of visual perception, "the primary perceptual phenomena." They are the forms that constitute the initial ordering of visual sensations. The child sees a head first as something round. This "global characteristic" strikes the child's eye "even before the more specific detail of a visual object is grasped." Later, when the child draws a head by attempting to draw a simple circle, he is not "leaving out details"; he is drawing what he

[45] Hiler, *Why Abstract?* pp. 25–27.

perceived. Long and sophisticated experience is required for seeing an object in the detail that appears in a photograph, and for so representing it. The drawings of children, and of primitive peoples also, show what they see, probably without conscious omissions. "Highly abstract forms which characterize early stages of representation are not due to the simplification of previously more complex patterns but spring rather from the priority of simple global forms." [46] Some abstract forms, at least, may have the force and freshness presumed to belong to a human being's initial ordering of experience.

Abstraction as a means of exploring the plastic wealth of new materials has been advocated to their gain by Hiler, Moholy-Nagy, and others. It has helped them study the precise qualities of chemically new colors, of transparencies, and the like. Abstraction has been recommended also as an interim way of painting, a kind of proving ground of form and color. Years ago Georgia O'Keeffe made this use of it on the advice of her teacher, Arthur Dow. Many teachers now show students how abstraction can help them make an initial plan for a picture. Geometrical patterns sharpen and clarify spatial relations: "Euclid alone has looked on Beauty bare."

Complete emancipation from any concern for the appearance of nature is a legacy from pure painting, a legacy enjoyed no more by those who construct abstractions than by artists generally. All eyes through the past four decades have been "conditioned" to a fresh way of seeing. One may hazard a guess that Grant Wood, Rivera, Orozco, and Picasso owe something of their independence to an aesthetic environment that included paintings that are pure form. Traces of this conditioning appear in current taste in applied design, in furniture and textiles, in posters and printing. The "layout" of many advertisements, the covers of many books, bring striking reminders of Mondrian's balanced rectangles.

From the standpoint of the retreat from likeness, abstraction has

contributed clarity to the theory of painting. Abstractions have shown as in a diagram that the essential character of painting is not likeness but form; that an artist's work is not copying but construction; that a work of art is an individual with a life of its own, and at the same time, is universal through an appeal free from associations with particular experiences; that apart from any reflection of values current in the world of affairs, a painting has the strictly plastic value of evoking a unique and rewarding experience of seeing. These points hold obviously for abstractions, and throw light upon representational painting also. Moreover, they are points that prove not to be new, but rather to be affirmed with an emphasis that is novel and striking.

Take the first and most obvious point. Abstractions show that their painters had no concern with exact resemblance; true enough, but painters of natural objects had begun to lose such a concern when Parrhasios admitted they copied no particular model, but rather brought together the "most beautiful" features culled from many models. Reynolds moved further away from the copyist in his "generalized" species, his figures in the Grand Style designed to impress spectators of all ages; further still Plotinus and Schopenhauer, who turned the artist toward Platonic Ideas, supersensuous entities for which he constructed a kind of symbol in plastic terms. Abstraction stands at the apex of comprehension that likeness per se has no aesthetic significance.

Abstract painting, being form and nothing else, demonstrates the point that form is the indispensable element in a painting. A painting can be a painting and effective without likeness, but destroy its form and you destroy it totally. Pressing this point, the purist insists upon reducing painting to its bare essence, in the sense of what is indispensable. His insistence has produced painting that is a kind of intellectual exercise, with the merit of making clear not merely that form is important (which indeed no one would have denied), but also that it takes precedence over likeness. This point is not new,

however; it is only made explicit in an emphatic way. It has been implied in the practice of painters who did not hesitate to sacrifice likeness to heightened beauty, to the form of the species or of the Idea. It is implicit also in the criticism that approved their so doing. The abstract artist has proclaimed what he holds to be the virtue of his painting alone, but what proves to be true of "good" representational painting also, that the primary aim of the art of painting is to create form.

In the light of abstraction, there is new understanding of *form*. Recall that in the history of painting "form" has sometimes referred primarily to the modeling of individual objects; to say then that an artist was weak in form meant little more than that he lacked skill in representing objects in the round. Again, form has been virtually synonymous with "type-form," the artist's required original. Reynolds said that the artist's model should be "the invariable form which Nature most frequently produces, and always seems to intend in her productions"; "that central form . . . from which every deviation is deformity." Reynolds came to know these forms by generalizing from particulars to discover what was essential to *the species* —this in contrast to the *Ideal Form* of followers of Plotinus, who saw their originals in a heavenly vision. Blake, as one of them, would have none of generalization; for him "All Forms are Perfect in the Poet's Mind." It was natural for Blake, and also in other connections for Reynolds, to use the plural—forms—for the shapes of various objects appearing on the canvas. The placing of these shapes in relation to each other would seem to have belonged to "perspective." Today form in the singular denotes the total arrangement of the picture space, and betokens the strong interest in the whole composition that is characteristic of abstract artists.

Moreover, in abstraction, form and content are obviously the same; there is no separate content. Form and *expression* are one; the arrangement of color and line in itself is moving. Form and *color* are one; the arrangement of colors constitutes the form. Form is the

whole composition, the artist's ordering of his materials in perfect unity. This point has been stressed with new intelligibility. But unity of form and content is not a new aesthetic virtue. It was the first requirement of Greek art. It was praised by Pater as the distinctive achievement of music which made all other arts "aspire to the condition of music." The kind of painting of which Pater demanded this unity was not abstract but representational, the painting of Giorgione.

An abstraction demonstrates that the painter is not a copyist. He must be a builder, responsible for a picture's total construction. What the artist contributes to a work of art is *the whole picture*. This is an extreme statement of what has been half-seen and half-said many times before. Through the centuries of talk about the artist's need of beautiful or saintly models and of great subjects, did anyone suppose that artistic success depended solely on a wise choice of model and subject? Certainly not. Witness the painter's study of geometry, perspective, and anatomy, of techniques of mixing and applying paints. It was precisely "man added to nature" that produced a work of art. Witness also the paeans of praise for the few artists at any time who produced acknowledged masterpieces. Some painters may have been modestly convinced that they owed a degree of their success to their subjects, or to the inspiration of a holy model. Sir Joshua Reynolds would have said so. And they were doubtless right in recognizing that some models, some subjects, set them free to make full use of all their skill and knowledge. At long last, however, it was they themselves who determined their designs. It is Chardin himself, as Bürger said, whom we admire in his glass of water. That everything depends finally upon the artist is set beyond question by an abstraction.

An abstraction is an individual with a life of its own. It is a little world in itself, to be entered as Kandinsky tells us he learned to enter a painting, "to move around in it, and mingle with its very life." Its life depends on its own internal harmony. This self-subsistence be-

longs not only to an abstraction, but is claimed for any genuine work of art. This is what Schopenhauer seems to have had in mind when he insisted that the essential character of a work of art lies in its independence of relations to other things, in its lending itself to an experience of wholly absorbed concentration. More recently the Cubists would seem to have symbolized the reality and the autonomy of a painting when they constructed *collages* with actual pieces of real material—wood, newspaper, and fabric.

To conceive an abstraction as an individual entity is to bring up to date the old discussions of individuals, particulars, and universals in art. An abstract artist obviously does not imitate a particular; he constructs an individual, uncluttered by associations with experience outside art. His painting consequently speaks not merely to those who share his background, but to all with eyes to see the universal language of color and form. It is universal as music is universal, in playing directly upon human senses.

The value of an abstraction can not depend on any relation to what has been antecedently judged beautiful, good, or real. An abstract painting is prized as the source of a peculiarly subtle awareness of relations of color and line, a distinctive way of seeing which parallels the subtle and complex awareness of sounds in music. Both seeing and hearing have an emotional tone; they are expressive. As one listens to music for the sake of a kind of hearing, so one who values abstractions enjoys in them a similar experience of seeing. But having learned from an abstract painting this way of seeing, we recognize virtually the same experience with some representative paintings also, provided that in looking at them we succeed in abstracting from the representative features.

This is entirely possible. Before a representative painting we may withdraw our attention from everything except color and line; we may see the painting as form and nothing else. This way of looking was described by Roger Fry in his account of seeing a Chardin still life of glass bottles.

It was a signboard painted to hang outside a druggist's shop. It represented a number of glass retorts and a still, and various glass bottles, the furniture of a chemist's laboratory of that time . . . Well, it gave me a very intense and vivid sensation. Just the shapes of those bottles and their mutual relations gave me the feeling of something immensely grand and impressive, and the phrase that came into my mind was, "This is just how I felt when I first saw Michael Angelo's frescoes in the Sistine Chapel." Those represented the whole history of creation with the tremendous images of Sybils and Prophets, but esthetically it meant something very similar to Chardin's glass bottles.[47]

Not all representative paintings lend themselves to vision of this kind. When they do, we may assume that the painter himself practiced a similar abstraction. He looked at whatever he painted as though it were still-life, caring not at all whether a roundish object before him might be a head or a pumpkin. A painter may lose this detachment in practical concerns; he may have a story to tell or a cause to support. His attention will then wander from the plastic aspects of his vision. If so, his painting will betray him, for here as elsewhere action follows thought. The result may move the beholder to sign a check or raise a flag, but it will have no tendency to plunge him into pure absorption in seeing.

But even when a painter has succeeded in expressing his feeling for pure form, his canvas may lend itself to experiences other than the one distinctive of art. We may shift our interest and attention, and begin to admire the painting technically as the product of expert craftsmanship. We may cherish it sentimentally, as a cue to pleasantly remembered emotions of real life. We may find it exciting as the record of adventure in history or fiction, or dig into it as a mine of material in the history of ideas. These experiences are familiar enough. They are rewarding in their several ways, and sometimes important, but they are not peculiar to painting; they may spring also from works of literature, from manufactured objects, and from natural scenes. They make us look at the painting and then

[47] Fry, *The Artist and Psychoanalysis*, p. 16.

away from it, comparing, appraising, placing in relations. We are not lost in seeing color and form in themselves.

To learn to distinguish these ways of seeing is a valuable lesson. It helps us to recognize when our experience is aesthetic and when it is not. Moreover, we learn to recognize and set apart the kind of art that admits of genuinely aesthetic seeing. If a painting is so constructed as to make the experience of form alone virtually impossible, it is not good art, even though it may be a technical tour de force or a priceless historical document.

Because representative paintings can be regarded in so many ways, some defenders of abstraction would have us abjure them altogether. This seems like needless asceticism. Having learned when we are seeing a painting aesthetically, why should we deny ourselves the full gamut of varied experiences which a masterpiece may make possible? And there are other more serious arguments against accepting the purist ban. We must urge that in spite of all that abstract painters have sacrificed to show what can be done with color and form alone, their paintings too often leave observers conscious of not having been deeply moved. Some abstractions I admit to finding disappointingly prosaic. When I see such a painting, I wonder whether the artist may have suffered from the curse of a divided mind: was he not as much intent on applying a theory as on expressing his vision in its most appropriate idiom? I am sure I am not alone in suspecting an intrusion of the doctrinaire and the pedantic. If an artist says to himself, "No forms from nature permitted," he is only in part a painter absorbed in the object seen. He is partly also a censor looking over his own shoulder, and in no better plight than the representative artist divided between a painting and a cause.

It follows that the abstract artist himself can create pure form effectively only when he turns to it freely, never when consciously bound by a self-denying ordinance. Should not an artist's training then include mastery of both representative and non-representative design? Should he not be, so to speak, bilingual, and able to use

whichever language springs involuntarily to his mind? One artist's account of his own free use of forms is in point here. The artist is Picasso, whose versatility makes him more than bilingual in his plastic idioms:

> When I have found something to express, I have done it without thinking of the past or of the future. I do not believe I have used radically different elements in the different manners I have used in painting. If the subjects I have wanted to express have suggested different ways of expression I have never hesitated to adopt them. I have never made trials nor experiments. Whenever I had something to say, I have said it in the manner in which I have felt it ought to be said.
>
> Different motives inevitably require different methods of expression. This does not imply either evolution or progress, but an adaptation of the idea one wants to express and the means to express that idea.[48]

With all the attention now paid to abstraction by painters who have grown up with it and can use it unself-consciously, pedantry should disappear.

Granted that painters may learn to use abstraction spontaneously and naturally, are they justified in looking forward to a time when representative painting, with its distracting confusion of values, may be cast into limbo? This was the hope of Willard Huntington Wright in 1915 when he wrote his defense of Synchromism. Kandinsky too had faith that this day would dawn when men had risen from materialism to a new spirituality. Of course, Kandinsky might say that the unspiritual world of today has never given his faith a chance. But speaking as an observer who is not unsympathetic, I must still point to limitations in materials and range of expressiveness which seem serious and unavoidable.

The abstract painter, bound to exclude natural forms from his paintings, must forgo the use of much visual material which he himself has once found expressive. Like everyone else, he has seen

[48] *Picasso: Fifty Years of His Art*, p. 271. This is from a conversation with Picasso in 1923, reported by Marius de Zayas, and originally published in *The Arts* (May, 1923), under the title, "Picasso Speaks."

things and scenes in his surroundings by means of which his emotions crystallized into clarity and found a natural expression. A mountain, a stretch of open water, a grove of birch and pine, furnished colors and shapes which "spoke to his condition." When he found in nature the images to express his moods, he was using materials in the sphere where almost every other man also is something of an artist. Every man who has found peace in the shape of a sloping hillside or the vast spread of a prairie is prepared to respond to certain forms in painting. When the artist refuses to avail himself of this wealth of common material, he is like a poet who renounces the mother tongue of himself and his hearers, insisting that they all master Esperanto. Or he is like a composer who purges his harmonies of all notes that might suggest the human voice or the call of a bird.

Abstractions lend themselves to the expression of certain attitudes toward the world: a feeling of alienation from nature and human beings, a sense of the fallibility and weakness of man in a world interpreted by mathematics and physics, the sturdy hopefulness of an imagination kindled by machines of miraculous delicacy and power. These and more feelings which find non-objective forms attractive were discussed in the preceding chapter. But there are certainly other passions which seem to take less kindly to abstraction. Even in a mechanized social order, human beings continue to feel strongly about other human beings, to find happiness in small, unimportant things, and to be excited by warm generosity and Quixotic loyalties. For expression of such feelings, geometrical designs seem incongruous, though no one could say positively that they could not serve.

If we urge now that representative forms should be as much at the painter's command as are abstractions, do we in any way abandon the final position in the retreat from likeness? Having learned from abstraction that likeness is not and never has been of the essence of good painting, do we play false to this knowledge in admitting that

the painter may on occasion find that forms in nature give him his best vocabulary of expression? No. We have not deserted the position of prime importance, that a painting is not a copy but a construction, so ordered as to constitute its own little world of vision which the observer experiences in itself alone, eyes absorbed and satisfied within the limits of the frame. This is of the essence of any painting, representational or abstract, constructed by an artist with the right way of seeing. His vision right, he is free to find his forms where he will.

To follow the retreat from likeness is to become aware that the novelty in abstract painting is less extreme than has been sometimes supposed. The new painting has roots, and an essence common to its genus. All the more reason then for seeing it, not as a passing phase, but as a well-grounded stage with its own contributions to the development of art. Abstract painting has served as a means of study and analysis, comparable in its way to the study of geometry by the Greeks and of anatomy by Leonardo; it is a potent instrument of research in the organization of space, and of motion through space. More important still, it has enriched the sources of expressive form. For some temperaments, it has brought the emotional expressiveness of painting into a new dimension.

# Illustrations

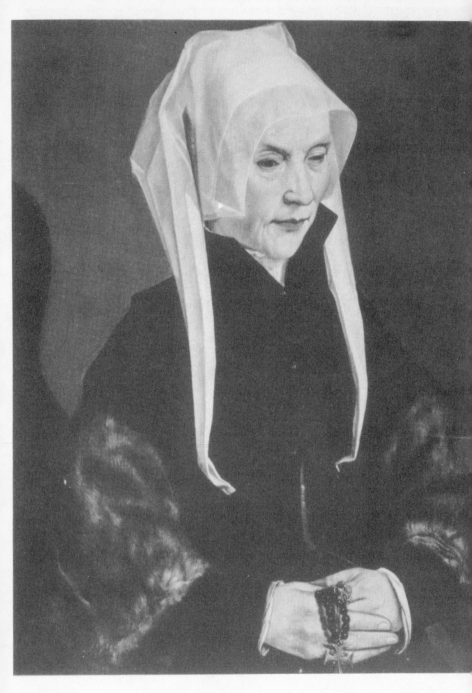

MARTEN VAN HEEMSKERCK (1498–1574): PORTRAIT OF AN OLD LADY

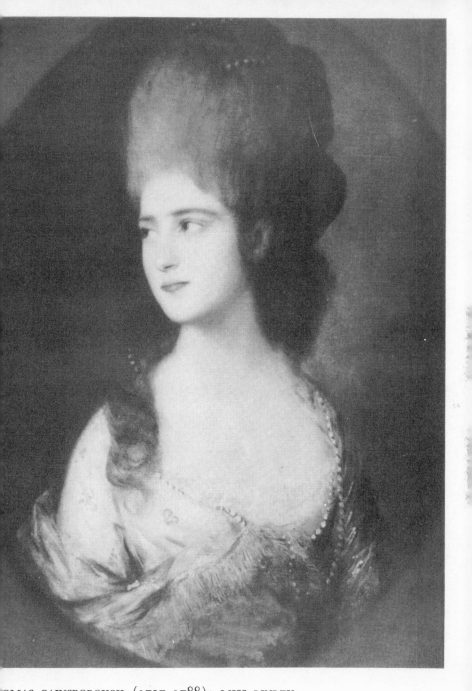

OMAS GAINSBOROUGH (1727–1788): MISS LINLEY

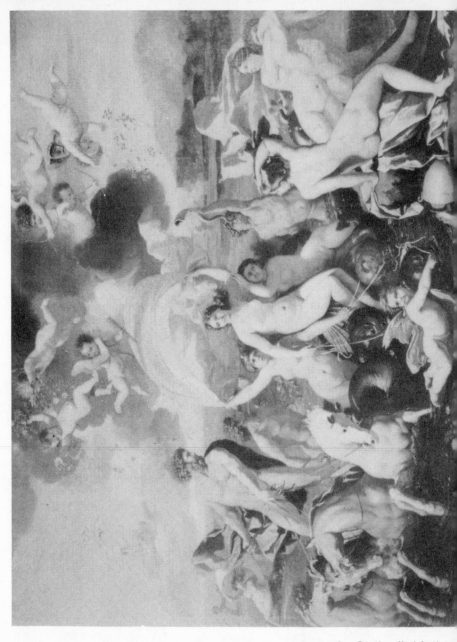

NICOLAS POUSSIN
(1594–1665)
THE TRIUMPH OF
NEPTUNE AND
AMPHITRITE

THE GEORGE W. ELKINS
COLLECTION, PHILADELPHIA
MUSEUM OF ART
COURTESY OF THE
COMMISSIONERS OF

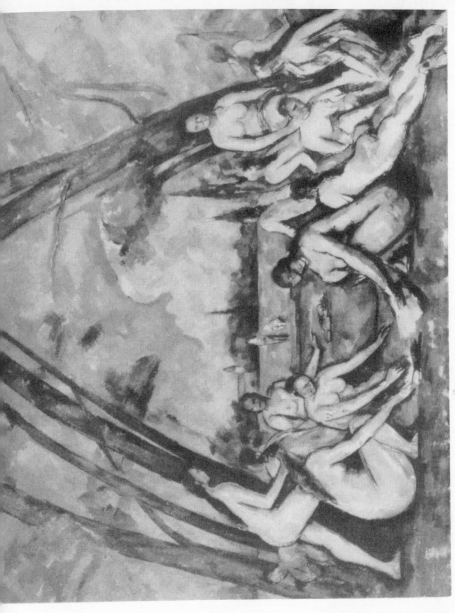

PAUL CÉZANNE
(1839–1906)
THE BATHERS

THE WILSTACH COLLECTION
PHILADELPHIA MUSEUM
OF ART
COURTESY OF THE
COMMISSIONERS OF
FAIRMOUNT PARK

PABLO PICASSO: DOG AND COCK, 19

COLLECTION OF T
MUSEUM OF MODERN ART, NEW YC
(MRS. SIMON GUGGENHEIM FUN

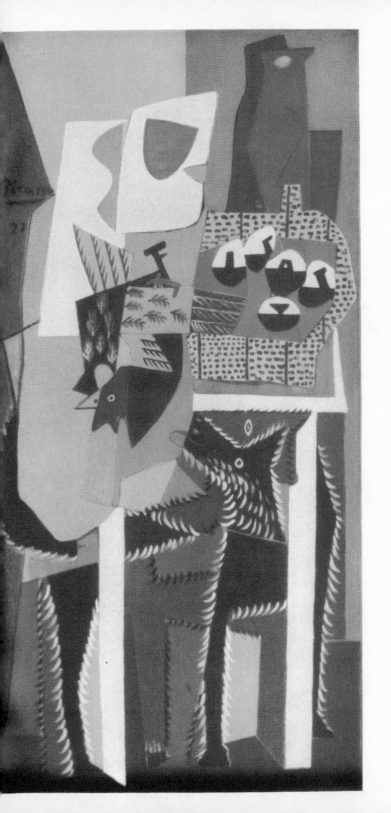

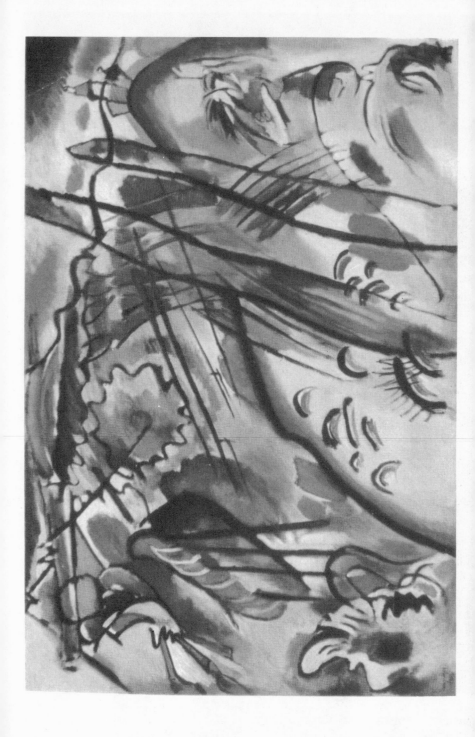

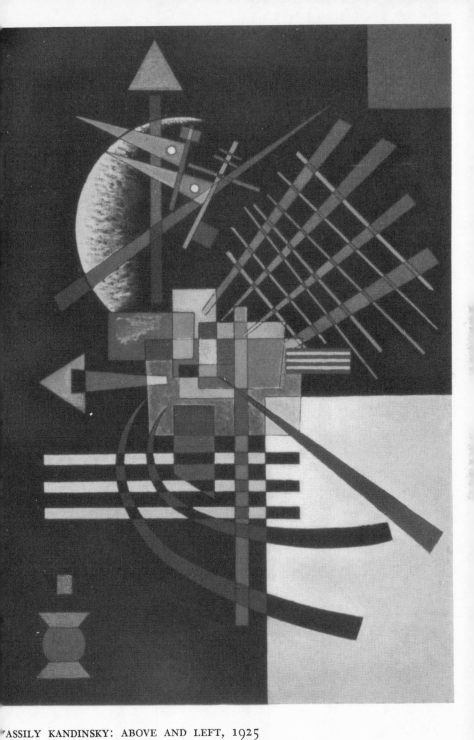

WASSILY KANDINSKY: ABOVE AND LEFT, 1925

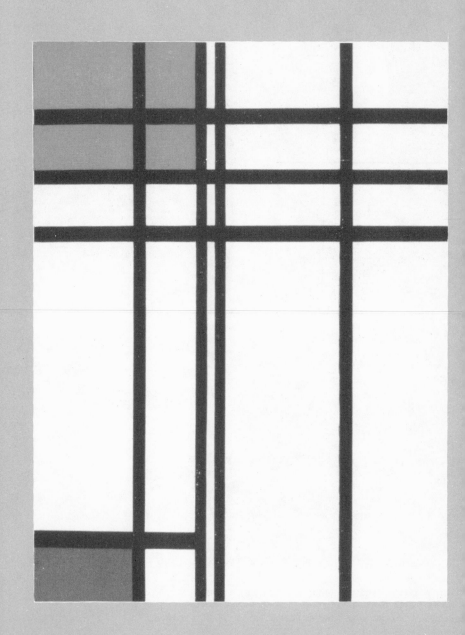

PIET MONDRIAN: PAINTING, 1937

# Principal References

Alberti, Leon Battista. Della pittura . . . Della statua. Bologna, 1782.

Alexander, Samuel. Beauty and Other Forms of Value. London, Macmillan and Co., Ltd., 1933.

Apollinaire, Guillaume. The Cubist Painters; Aesthetic Meditations. Translated by Lionel Abel. New York, Wittenborn and Co., 1944.

Aristotle. Works. Translated under the editorship of W. D. Ross. Oxford, Clarendon Press, 1908–31. See also Butcher; Bywater.

Arnheim, Rudolf. "Perceptual Abstraction and Art," Psychological Review, LIV (March, 1947), 68–82.

Barnes, Albert C. The Art in Painting. New York, Harcourt, Brace and Co., [1925].

Barr, Alfred H., jr. Cubism and Abstract Art. New York, The Museum of Modern Art, 1936.

—— German Painting and Sculpture. New York, The Museum of Modern Art, 1931.

—— Picasso; Fifty Years of His Art. New York, The Museum of Modern Art, 1946.

—— Picasso; Forty Years of His Art. New York, The Museum of Modern Art, 1939.

Bayer, Herbert, and others. Bauhaus 1919–1928. New York, The Museum of Modern Art, 1938.

Bell, Clive. Art. London, Chatto and Windus, 1914.

Bellori, Giovanni Pietro. Le vite de pittori, scultori, et architetti moderni. Rome, Por il succeso, al Mascardi, 1672.

Bergson, Henri. Laughter. Translated by Cloudesley Brereton and Fred Rothwell. New York, The Macmillan Co., 1914.

Bosanquet, Bernard. A History of Aesthetic. 2nd ed. London, George Allen and Unwin, Ltd., 1922.

Burnet, John. Early Greek Philosophy. London, Adam and Charles Black, 1904.

Butcher, S. H. Aristotle's Theory of Poetry and Fine Art. London, Macmillan and Co., 1895.

Bywater, I. Aristotle on the Art of Poetry. Oxford, Clarendon Press, 1909.

Carritt, E. F. The Theory of Beauty. 2nd ed. London, Methuen & Co., Ltd., 1923.

Cézanne, Paul. Letters. Translated by Marguerite Kay and edited by John Rewald. London, B. Cassirer, [1941].

Chassé, Charles. Le Mouvement symboliste dans l'art du XIX siècle. Paris, Librairie Floury, 1947.

Circle; International Survey of Constructive Art. Edited by J. L. Martin, Ben Nicholson, and N. Gabo. London, Faber and Faber, Ltd., 1937.

Collingwood, R. G. The Principles of Art. Oxford, The Clarendon Press, 1938.

Conway, W. M. Literary Remains of Albrecht Dürer. Cambridge, The University Press, 1889.

—— The Van Eycks and Their Followers. London, J. Murray, 1921.

Croce, Benedetto. Aesthetic. Translated by Douglas Ainslee. 2nd ed. London, Macmillan and Co., Ltd., 1922.

Denis, Maurice. Nouvelles Théories sur l'art moderne. Paris, L. Rouart and J. Watelin, 1922.

—— Théories; 1890–1910. Paris, L. Rouart and J. Watelin, 1912.

Dewey, John. Art as Experience. New York, Minton, Balch & Co., 1934.

Dodds, A. E. The Romantic Theory of Poetry. London, E. Arnold & Co., 1926.

Du Fresnoy, Charles Alphonse. The Art of Painting. Translated by John Dryden. 2nd ed. London, B. Lintott, 1716.

Dürer, Albrecht. Vier Bücher von menschlicher Proportion. [Nürnberg, J. Formschneyder, 1528.]

—— Records of Journeys to Venice and the Low Countries. Edited by Roger Fry. Boston, The Merrymount Press, 1913.

Eastlake, Sir Charles. Materials for a History of Oil Painting. London, Longman, Brown, Green, and Longmans, 1847.

Frank, Waldo, and others. America and Alfred Stieglitz. New York, Doubleday Doran & Co., 1934.

Freund, Gisèle. La Photographie en France au dix-neuvième siècle. Paris, A. Monnier, 1936.

Fry, Roger Elliot. The Artist and Psychoanalysis. London, L. and V. Woolf, 1924.

—— "The Arts of Painting and Sculpture," in *An Outline of Modern Knowledge*. New York, G. P. Putnam's Sons, 1931.

—— Cézanne. London, L. & V. Woolf, 1927.

—— Introduction and Notes for Discourses of Sir Joshua Reynolds. London, Seeley & Co., 1905.

—— Transformations. London, Chatto and Windus, 1926.

—— Vision and Design. Revised ed. London, Chatto and Windus, 1925.

Gleizes, Albert, and Jean Metzinger. Cubism. Translated. London, T. F. Unwin, [1913].

Goldwater, Robert J. Primitivism in Modern Painting. New York, Harper and Brothers, 1938.

Harrison, Jane Ellen. Introductory Studies in Greek Art. London, T. F. Unwin, 1885.

Hiler, Hilaire, Henry Miller, and William Saroyan. Why Abstract? [New York], J. Laughlin, [1945].

Hilles, Frederick Whiley. The Literary Career of Sir Joshua Reynolds. Cambridge, The University Press, 1936.

Howard, William Guild. "Ut pictura poesis," *Publications of the Modern Language Association of America*, XXIV (new series, XVII) (1909), 40–103.

Hulme, T. E. Speculations. London, K. Paul, Trench, Trubner & Co., 1924.

Hussey, Christopher. The Picturesque. London and New York, G. P. Putnam's Sons, 1927.

Iamblichus. Life of Pythagoras. Translated by Thomas Taylor. London, A. J. Valpy, 1818.

James, William. Varieties of Religious Experience. London and New York, Longmans, Green and Co., 1902.

Kandinsky, Wassily. The Art of Spiritual Harmony. Translated by Sir Michael Sadler. London, Constable & Co., Ltd., 1914.

—— Concerning the Spiritual in Art, and Painting in Particular, 1912. [Sadler translation, with considerable retranslation by Francis Golffing and others.] New York, Wittenborn, Schultz, 1947.

—— On the Spiritual in Art. Translated. New York, published by the Solomon R. Guggenheim Foundation for the Museum on Non-Objective Painting, 1946.

—— Punkt und Linie zu Fläche. Munich, Laugen, 1926.

Kandinsky, Wassily. " 'Toîle vide,' etc.," *Cahiers d'art*. Paris, 1935.
—— Uber das Geistige in der Kunst. Munich, R. Piper, 1912.
—— and Franz Marc. Der blaue Reiter. Munich, R. Piper, 1914.
Kant, Immanuel. Critique of the Judgement. Translated by J. H. Bernard. 2nd ed. London, Macmillan and Co., Ltd., 1914.
—— Critique of. Aesthetic Judgement. Edited by James Creed Meredith, Oxford, Clarendon Press, 1911.
Kate, Lambert Hermanson ten. The Beau Ideal. Translated by James Christopher Le Blon. London, Bettenham, 1732.
Koffka, Kurt. Principles of Gestalt Psychology. New York, Harcourt, Brace and Co., 1935.
Köhler, Wolfgang. Gestalt Psychology. New York, H. Liveright, 1929.
Lomazzo, Giovanni Paolo. A Tracte Containing the Artes of Curious Paintings, Carvinge and Building. Translated by R[ichard] H[aydocke]. Oxford, J. Barnes, 1598.
Loran, Erle. Cézanne's Composition. Berkeley and Los Angeles, University of California Press, 1943.
Lozowick, Louis. Modern Russian Art. New York, Museum of Modern Art, Société Anonyme, 1925.
Mallarmé, Stéphane. Divagations. Paris, E. Fasquelle, 1897.
Maritain, Jacques. Art and Scholasticism. Translated by J. F. Scanlan. London, Sheed & Ward, 1930.
Mauclair, Camille. L'Art indépendant français sous la troisième république. Paris, La Renaissance du Livre, 1919.
McKeon, Richard. "Literary Criticism and the Concept of Imitation in Antiquity," *Modern Philology*, XXXIV (August, 1936), 1–35.
Moholy-Nagy, László. The New Vision; and, Abstract of an Artist. 4th ed. New York, Wittenborn, Schultz, 1947.
Mondrian, Piet. Plastic Art and Pure Plastic Art. 2d ed. New York, Wittenborn, Schultz, 1947.
Montague, William Pepperell. The Ways of Knowing. London, G. Allen & Unwin, Ltd., 1933.
Morison, Stanley. Fra Luca de Pacioli. New York, The Grolier Club, 1933.
Morris, George L. K., ed. American Abstract Artists. New York, The Ram Press (Distributed by Wittenborn and Company), 1946.
Newhall, Beaumont. Photography; a Short Critical history. 2d ed. New York, The Museum of Modern Art, [1938].

Ozenfant, Amédée. Foundations of Modern Art. Translated by John Rodker. London, J. Rodker, 1931.

—— [and Jeanneret]. La Peinture moderne. Paris, G. Crès & Cie., [1927?].

Panofsky, Erwin. Albrecht Dürer. Princeton, Princeton University Press, 1943.

—— "Idea." Leipzig, Berlin, B. G. Teubner, 1924.

Parkhurst, Helen Huss. Beauty. New York, Harcourt, Brace and Co., 1931.

Plato. Dialogues. Translated by Benjamin Jowett. Oxford, Clarendon Press, 1892.

—— Lexicon Platonicum. Edited by F. Astius. Leipzig, 1835.

Pliny. The Elder Pliny's Chapters on the History of Art. Translated and edited by K. Jex-Blake and E. Sellers. London, Macmillan, 1896.

Plotinus. Enneads. Translated by Stephen Mackenna. 5 vols. London, The Medici Society, 1917-30.

—— The Philosophy of Plotinus. By W. R. Inge. London, Longmans, Green and Co. 1918.

Read, Herbert E. Art Now. London, Faber and Faber, Ltd., 1936.

Rebay, Hilla, ed. In Memory of Wassily Kandinsky. New York, The Solomon R. Guggenheim Foundation, 1945.

Rey, Robert. La Renaissance du sentiment classique dans la peinture française à la fin du XIX siècle. Paris, Les Beaux-arts, G. van Oest, [1931].

Reynolds, Sir Joshua. Works. Edited by Austin Dobson. London, Oxford University Press, 1907.

—— Discourses. Edited by Roger Fry. London, Seeley & Co., 1905.

Rewald, John. The History of Impressionism. New York, The Museum of Modern Art, [1946].

—— (ed.) Paul Cézanne; Letters. London, B. Cassirer, [1941].

—— Paul Gauguin: Letters to Ambroise Vollard and André Fontainas. San Francisco, The Grabhorn Press, 1943.

Richardson, Jonathan. An Essay on the Theory of Painting. London, Printed by W. Bowyer, for John Churchill, 1715.

Richter, Gisela. The Sculpture and Sculptors of the Greeks. New Haven, Yale University Press, 1929.

Sandys, J. E. A History of Classical Scholarship. 3 vols. Cambridge, The University Press, 1903-8.

Santayana, George. Obiter Scripta. New York, C. Scribner's Sons, 1936.

Santayana, George. The Sense of Beauty. New York, C. Scribner's Sons, 1896.

Schopenhauer, Arthur. Sämmtliche Werke. 6 vols. Leipzig, F. A. Brockhaus, 1873–74.

—— The World as Will and Idea. 3 vols. Translated by R. B. Haldane and J. Kemp. London, Trübner, 1883–86.

—— Encyklopädisches Register zu Schopenhauers Werken. By Gustav Friedrich Wagner. Karlsruhe, 1909.

Shapiro, Meyer. "Nature of Abstract Art," Marxist Quarterly, I (Jan.-March, 1937), 77–98.

Spurgeon, Caroline F. E. Mysticism in English Literature. New York, G. P. Putnam's Sons, 1913.

Swindler, Mary H. Ancient Painting. New Haven, Yale University Press, 1929.

Underhill, Evelyn. Essentials of Mysticism. New York, E. P. Dutton & Co., 1920.

Vasari, G. Leonardo da Vinci. London, Phaidon Press, 1943.

Véron, Eugène. L'Esthétique. Paris, Reinwald, 1878.

Vinci, Leonardo da. Note-Books. Translated by Edward McCurdy. New York, Empire State Book Co., 1923.

Vollard, Ambroise. Paul Cézanne; His Life and Art. New York, Frank-Maurice, 1926.

Wilenski, R. Modern French Painters. New York, Reynal & Hitchcock, 1940.

—— The Modern Movement in Art. 2d ed. London, Faber and Faber, Ltd., 1935.

Worringer, Wilhelm. Form in Gothic. Authorized translation. London, G. P. Putnam's Sons, Ltd., 1927.

Wright, Willard Huntington. Modern Painting. New York, John Lane Co., 1915.

# Index

# DATE DUE
# REMINDER

FEB 24 '96

**Please do not remove
this date due slip.**